Bound by Creativity

Bound by Creativity

HOW CONTEMPORARY ART
IS CREATED AND JUDGED

Hannah Wohl

The University of Chicago Press CHICAGO & LONDON

The University of Chicago Press, Chicago 60637
The University of Chicago Press, Ltd., London
© 2021 by The University of Chicago
Published 2021
Printed in the United States of America

30 29 28 27 26 25 24 23 22 21 1 2 3 4 5

ISBN-13: 978-0-226-78455-7 (cloth)
ISBN-13: 978-0-226-78469-4 (paper)
ISBN-13: 978-0-226-78472-4 (e-book)
DOI: https://doi.org/10.7208/chicago/9780226784724.001.0001

Library of Congress Cataloging-in-Publication Data

Names: Wohl, Hannah, author.
Title: Bound by creativity : how contemporary art is created and judged / Hannah Wohl.
Description: Chicago ; London : The University of Chicago Press, 2021. | Includes
 bibliographical references and index.
Identifiers: LCCN 2020046173 | ISBN 9780226784557 (cloth) | ISBN 9780226784694
 (paperback) | ISBN 9780226784724 (ebook)
Subjects: LCSH: Art and society—New York (State)—New York. | Artists—New York
 (State)—New York. | Creative ability—Social aspects. | Aesthetics—Social aspects. | New
 York (N.Y.)—Intellectual life—21st century.
Classification: LCC N72.S6 W645 2021 | DDC 700.9747—dc23
LC record available at https://lccn.loc.gov/2020046173

CONTENTS

Introduction:
Aesthetic Judgment in the
Contemporary Art World

In the 1990s, contemporary artist Lucky DeBellevue began experimenting with pipe cleaners, weaving the fuzzy wires into globular floor sculptures and intricate webs crawling up the sides of gallery walls. Lucky's pipe cleaner sculptures were widely exhibited in galleries and museums. He had a solo exhibition of the works in the atrium of the Whitney Museum of American Art, with a golden cobweb of pipe cleaners unfurling across the tall ceiling and spires rising from the marble floors. The exhibition's catalog hailed the installation as "magical," describing a "beguiling synthesis" of kitsch and high art.[1]

Suddenly, Lucky stopped. Years later, sitting in his studio, Lucky explained to me that after a decade of producing pipe cleaner sculptures, he could not think of any more variations of this visual element. He said, "I remember I still have one piece that I kept trying to finish, and it just wasn't ending anymore. . . . I kept doing things to it, and it just wasn't exciting to me."

"Why do you think that boredom set in?" I asked.

Lucky replied, "I had already done so many permutations and so many formal ideas and referenced things—enough to where I just reached the end of it."

After making many variations of these sculptures, such as interlacing colored pipe cleaners together to create the painterly impression of blending pigments and weaving feathers between the pipe cleaners, the idea of further pipe cleaner sculptures filled him with boredom, rather than excitement.

Over the next fifteen years, Lucky experimented with printmaking and other media, pressing painted abstract shapes onto linen canvases, pasting rows of pistachio shells on canvases, and making canvases out of reusable shopping bags. He judged the abstract shapes to be closely aligned with his

distinctive identity as an artist: "I would cut out shapes that I was interested in. And I kept making those and making those and making those—a hundred or so. And I realized that at some point . . . I thought, 'these really are my shapes. This is really my vocabulary' . . . Kind of like my fingerprint."

Lucky described the new works as conceptually consistent with his pipe cleaner sculptures. He viewed the media to be everyday, rather than high art, materials, and he saw the works as displaying his commitment toward the DIY (do-it-yourself) movement and the democratizing potential of art. However, to others, the pipe cleaner sculptures and the pistachio shell canvases looked like they could be the works of two different artists. Curators, dealers, and collectors wanted to exhibit and collect only his pipe cleaner sculptures. Lucky described this period in his career as "excruciating," and he questioned whether to continue working as an artist.

Finally, in 2014, Lucky had a studio visit that did not end in polite rejection. Mark Beckman,[2] an art dealer opening a new gallery on the Lower East Side, offered to represent Lucky and show Lucky's new work in the gallery's first solo exhibition. Lucky provided Mark with the legitimacy of a prestigious exhibition history, and Mark afforded Lucky visibility. The exhibition was not a home run, as the works went unsold for most of the exhibition, but it sparked attention. The *New York Times* gave the show a positive review in the final weeks of the exhibition. Mark had been present to discuss the exhibition when the critic visited the gallery, and the critic similarly discussed the elevation of everyday materials into art as a core consistency in Lucky's work. The review attracted some sales to prominent collectors, and both Mark and Lucky were satisfied.

Mark contrasted the review to one written by Ken Johnson in the *New York Times* in 2000. In the gallery's back room, he unearthed the article from a pile on his desk and stabbed his index finger at it, describing the review as "infamous" and harmful to Lucky's career. "People say they are against branding, and then they say stuff like this," he said. The review stated: "Mr. DeBellevue may understandably want to avoid typecasting as 'the pipe cleaner guy,' but these works have it all: formal rigor, inventive and intensive craft, goofy humor and poetic imagination. You wonder why, for now, at least, he bothers doing anything else."[3] Most readers would likely see this review as positive, but Mark perceived the review as portraying the aesthetic value of Lucky's work in overly narrow terms that excluded newer works, like the pistachio shell canvases.

It is unclear whether those who knew Lucky's work remembered that specific review so many years later. What is certain is that collectors continued to strongly associate Lucky's work with pipe cleaners. A year after the initial

studio visit, Mark exhibited Lucky's work at a prominent art fair that showcased the work of emerging artists in New York, and Mark offered to let me observe in his booth. As I helped Mark and Lucky assemble the booth before the fair's VIP opening, during which invited collectors, curators, and reporters tour the booths, Mark discussed the "talking points" with me. Mark explained that because mid-career artists (artists over the age of forty who have achieved stable careers but not stardom) were often seen as "over the hill" by collectors, he wanted to describe Lucky, who was in his fifties, as a young artist.

He reasoned, "You can say he's young, even if he is in his fifties, because he has been off the market for over ten years."

I asked, "What should I say if they ask about the pipe cleaners?"

Mark replied that I should not mention it, but if collectors asked, that I should highlight the "umbrella themes" throughout the work: Lucky was dignifying nontraditional art making, his work was associated with the DIY movement, he embraced accidents in the creative process, and his work played on humor. The topic quickly proved impossible to avoid. For the next nine hours, collectors meandered into the booth, exclaiming, in surprise, "I remember when he was doing pipe cleaners."

Peter Hort, a prominent collector, asked me, "This is Lucky? I have his pipe cleaners."

Mark explained that Lucky was experiencing his "second life" as an artist, and he reiterated the conceptual linkages between the pipe cleaner sculptures and the newer works. Toward the end of the fair, Mark was chain-smoking outside the back door of the auditorium. Renting the booth alone for four days cost $9,000, and he was still waiting for a sale.

The story of Lucky DeBellevue's work and career elicits many questions: Why would Lucky devote fifteen years to producing pipe cleaner sculptures, and why would he believe that pipe cleaners and pistachio shells were part of the same "language"? Why would Mark exhibit Lucky's new work, after a critic questioned why Lucky would bother "doing anything else"? Why were the pipe cleaner sculptures, but not the pistachio shell canvases, so vividly ingrained in collectors' minds? These questions hit upon the core nature of art.

Critics in various cultural fields have spilled much ink arguing over which works are "good" and what criteria for judging these works are legitimate. In our everyday lives, we express and debate aesthetic judgments when we talk about whether we liked a film, album, restaurant dish, or novel.[4] Some cultural fields enjoy at least a minimal consensus over aesthetic value. For example, restaurant diners could debate over the merits of including cashews in a dish, but would be united in their nausea over a raw sewage soup. But all such

bets are off in the contemporary art world.[5] A curator can extol pipe cleaners as "magical," a museum can exhibit works made of elephant dung and pornographic photographs,[6] and a collector can purchase a formaldehyde shark for $12 million.[7] In this field, aesthetic value is radically uncertain.[8] Despite this uncertainty, those in the contemporary art world must commit to aesthetic decisions. Artists must decide how to produce their work, dealers and curators must select which works to exhibit, critics must choose how to interpret exhibitions, and collectors must purchase certain works for their collections.

Artists and others make aesthetic judgments by assessing "creative visions." I define a creative vision as a *bundle of recognizable and enduring consistencies within a body of work*, with a body of work being the oeuvre or corpus of an individual.[9] Each artist's body of work is all of the work that the artist has produced, including preliminary works, such as sketches, and works that have never left the studio. Artists perceive nonrandom consistencies among multiple works that are rooted in their aesthetic interests and commitments. These consistencies occur in formal and conceptual elements.[10] Formal elements, such as line, color, shape, form, texture, and composition, are produced by using certain media and techniques. Conceptual elements, including subject matters, themes, ideas, and emotional states, are discerned from formal elements.[11] Those other than the artist, such as dealers and collectors, also have bodies of work, which are composed of the artworks that they exhibit or collect. Like artists, they view themselves as having creative visions, in that they perceive continuities among the works that they select and believe that they have certain aesthetic sensibilities that guide these choices.

Artists and others in the art world use several terms synonymously with creative vision, including language, vocabulary, and style. The terms "style" and "signature style" are sometimes used interchangeably with the term creative vision, while other times, these terms are used pejoratively to describe artists who have economically capitalized on a formally narrow "brand."[12] In contrast, the term creative vision has a generally positive and less contentious valence. In the art world, this term is used in the service of both interpretation (What elements compose an artist's creative vision?) and evaluation (Does an artist have a true creative vision?).

In the absence of objective criteria or reliable metrics for aesthetic judgment, perceptions of creative visions are central to how those in the contemporary art world interpret and evaluate works of art. Lucky DeBellevue was guided by these perceptions when he chose to spend years making pipe cleaner sculptures and when he decided to switch to pistachio shell canvases. Perceptions of creative visions also underlay critic Ken Johnson's assertation that Lucky

should continue to produce pipe cleaner sculptures, dealer Mark Beckman's narrative about how the pipe cleaner sculptures and pistachio shell canvases were conceptually related, and collector Peter Hort's strong association of the pipe cleaner sculptures with Lucky's body of work. Perceptions of creative visions are important because those in the art world rely upon them to make aesthetic choices and regularly invoke them to account for their decisions. These perceptions influence expectations of how bodies of work should develop over time, understandings of the core elements within specific bodies of work, and beliefs about which bodies of work share significant commonalities.

This book explores how perceptions of creative visions shape aesthetic judgments. Addressing this question entails examining much more than the work and career of Lucky DeBellevue. It requires taking a bird's-eye view that includes, under a single gaze, artists' often solitary work in their studios as well as their interactions with others in studio visits, exhibition installations, gallery exhibition openings, art fairs, and parties. Together, in these moments of solitude and sociality, artists make creative choices, communicate aesthetic meaning, and receive artistic critiques that they carry back into their studios. It is here, within the contemporary art world as a whole organism, that the creative process occurs and can be understood.

THEORIZING AESTHETIC JUDGMENTS AND CREATIVE VISIONS

Most people have a favorite song. When they hear it, they experience a surge of emotion: joy, sadness, melancholia. They might feel their heart thumping rhythmically and be moved to dance. They might recall a poignant memory. They might ponder the score or a particular line, drawing out a life lesson, which may take on new meanings as they replay the song. They might play the song intentionally to evoke a particular mood or reaction, such as the cathartic recognition of a broken heart. The song might serendipitously play in their presence, inducing an unexpected change of emotion. Perhaps the song is a guilty pleasure. They might bashfully admit to enjoying it, apprehensive of the potential social sanction. In each of these moments, the aesthetic experience of hearing the song does something to the person, eliciting feelings, thoughts, movements, and actions. These moments are shaped by previous social experiences, such as memories and associations, and influence how individuals interact in the world.

Aesthetic judgment is the process by which individuals perceive and evaluate sensory experiences.[13] Because each creative work is, by definition, unique,

it cannot be evaluated on a common metric. Furthermore, as the maxim "It's a matter of taste" suggests, aesthetic value is not objective. Creative works have no utilitarian function. We appreciate a song, novel, or painting because it feels pleasurable, evokes emotions, or captures ideas. Given that we can, and often do, disagree in our aesthetic judgments, how do we judge a work of art as good and how do we negotiate these judgments with others?

The seemingly mundane experience of listening to a song or observing a work of art has captivated scholars for centuries.[14] Philosophers have long recognized aesthetic judgment as central to our cognitive understandings of reality. Philosopher Immanuel Kant argued that we perceive things as specific through sensuous perception, before we interpret them as concepts, or as part of a class of objects.[15] Only by forming aesthetic judgments, such as "this is beautiful," can we make sense of the objects in our surroundings.[16] Kant believed that we expect others to agree with our aesthetic judgments, and that, when we discover disagreements in aesthetic judgment, we feel justified in defending our views. Two centuries later, political theorist Hannah Arendt extended Kant's theory of aesthetic judgment by arguing that, through aesthetic judgments, individuals not only communicate their evaluations of objects, such as artworks, but also disclose what kind of person he or she is and within which kinds of social groups he or she belongs.[17] When we discover that someone else dislikes our favorite song, it chips away at our feelings of commonality with that person.[18] Alternatively, when we learn that a colleague with whom we thought we had little in common frequents the same hole-in-the-wall restaurant, we feel a sudden kindling of companionship.

While philosophers largely examine aesthetic judgments through theoretical arguments, social scientists often seek to understand how the social world shapes aesthetic judgments through empirical studies of specific social contexts. Social scientists view cultural fields, or creative industries, as markets in which individuals produce, circulate, and consume artistic, intellectual, or cultural works, such as visual art, music, novels, films, theater, and culinary dishes.[19] Their interests in these fields are rooted in the social world. They wonder how the desire for money or prestige influences the content of novels, how changes in technology affect the distribution of music, and how one's educational background shapes one's culinary taste.

To address these questions, they have developed several key approaches. French sociologist Pierre Bourdieu argued that individuals' aesthetic judgments—from their choice in carpeting to their musical preferences—are shaped first and foremost by their socioeconomic status.[20] Tastes are ingrained through childhood socialization and formal education. For Bourdieu, individ-

uals make aesthetic judgments in ways that they believe will maximize money or prestige. This struggle for scarce resources happens on an uneven playing field, as those with high socioeconomic status both have more resources and are given the cultural authority to decide for everyone else what constitutes "good" taste.

Across the Atlantic, American social scientists were asking similar questions. They were interested in explaining the nuts and bolts of creative production. Sociologist Howard Becker claimed that creative works were produced not by artists alone, but through the cooperative activities of people guided by the same social conventions.[21] In the 1970s and 1980s, sociologist Richard Peterson and others developed the "production of culture" perspective.[22] This perspective addressed how social influences, like laws, market forces, and organizational structures, affect the ways in which works are produced, distributed, and consumed. Social scientists using this approach focused on how social factors shape the aesthetic judgments of those who interact with creative works. On both continents, social scientists were united in trying to debunk the idea that certain artists are creative geniuses. While they argued that these individuals do special tasks associated with being an artist in their fields, they emphasized that the production and circulation of creative works involved the collaboration of many people, from songwriters to studio managers. They believed that creative products are produced by people who divide labor among themselves, like an assembly line for air conditioners. In this view, creative genius is not inherent to individuals, but instead is a role with which certain individuals are designated during creative production.

However, some social scientists felt that these perspectives had missed something fundamentally important about culture—that, to those involved, creative works *are* different from Frigidaires.[23] They argued that novels, songs, and paintings were unlike mundane objects in that those who produced, distributed, and consumed these works perceived them to have special meanings. Incorporating humanistic perspectives, these social scientists called for bringing artistic meaning back into social scientific analyses of culture.[24] Sociologist Wendy Griswold contended that social scientists should analyze meaning by examining the relationship between artists' intentions, audiences' interpretations, the broader societal context in which the work was produced and consumed, and the qualities of the work itself.[25] Others focused on the physical or sensory attributes of the work.[26] They looked at how the color, medium, placement, or physical decay of creative works changed the way in which people interpreted these objects.[27] Together, they revealed how the meaning and sensory qualities of creative works affected individuals' interpretations

and uses of these works. These social scientists turned the question of how the social world shaped aesthetic judgment on its head. They asked, instead, how aesthetic judgment shaped the social world.

Social scientists have made important strides in understanding the role of aesthetic judgment in social life. But upon entering a studio, gallery, or collector's home, questions emerge that these theories leave unexplained. How do artists make aesthetic judgments about their own work as they experiment in the often solitary realm of their studios? How do these aesthetic judgments unfold over time as artists consider their past works and form ideas for future works? How are these aesthetic judgments shaped by others' evaluations of previous works that circulate through the art world? Social scientists tend to focus on aesthetic judgments of discrete works, but addressing these questions requires analyzing how individuals orient their aesthetic judgments toward bodies of works. Specifically, it necessitates focusing on artists' judgments of their own work during the creative process, examining how these judgments change over time as artists reflect upon their broader bodies of work, and exploring how the way in which others view these bodies of work shape artists' aesthetic judgments. In this way, I take a production-focused, temporal, and relational approach to analyzing aesthetic judgments.

Social scientists who have analyzed bodies of work, rather than individual works, have shown that artists must balance the dual pressures of conformity to and distinctiveness from others' bodies of work. [28] Management scholar Ezra Zuckerman finds that audiences often select bodies of work or individual works that they view as "optimally distinctive" within a larger genre: consistent enough to be recognized as part of the genre, but distinctive enough to be identifiable within the genre. [29] For example, a traditional French chef may borrow certain elements from nouvelle French cuisine to distinguish the restaurant from its competitors, while retaining enough elements of traditional French cuisine so that patrons still classify it as such. [30] In certain situations, artists and creative producers more broadly may benefit from more or less consistency within their bodies of work. [31] However, these studies largely examine audiences' perceptions, rather than how creative producers perceive and create their own bodies of work. Furthermore, by focusing on the relative breadth of creative producers' bodies of work, they do not show how artists and their audiences interpret certain qualities and the relationships among these qualities as representing distinctive bodies of work.

Enter creative visions. I take anthropologist Alfred Gell's concept of the body of work as a "distributed object" as the point of departure. [32] For Gell, no work exists in isolation. Instead, each work is connected in a network of

relationships to other works through a family lineage.[33] The distributed object includes all of the works that each artist creates, from preparatory studies or sketches to works that the artist deems complete. Within the distributed object of the body of work, earlier works foreshadow later works, while later works contain vestiges of earlier ones. Gell argues, therefore, that the works within the distributed object are not only connected through their similarities but also mapped over time.

In my view, each creative vision characterizes the distributed object of a body of work. Creative visions represent a bundle of meaningful consistencies within a body of work, which changes over time as the body of work evolves. Each body of work is also connected to other bodies of work: two bodies of work may share the medium of pipe cleaners or the theme of democratization, which audiences can appreciate when they view these artists' works side-by-side in a group exhibition or a collector's home. While individual elements are often associated with broader genres or artistic movements,[34] it is the particular way in which these elements are bundled together—the relationships among a constellation of elements—that allows artists and their audiences to view each creative vision as distinctive.[35]

Artists, dealers, collectors, and other viewers see the distributed object from different vantage points, and this shapes their perceptions of the creative vision. An artist is aware of the sketches that never became full-scale works, the works stored in the back of the studio, and even ideas for works that have never been articulated. The artist's dealer has likely made multiple visits to the artist's studio and has seen some works that have never left the studio. A collector may have attended one or more exhibitions by an artist and may also see the artist's works displayed on websites, in catalogs, or in other collectors' homes. Each person accesses a different slice of the distributed object, which includes more or less of the total object. Depending on a viewer's position within the art world and knowledge of other bodies of works he or she will have different interpretations of how bodies of work relate to one another. These perceptions influence whether or not someone will view an artist as fitting into a group show, gallery roster, or collection as well as their ideas about which consistencies are significant to a creative vision and aesthetically valuable. Perceptions of creative visions are individualized, but deeply social.

These perceptions anchor aesthetic judgments. Ask an artist why he or she makes a certain kind of work or why he or she finds particular work to be aesthetically satisfying, and you are likely to get a vague and uninformative answer along the lines of "it works," "it's intuitive," or "it just appeals to me."[36] But artists and others do identify specific formal and conceptual consisten-

cies as representative of creative visions, and these perceptions influence their aesthetic judgments. As they come into contact with multiple works within a body of work, they reinterpret the aesthetic meaning and significance of each work and the body of work as a whole.

A BRIEF HISTORY OF CREATIVE VISIONS

While the history of art is far too long and complex to cover here, several key artistic and organizational transformations progressively oriented aesthetic judgments around perceptions of creative visions within the Western art world. During the Renaissance, patrons, including wealthy individuals and institutions, hired artists to paint portraits, frescos, altarpieces, and other works.[37] They recognized certain painters as having exceptional talent and distinctive formal techniques, such as compositions, shapes, or colors. Patrons paid for paintings by calculating the cost of materials as well as the cost of the master's skill. For example, one contract stated that the patron would pay Botticelli "two florins for ultramarine [pigment], thirty-eight florins for gold and preparation of the panel, and thirty-five florins for his brush [Botticelli's labor and skill]."[38] Patrons required the most technically complex parts of the painting to be painted by the master's own hand, instead of those of his assistants, and they paid the master an exponentially higher rate for his time.

Masters were recognized and valued for distinctive elements of their work. However, these elements were primarily formal and not conceptual. Moreover, masters' creative autonomy was circumscribed. In contracts, patrons stipulated many of the formal qualities of the work, including the general subject to be painted, the qualities of the paints to be used, and the amount of money to be paid. Often, the contract would reference other paintings that the artist had done for previous clients to specify certain artistic details, such as the type of finish to be applied or which kinds of objects to include in the composition. Together, the master and the patron negotiated a vision for each work, and this negotiation did not compromise the master's reputation.[39]

The post-Renaissance art world moved to Paris. Parisienne artists abandoned their guilds and joined state-sponsored Royal Academies, in which they learned to emulate the painting style of masters and exhibited their work in juried Salon exhibitions.[40] This academy system eroded during the Belle Époque, a period from 1871 to the beginning of World War I.[41] A group of artists, who would later become known as Impressionists, began painting outdoors, using newly available synthetic paints. The Impressionists broke away from the academies, who were scandalized by their intentionally visible

brushstrokes and unblended colors, and they began exhibiting their work independently. While the Impressionists were disaffiliating from the academies, unsustainable droves of artists were flocking from the countryside to the academies in search of middle-class careers.

As the academies gasped their last breaths, artists, private agents for collectors, and entrepreneurial businessmen entered the market as dealers, emulating the practices of the Amsterdam art world, where dealers had been active since the seventeenth century.[42] French dealers, such as the notable Impressionist dealer Paul Durand-Ruel, bought or consigned works from artists to sell in their galleries. They did not sell works piecemeal, as the academies had done, but exhibited work in group and solo exhibitions. Collectors could now purchase "siblings" of already recognized paintings and view an artist's creative trajectory.[43] Dealers encouraged the new middle class, which emerged in place of the declining aristocracy, to speculate on art by investing in artists' bodies of work, rather than purchasing individual works. A "river of canvases" sold through the academies became a "set of careers" promoted by dealers.[44]

Art criticism, which first emerged in the 1740s but became increasingly professionalized, buttressed this emphasis on the artist's body of work.[45] Critics focused on reviewing solo exhibitions where they could portray the meaning of an artist's creative vision by discussing the techniques and theory among multiple works. They created a public discourse regarding each artist's creative vision and taught the public that these creative visions were salient. However, broader artistic styles remained more important than individual creative visions. The Impressionists distinguished themselves from each other by focusing on certain subject matters and techniques, but they were first and foremost Impressionists.

The center of the art world shifted from Paris to New York in the early 1900s. The Armory Show of 1913, the first major modern art exhibit in the United States, introduced American audiences to the avant-garde and increased exposure for American avant-garde artists. During World War II, many artists and other intellectuals fled Europe and relocated to New York, where they settled into lofts in the East Village.[46] As galleries sprung up, artists formed gallery co-ops and alternative spaces to thwart what they viewed as the commodification of art. By the mid-twentieth century, New York had become the undisputable center of the art world.

A porcelain urinal served as a critical turning point in the history of art. In 1917, artist Marcel Duchamp purchased a urinal, dated and signed it with the pseudonym "R. Mutt," titled it *Fountain*, and submitted it to the Society of Independent Artists' exhibition in New York.[47] Although the exhibition was

FIGURE 1.1. Alfred Stieglitz's photograph of *Fountain*.

unjuried, the board rejected the piece, claiming that it was offensive and not art. Duchamp, the undisclosed artist and a board member, resigned. *Fountain* was placed behind a partition during the exhibition and is believed to have been lost shortly after.[48] While all that remains of the original is a photograph by Alfred Stiglitz, it became one of the most important works of the twentieth century.[49]

Fountain challenged conventional definitions of art. Whether it was art and, if so, what exactly made it art was the subject of intense debate for the next hundred years. Duchamp considered it to be a "ready-made," or an everyday object selected to be a work of art. But if an everyday object could be art, then what was not art? Subsequent attempts to answer the "What is art?" question shaped the trajectory of art history.[50] Dozens of art movements rapidly unfolded in the decades following *Fountain*, with their edges blurring as artists drew inspiration from one another.[51] Abstract Expressionism, the most influential art movement of its time,[52] evolved from surrealism in the 1940s. Abstract Expressionists, such as Willem de Kooning, Mark Rothko, and Jackson Pollock, abandoned the vestiges of figuration by making automatic markings, usually in paint. In the 1950s, pop art transformed images from mass

culture into high art with a twist of irony. Pop art, as epitomized in Andy War-hol's *Campbell's Soup Cans*, often reproduced and collaged advertisements and cartoons. In the 1960s and 1970s, Minimalist artists, like Donald Judd, Agnes Martin, and Frank Stella, reduced their paintings and sculptures to the elemental, making the bold statement that art could be shapeless, formless, colorless, and textureless.[53] Throughout modernism, artists highly identified with these successive art movements. They clustered in dense collaborative circles, in which they exchanged ideas with other artists involved in the same movement.[54]

This all changed with the "end of art." It was a theoretical, not literal, end. The narrative of art history, in which one art movement replaced the next in the continual breaching of conventions, dissolved after minimalism.[55] Once art could be a urinal or a blank canvas, the last barriers crumbled. There were no more artistic conventions to be breached, no edge to cutting-edge, and no shock value for the informed viewer. Art movements did not disappear, but they stopped moving. No longer sequential, they were equalized. Artists entered an era of "anything goes," in which they could choose from a menu of styles. The art world became a cacophony of abstraction, minimalism, surrealism, hyperrealism, pop, new media, and found objects—an aesthetic melting pot. When artists discussed their work, if they mentioned other art-ists or particular genres at all, they tended to describe them as "references." Art movements diminished in salience because there was no clear consensus around which movements constituted the forefront of the avant-garde. Artists were no longer primarily valued for being part of innovative movements, but instead for having distinctive creative visions that could involve elements from multiple genres.

In recent decades, the increasing academization and professionalization of the art world has placed further emphasis on creative visions. Having ex-cised themselves from the Royal Academies, artists now returned to academic training by entering the university. Master of Fine Arts (MFA) programs, first established in the 1960s, have proliferated widely.[56] *US News and World Report* currently ranks 226 such programs in the United States alone.[57] These pro-grams minimize technical training and elevate theory.[58] Students are taught to see art as a professional career and to view articulating their voice as their chief task.[59] Those fortunate enough to find gallery representation upon graduating have dealers who work to nurture artists' careers for years, if not decades, and present artists' creative visions as slowly maturing over time.[60]

The globalization of the art market has intensified competition among art-ists. The art world has grown larger and more connected, sprawling from Los

Angeles to Beijing and from Copenhagen to Cape Town.[61] China has become an art market powerhouse, with auction houses driving sales.[62] The Middle East, particularly Dubai and Abu Dhabi, has also emerged as an economic capital of the art world.[63] A growing class of local elites and Western collectors' increasing interest in buying work from traditionally underrepresented markets has spurred the art market in these and other cosmopolitan cities. Artists now seek to develop both local and international reputations, showing work in galleries and museums across the world. Art fairs—where hundreds of galleries exhibit work in booths to an international clientele of collectors, curators, critics, and casual viewers—have also proliferated globally. The number of exhibition schedules for fairs and galleries has quickened to a dizzying speed, with artists and dealers bemoaning the number of exhibitions they are expected to erect. In 2000, there were roughly 55 major art fairs; by 2017, there were around 260.[64] The internet has aided this connectivity. Dealers send digital images of artworks to collectors nearly instantaneously, and artists post images of their works on social media, sometimes before works have even left their studios.[65] In this exponentially expanded field, artists jockey for recognition in the hope that their distinctive voices will rise above the din.

By the twenty-first century, perceptions of creative visions had become the dominant mode of interpreting and evaluating art. Successive artistic movements placed increasing import on the theory of the work over formal stylistic features. Organizational changes gave artists more creative autonomy, provided exhibition opportunities that emphasized connections within each body of work, enabled a public discourse focused on discussing bodies of work, and increased competition among artists. Contemporary artists now faced the central question of how to create bodies of work that they and their audiences would recognize as distinctive and interesting.

OBSERVING THE NEW YORK ART WORLD

To understand how artists developed creative visions, I focused on the contemporary art world in New York, a city with a particular and significant position in the global art world. New York remains an (and many would say *the*) art world capital today.[66] A look at the ecosystem reveals the continued dominance of New York within the global art world. Many prestigious MFA programs, such as Yale University, Columbia University, School of Visual Arts, and Bard College, are located in or near the city.[67] While artists can and do have successful careers in other locations, they are often counseled during their MFA programs to move to or remain in New York after graduation. Art-

ists migrate to the city to immerse themselves in a dynamic art community and to signal seriousness, commitment, and potential to themselves and others in the art world. They want to live in a place where they believe that they can sustain careers as artists.

New York far outstrips other art markets in terms of the number of galleries located in the city. At the time of this research, Artsy, the premier online platform for art collecting, listed 338 contemporary art galleries in New York, compared to 161 in London, 149 in Los Angeles, 66 in Miami, 48 in Berlin, and 37 in Hong Kong.[68] Similarly, the Art Dealers Association of America has 103 member galleries of contemporary art in New York, twelve in Los Angeles, and one in Miami.[69] Most mega-galleries—galleries with multiple branches globally—have their flagship locations in New York. Galleries in New York are supported by the world's densest community of elite collectors. In 2019, *ARTnews'* annual directory of top 200 collectors globally listed forty-three of the 200 collectors as having homes in New York. In comparison, the next locales most populated with top collectors were London, with seventeen collectors, and Los Angeles, with fourteen collectors.[70]

New York is also a magnet of critical recognition. Major periodicals publishing art criticism—such as *Artforum, Art in America, ARTnews,* and the *New Yorker*—operate their headquarters out of New York. Reviews of New York exhibitions significantly outweigh those in other locales in prestigious art periodicals. In 2019, *Artforum* reviewed an average of 14 New York exhibitions each month, compared to 3.6 Los Angeles exhibitions, 2.5 London exhibitions, and one to two exhibitions in other major art world cities.[71] Contemporary art museums are another pillar of critical recognition. In New York, these include the Whitney Museum of American Art, the Museum of Modern Art (MoMA), the Guggenheim Museum, and the New Museum, to name a few.

The art world is a "winner take all" market, where a small number of people capture the lion's share of critical and commercial success.[72] In New York, the peaks of prestige, visibility, and economic success are higher.[73] The experience, for artists, is a double-edged sword. The potential rewards feel greater, but so do the risks of failure. For everyone involved, the consequences of aesthetic judgments are amplified in this setting.

Like many artists, I began my immersion into the art world by moving to New York. I arrived with a few phone numbers and email addresses of artists from existing social contacts. Artists were generous in allowing me to interview them in their studios and introducing me to other artists. I conducted interviews with fifty-three artists, interviewing artists at different stages in their

careers, from those who had recently graduated from MFA programs and had exhibited work only in group exhibitions[74] to those who had exhibited their work for decades, were represented by prestigious galleries, and had exhibited their work in major museums.

I used artists' studios as an ethnographic site to discuss works in the room. This included works in different stages of development, such as sketches, models, unfinished work, and unsold, finished work. I analyzed artists' creative decisions by focusing on their unfolding judgments of these specific objects. Accordingly, I studied artists with studio practices that involved making traditional art objects, including drawings, paintings, photographs, sculptures, installations, and video art. Thirty-three of the artists whom I interviewed worked in multiple media. Some had more wide-ranging artistic practices that included nonphysical objects, like performance art. Because I am interested in the circulation of physical art objects, I did not interview "post-studio" artists, whose art making primarily consists of nonphysical objects.[75] When possible, I maintained contact with artists after interviewing them, sometimes returning to their studios several times to see how their bodies of work had evolved and attending their gallery and museum exhibitions. I collected artists' exhibition reviews, press releases for exhibitions, artists' statements, and curricula vitae. I also interacted with communities of artists more broadly by participating in informal reading groups and lecture series.

Through my interactions with artists in their studios and the art world, I realized that a study of the creative process that focused on artists alone would be incomplete. Artists were not off making their works on desert islands, but were embedded in networks of artists, dealers, curators, collectors, and other art world personnel. Artists developed understandings of what was interesting, innovative, or relevant through these interactions in the art world and broader society. My next step was to engage with the dealers and curators who exhibited artists' works.

Contemporary art galleries represent artists, with about twenty to thirty artists per gallery. In return for 50 percent of the sales, galleries promote artists on websites and social media, exhibit artists' works in group and solo exhibitions at the gallery and art fairs, and facilitate sales to collectors and museums. Curators work either full-time or as freelancers in museums and other nonprofit art institutions. They are unlike dealers in that they do not formally represent artists and do not broker sales. However, like dealers, they choose the artists to whom they offer exhibitions, negotiate with each artist about which of their works to exhibit, and organize the display of these works. While collectors also purchase work from auction houses, I did not focus on these institutions.

Most contemporary art in the United States is purchased from galleries, and contemporary works sold at auction are primarily by very established artists.[76] Furthermore, auction houses operate chiefly as a secondary market for reselling works previously sold to collectors by galleries.[77]

I interviewed eighteen dealers, ranging from a dealer who had recently opened an art gallery in her father's Chinatown button shop to the revered Paula Cooper, who established her gallery in 1968. I also interviewed nine curators, including those who did freelance exhibitions or exhibitions in alternative exhibition spaces for emerging artists as well as those who curated exhibitions at the city's most prestigious museums, such as MoMA and the Whitney Museum of American Art. I spoke with dealers and curators in their galleries, alternative exhibition spaces, and museums, often in the backroom offices where they do day-to-day work and conduct business. My conversations with dealers and curators focused on how they select specific works for group and solo exhibitions and how they interact with prospective collectors and other viewers. Additionally, I asked dealers about how they choose artists to represent and how they maintain relationships with represented artists. To observe how curators and dealers make decisions over how to exhibit works and interact with others in the art world, I attended their exhibition installations, exhibition openings, and art fairs. Additionally, I analyzed a data set of reviews published by critics in top art periodicals, as critical reviews of exhibitions enhance artists' visibility and reputations and because critical reviews add to the discourse regarding the meaning of artists' work.

This research brought me to the doorsteps of collectors' homes. Collectors provide much of the money that keeps artists, galleries, and other art institutions in business. While artists and dealers had public presences and were generally willing to be interviewed, gaining access to collectors was more difficult, as artists and dealers were rightfully protective of their relationships with collectors. Eventually, a prestigious dealer reached out to a few collectors on my behalf. These interviews quickly led to more contacts, as collectors were friends with other collectors but did not rely on them for their careers. I interviewed five art advisers—those who professionally recommend works to collectors—and twenty-six collectors (including five couples), ranging from young collectors buying the work of emerging artists to major collectors who owned private museums and sculpture parks. I asked them about how they chose works for their collections or made recommendations to their clients. I also accompanied them to private parties, exhibition openings at galleries, VIP open houses of private collections, and VIP previews of art fairs. I collected this data between June 2014 and June 2016, and I conducted additional

follow-up interviews from June 2017 to June 2018. As I am often discussing specific works of art, I use real names for artists, dealers, curators, art advisers, collectors, and others with their permission, unless otherwise indicated.[78]

Artists, dealers, curators, and collectors are mapped onto the geography of New York City in particular patterns. Wealth moves uptown; hipness moves downtown. Older collectors line Park Avenue and flank Central Park in sprawling apartments, while younger collectors prefer the trendy downtown neighborhoods of the West Village and SoHo. Rows of galleries for established artists engulf Chelsea, punctuated by the occasional luxury car dealership. The most elite galleries generally take up street-level real estate, while less prestigious galleries are sequestered in upper floors. Galleries for emerging artists dot the Lower East Side and spill into Chinatown, squeezed into obscure apartment walkups or sandwiched between cafes, hole-in-the-wall restaurants, and produce stalls. More remote still are the pockets of Brooklyn galleries, which tend to be artist-run and have struggled to lure collectors, who sometimes seem to conceive of Brooklyn as located in another state. Artists, in their continual search for affordable studio space, become the first gentrifiers of the next, soon-to-be hot neighborhood. At the moment, they crowd into industrial buildings in Bushwick, but soon they will move on. The city sorts people, pushing them together or ensuring that their paths do not cross.

My simultaneous fieldwork with these various actors often required the social acrobatics of spending the afternoon sitting with a group of artists in a new Lower East Side gallery discussing an essay by Walter Benjamin and the evening at a catered party in the Upper East Side penthouse apartment of a collector displaying the newest "rehanging" of his collection to his guests. The art world itself mirrors this frenetic movement between coexisting, yet incongruent, social spheres, which bump and overlap with friction or ease as artists move from the solitude of the studio to the compulsory socializing among clusters of artists, dealers, curators, collectors, and other art world personnel. Similarly, the book moves back and forth between these diverse social scenes, drawing together data involving the creation, exhibition, and collection of contemporary art. Examining these interconnected aesthetic judgments reveals how artists' social interactions within the art world shape their aesthetic judgments during the creative process.

PLAN OF THE BOOK

Contemporary artists do not think of the work that they produce as discrete experiments or as merely part of broader artistic movements. Instead, they

view each work as extending from their previous works and as a potential influence for future ones. They perceive their bodies of work to be "in conversation" with the bodies of work of their predecessors and contemporaries. Artists' perceptions of their own and others' creative visions are central to the way in which they produce their work. But how do they form these perceptions and how do these perceptions change as they produce, exhibit, and sell new work?

Each chapter uncovers a layer of this puzzle. Chapter 2 examines the role of contemporary artists and their relationships with those who exhibit and collect their work. In an art world that has become increasingly professionalized, how do artists present themselves as having true creative visions? The art world turns professionalism on its head, as artists interact in ways that display eccentricity, aesthetic obsession, and economic disinterest. In turn, dealers, curators, and collectors legitimate themselves as supporters of artists' creative visions by affording artists autonomy—within limits—over the creative process.

Chapter 3 brings the reader into the realm of the studio. How do artists produce work and how do they come to understand their creative visions through this experimentation? During the creative process, artists' particular emotional responses to their work influence decisions about whether to repeat, further contemplate, or abandon elements. Through a cyclical creative process guided by these emotional reactions, artists produce certain formal and conceptual consistencies within their bodies of work that they recognize as interesting and relevant to their creative visions.

Artists' social interactions in the art world shape their aesthetic decisions during solitary moments in their studios. Chapter 4 and chapter 5 transport the reader into the art world to analyze how others in the art world evaluate artists' work. Chapter 4 explores how dealers and curators choose works for exhibitions and how critics interpret these exhibitions in reviews, while chapter 5 examines how art advisers and collectors select works for private collections. Both those who exhibit and those who collect work select artists' bodies of work that they view as aligned with their own creative visions. Furthermore, they look for artists' bodies of work that they judge as maintaining the right balance of consistency and variation, while also privileging work that they view as representative of artists' bodies of work.

Having examined how artists produce creative visions and how others interpret these creative visions, chapter 6 returns to the studio. How do artists' careers shape the way in which they present their creative visions? As their careers evolve, artists confront the changing visibility of their creative visions and different opportunities for exhibiting their work. At each career stage, they use

a distinctive approach for communicating consistencies and variations within their bodies of work.

The conclusion revisits the story of Lucky DeBellevue to explain how artists make aesthetic judgments and how others in the art world interpret artists' aesthetic choices. Amidst aesthetic uncertainty, perceptions of creative visions act as anchors in multiple ways: as perceptions of consistencies and variations within specific bodies of work, as general expectations regarding how artists should experiment, and as broad sensibilities that bond certain individuals together through shared aesthetic interests and commitments.

The Eccentric Artist:
Negotiating Creative Autonomy
in the Art World

After hours at a gallery in a still gritty part of the Lower East Side, I sat in the back room with an artist-turned-dealer. She vented, "They are fucking psycho, lazy, useless, undependable." The dealer's voice trembled with frustration, her eyes heavy with fatigue behind her tortoise shell glasses:

> OK, so artists sometimes—it is probably not their fault that they are completely incapable of taking care of themselves. They are just in a permanent childlike state, and actually making art and having someone else sell for them is the only way that they could ever survive as people because they would otherwise be homeless. . . . And I guess they can kind of be visionary and inspiring in one way or another, but [they are] those kinds of really hopeless people.

Heaving sharply with exasperation, she glanced at her cellphone as she waited, to no avail, for a call from an artist who was currently missing their prearranged meeting.

In one long breath, the dealer had swung from "psycho" to "visionary." She portrayed artists as helpless children who must be managed by the adults in the room. But she also perceived artists to be highly gifted individuals with true creative visions. Artists' visions, the dealer believed, were worth spending a career to cultivate, however frustrating the process may sometimes feel.

How do artists present themselves as true "visionaries," or those with authentic creative visions?[1] How do dealers, curators, and collectors navigate their professional relationships with artists, whom they believe to be both "visionaries" and "psychos"? Artists interact with others in the art world in ways

that show their eccentricity, aesthetic commitment, and economic disinterest. In turn, dealers, curators, and collectors fulfill their own roles by presenting themselves as good supporters of artists' creative visions. These individuals are not merely play-acting. As sociologist Erving Goffman argues, everyone performs a social role at all times, even when he or she is alone.[2] In our interactions with others, we work to portray our idealized images of how we would like to see ourselves and how we want to be seen by others. While we sometimes feel as though we are playing a part, we often believe that we are naturally expressing our authentic selves, especially as we become more accustomed to our roles. Through their interactions in the art world, artists, dealers, curators, collectors, and others give legitimacy to the idea of creative visions. This idea shapes artists' relationships with dealers, curators, and collectors. In some ways, it affords artists authority over their work, while, in other ways, it divests them of control over their professional lives.[3]

ECCENTRICITY

I sat with Simon Moser, a middle-aged conceptual artist, and Eli Walker, a dealer for an emerging gallery whom I had met several times previously, at a Thai restaurant on a Saturday night.[4] We discussed how Eli managed relationships with other galleries and worked to cultivate a collector base. The conversation turned to an upcoming art fair. Suddenly, Simon's face lit up, and he told Eli that he should bring me along as an assistant. In addition to dealers, several assistants typically staff each fair booth to help discuss and sell the works. At established galleries, these assistants are mostly young, conventionally attractive white women, while at more emerging galleries, assistants are somewhat more diverse in terms of appearance and demographics. Simon thought my look was well aligned with the latter.

"Dress her up a little. She's pretty, but she looks real and innocent—she's a code breaker. But then you talk to her, and she is also intelligent, and you would never know. She looks like she came from the countryside. Like Heidi—she looks like she came out of the Alps. Maybe we don't even dress her up!" Simon exclaimed.

Eli looked mortified and grumbled about misogyny in the art world.[5] Nevertheless, he said I was welcome to come, dressed however I would like.

Toward the end of the meal, Simon casually reached over and cradled the leftover curry sauce at the bottom of my bowl, draining the remaining liquid into his mouth. Soon, he grew restless, complaining to Eli that we were missing a nearby party to celebrate the opening of a new gallery in Chinatown.

"Half of success is showing up," Simon flippantly informed me.

Eli decided to head home, and I agreed to accompany Simon to the party across town. Cycling was Simon's preferred mode of transport. I perched rigidly on the handlebars of Simon's bike, the winter night air biting my bare hands. We sped through downtown traffic, swerving as a white minivan entered our lane. Simon let out a laugh and instructed me to simply "kick" the car away the next time. We made a sharp turn and grazed a passing car, which I gingerly pushed with my foot. Simon was wearing a fur hat, which gradually crept over his eyes under his neon bike helmet. He jovially proclaimed himself to be "completely blind." I was rapidly coming to regret having accepted the ride. Finally, we screeched to a halt in front of a bar, and I lurched to the ground in front of a gaggle of amused artists who were smoking outside. Simon led me in and immediately hurled himself into the writhing mass of bodies on the dance floor, thrashing his limbs to and fro until the early morning.

Months later, I stood in Eli's booth at the fair that we had discussed over dinner, wearing a sweater and black tapered jeans. During the VIP opening for invited collectors, curators, critics, and other art world personnel, Simon milled around the booth, although his work was not on display during this particular fair. Recently, a prominent art periodical had profiled Simon, who was a tenured art professor. They documented Simon's unconventional teaching methods, which involved having his students live in squalid conditions to experience their prospective lives as starving artists. Rather than being horrified by this portrayal, Eli enthusiastically emailed the article to everyone on the gallery's mailing list. Eli publicized evidence of Simon's eccentricity, showing that the gallery supported his colorful personality. At the fair, several collectors approached me, asking gleefully, "Simon—is he completely crazy?" Their expectations were clear. "Completely," I assured them.

Pablo Helguera, artist and director of Adult and Academic Programs at MoMA, has stated, "An artist is behaving in the expected manner when he or she is behaving badly, fulfilling the role of the *enfant terrible*."[6] Simon proudly portrayed the classic enfant terrible, the unruly artist who refuses to bend to convention. In a long history of eccentric artists, he managed to make his reputation as one. This history begins in Paris during the Belle Époque. As the Academy system crumbled and was replaced by the dealer-critic system, Impressionist artists began exhibiting their work independently and experimenting with new styles. This new era of artistic exploration was buoyed by bohemian culture. The social life of the art world shifted from private salons—parties during which writers, musicians, and artists would converse and perform in the homes of the bourgeoisie—to the cafes, where the working-class

intelligentsia and demoted bourgeoisie idled away the day discussing art and politics. Nighttime cabarets, which hosted literary events, weekly papers, and performers, took this intellectual energy to an ecstatic ferment of experimentation and farce. In one performance, the cabaret's proprietor directed his pet donkey, Lolo, to twitch his painted tail over a canvas. The resulting painting was adorned with a false name and exhibited in the Salon des Independents to generally positive critical reviews.[7] When artists moved into New York lofts during World War II,[8] the fervor of nonconformity and artistic collaboration found a new stage.

Against a backdrop of a globalized art world in which works have become exponentially more expensive, the past few decades have seen a rapidly professionalized field. Contemporary artists now view their work as not only a calling, but also a career. They have argued publicly for certain protections and remunerations, such as copyright provisions for reproductions of their works and compensation for performances in museums.[9] They are more likely to attend MFA programs, and successful artists may later become faculty in such programs.[10] Established artists hire studio assistants to do a range of activities, from archiving work to preparing canvases to sometimes even fabricating the works themselves. Artists develop professional networks through MFA programs, galleries, artist residencies, and studio spaces.[11]

But if being an artist is a professional career, it is still quite unlike being a doctor or a lawyer. While artists acquire graduate degrees, maintain social media presences and social networks, and work with galleries, museums, and other organizations, they are simultaneously socialized into the role of the enfant terrible from their early days in MFA programs. Sociologist Gary Fine, who conducted an ethnography of MFA programs in the Chicago area, reveals that artists were allowed, and often encouraged, to perform the role of the enfant terrible in their MFA programs in ways that range from dress and bodily comportment to the content of their work.[12] As Fine reveals, MFA students were distinct from graduate students in other disciplines in that they tended to swear in class and take smoking breaks during seminars. Some discussed hard drug use openly, while others were lauded for producing "shocking" art, often with sexual content. In contrast, those who seemed to conform to more traditional and conservative values, such as Christian students, were told that they did not belong in art school. Fine quotes Carol Becker, a dean of faculty at Columbia University's School of the Arts, as saying, "The implications for art school are that it is forced into the role of the permissive parent, while their students play out their respective parts as precocious and at times unruly children."[13] When students graduate and enter the art world, dealers—like

Eli—and other art world professionals often take up the role, willingly or not, of the "permissive parent."

Artists who successfully perform the role of the enfant terrible do so by behaving badly in the right way. But in some moments, they merely behave badly, straining their relationships with dealers and others in the art world. At the exhibition opening for another artist represented by the gallery, Simon and I chatted with the group of artists who spilled onto the sidewalk outside. Eli walked up to Simon and said in a slow, meaningful voice, as if instructing a child, "Simon, there are two collectors inside. I told them about your work and they would like to meet you."

"Do I know them?" Simon whined.

"No, but I would like you to meet them," Eli repeated firmly. Simon reluctantly weaved through the crowd of flannelled thirty-somethings toward the back room of the gallery, where an older couple sat expectantly. A few minutes later, Simon stomped back out.

"Why did you introduce me to those stupid people?" he complained to Eli. "They had no idea what they are talking about. That fat cow asked me if I was the dealer." Simon froze, realizing that the couple was only a few feet away, and the female collector looked at him and then averted her eyes.

"Oh," Simon whispered in horror, "I think she heard me."

Eli hissed furiously, "They are important people. When I say I want to introduce you to someone, it means that they are important. I don't introduce you to just anyone." The couple turned to leave, and Eli looked at Simon desperately and told him to be nice to the collectors. The couple spent a few minutes pleasantly chatting with Simon and Eli about an upcoming exhibit that they were sponsoring at a cultural institution, with Eli promising them that both he and Simon would be in attendance. It was unclear whether the couple had overheard the "fat cow" comment. After we watched them disappear around the corner, Simon conceded that it was his fault for not seeing the couple behind him, but blamed Eli for not informing him that they were important collectors.

"If I introduce you to someone, it means they are important!" Eli seethed, apoplectic with frustration. "And you should just be nice anyway!" he finished in exasperation. Eli turned to me, pleadingly, "Hannah, you know I am right."

"Well, it isn't great that she probably overheard you calling her a fat cow," I stated flatly, "But you may have partially redeemed yourself with your ass-kissing."

Simon laughed loudly, his head thrown backward. Eli agreed that the situation was somewhat salvaged, but then wheeled on Simon once more, demand-

ing that he stay completely out of negotiations with the Whitney Museum of American Art over the prospective acquisition of Simon's work.

In this case, Eli interpreted Simon's behavior as not the benign eccentricities of a visionary, but instead as offensive. Eli had to rein in the enfant terrible to prevent Simon from souring relationships with collectors upon whom both Eli and Simon depended for survival. Other dealers recounted difficulties with artists who surpassed their tolerance for bad behavior, such as artists who failed to deliver work for an exhibition, demanded excessive physical modifications to the gallery, or alienated potential collectors with their unsociability. One Lower East Side dealer vented about the current exhibit in her new gallery, explaining that, after the dealer had altered the windows and floor of the gallery space at the artist's demand, the artist had sent her a list of terms that she was not allowed to use when describing the artist's work. The dealer, feeling unable to discuss the work in the way she understood it, did not enter the gallery for the duration of the exhibit, telling her co-owner that the artist had one more exhibit to prove that she could be a "team-player." When artists enact the role of the enfant terrible in ways that dealers and others in the art world view as inappropriate, they become financial liabilities. Performing the role of the enfant terrible requires a balance of risk and reward, as dealers prefer bragging about artists' misdeeds to collectors, rather than apologizing for them.

These risks are not equal for all artists. Emerging artists imperil exhibition and representation opportunities when they inconvenience curators and dealers, as they are more expendable than established artists, who have longstanding relationships with curators and dealers as well as higher prestige and demand for their work. Yet they must also show that they privilege aesthetic concerns over badly needed money and recognition. Emerging artists often perform their unconventionality in more innocuous ways, such as attending their own exhibition openings in blue lipstick, paint-covered clothing, and combat boots. Furthermore, female artists whom I interviewed stated that they felt that male artists were afforded more latitude in presenting eccentricity, as eccentricity was associated with masculinity and male genius.[14] Indeed, research on how students review studio art professors' teaching reveals that students are more likely to use both "eccentric" and "genius" when evaluating male studio art professors in comparison to female studio art professors.[15] Experimental research shows that individuals evaluate work more highly when they view the artist as eccentric, especially when they perceive this eccentricity as authentic.[16]

Simon is an extreme example of the enfant terrible, the eccentric artist whose behavior often veered into inappropriateness. Many artists dress and

behave in more subdued tones, and some are viewed as eccentrics predominantly due to the content of their work. Eccentricity is not a requirement, but a resource for displaying that one is a true artist. Some artists, such as established artists and male artists, are better positioned to capitalize upon this resource than others. In addition, artists portray two other characteristics to present themselves as true artists: aesthetic obsession and economic disinterest.

AESTHETIC OBSESSION AND ECONOMIC DISINTEREST

Like many collectors, Sue Stoffel frequently traveled to artists' studios to see a larger breadth of their works and to understand their artistic practices. I accompanied Sue on a studio visit with an emerging artist. The artist had spent the past several years making sculptures of pink pillbox hats meticulously positioned to mirror the frame-by-frame trajectory of Jackie Kennedy Onassis' hat during John F. Kennedy's assassination, as captured on film. The studio was packed with sculptures composed of dismantled wooden chairs and yarn pillbox hats. Sue asked the artist to lead us through her work. We slid sideways and ducked as we moved between the maze of works, which sprawled across the floor and dangled from the ceiling. In a loose chronology, the artist presented an early work of miniature clay sculptures of pillbox hats so small that they looked like eraser heads, followed by several large-scale wooden sculptures. She explained how her interests evolved from the "alluring" trajectory of the hat to the negative space around the hat, which she traced using a frame-by-frame analysis of the seven-second film footage. She stated that she was still having trouble rendering the 313th frame, in which JFK was shot.

"You are still not done!" Stoffel shook her head in amazement.

"No," the artist conceded, "Every time I finish one I have to make another. I probably have between four and six left in this section of film."

"Oh, God!" Sue exclaimed, "I'm overwhelmed."

Throughout the studio visit, Sue questioned the artist, who was currently not represented by a gallery, about her connections to specific curators and dealers in the art world. "What galleries have come through?" Sue asked, "What about Tanya Bonakdar? She would love this."[17]

"I would love an introduction," the artist ventured, "I haven't really sought out a gallery. I've just been working."

"As you should be," Sue replied reassuringly, to which the artist responded that she was a bit of a "cave dweller."

In the cab after the visit, Sue declared, "She's obsessed!"

Collectors like Sue do not judge work by the object alone. Instead, their interpretation of the work is refracted through their interactions with the artist. Studio visits are prime locations for understanding the artistic practice because visitors interpret both the personality of the artist and the atmosphere of his or her workspace. The studio visit is a sacred and ritualized event.[18] An artist provides modest snacks, such as bottled water and nuts, to the visitor, who defers to the artist's authority in the space, allowing the artist to display what he or she wants. Whether visitors are peers who are providing constructive feedback about the work or collectors interested in buying the work, they describe the studio as an intimate and sensitive environment, one that is highly vulnerable for the artist. They walk on eggshells through the studio lest they say anything that might derail the artist's creative process.[19]

In artists' studios, which range from fastidiously tidy to frenzied disarray, collectors and other visitors look for signs of aesthetic obsession in the material surroundings. Collector Lesley Lana asserted that she was captivated with artists' studios because they transported her a world away from the "Excel worksheet" environment of her workplace and exposed something of each artist's creative process.[20] She described a studio visit with Miami-based artist Cristina Lei Rodriguez that she had attended with her husband, Phillip Heimlich:

> She works in plastic and resin and sequins and glitter. Everything is drippy and messy. . . . And we went to her studio, and her studio is exactly like that. There's glitter everywhere and everything is dipping resin everywhere—it's a mess. And it was fascinating to me because I could never work in a space like that. But that's where she goes every day, and that's what feeds her creativity.

Phillip replied, "That's why I like meeting them, understanding the artist, hanging out with them for a while."

Collectors view artists' need to produce a certain kind of work as primal and irrepressible, and they perceive the studio space as a reflection of this aesthetic obsession. Many believe that it is important to see the studio space and become personally acquainted with the artist to better understand the creative vision. Another artist told me that collectors repeatedly expressed surprise that she was not "crazy" when they met her, given the flamboyant nature of her work. In this case, collectors were intrigued to find that the artist's personality did not match her art.

The flip side of aesthetic commitment is economic disinterest. As with

eccentricity, the association of aesthetic obsession and economic disinterest with being a true artist has its roots in Paris' Belle Époque. Artists rejected the bourgeoisie not only in lifestyle, but also in their work. The avant-garde increasingly defined good art as neither that which fulfilled a political function nor that which satisfied the bourgeois, but that which was "art for art's sake."[21] The avant-garde denigrated that which attained rapid commercial success as low art, while viewing that which was commercially rejected, at least in the short run, as true high art. Money came to delegitimize art.

Those in the contemporary art world view artists whom they perceive to be financially savvy with moral suspicion, and artists hastily distance themselves from such associations.[22] At art fairs, which are notorious for their mercenary focus, artists wincingly described the setting as "like seeing where the sausage gets made," and dealers professed that they felt like "used car salesmen." One artist rubbed a mock slick of oil off his body, joking that he felt dirty and needed a shower. Artists often bragged to me that they were "bad businessmen," in that they did not actively push their work onto prospective dealers, curators, and collectors during studio visits, but were only interested in discussing artistic practice and meaning. In their social interactions, artists display their distaste for the whiff of money.

Yet, as artists explained to me, they did not want to actually be "starving artists." Many artists whom I interviewed appeared to be in economically precarious positions. They described being saddled with hefty debts from undergraduate and MFA programs, and they seemed constantly in search of cheaper studio spaces. They were pleased and relieved when they sold work. Yet they justified their desire for money as need, rather than greed. They argued that, while the price of their works was high, the works were also costly to produce.[23] It was not just the materials themselves or the time it took to make the piece, but the cost of renting a studio in Brooklyn, hiring studio assistants, and other work expenses. Artists with children often pointed to the need to provide for their families in the overpriced city.[24] Life was expensive. Still others emphasized that artistic careers were unpredictable—flush years were often followed by lean ones. A committed artist, they argued, planned ahead to sustain his or her career. More emerging artists, in particular, often held one or more part-time jobs in the art world, as artist assistants, gallery assistants, art handlers, or other roles. This contingent labor helped them not only build a professional network, but also economically survive.[25] Artists do not claim to completely reject economic interests.[26] Rather, they argue that they do not prioritize economic interests over aesthetic ones.

Within the New York art world, performing economic disinterestedness is especially important, as artists are at higher risk of being perceived as driven by their entrepreneurial spirits. Artists are swift to defend themselves against the label of "hot emerging artist," young artists who gain quick popularity among collectors without the underpinnings of critical success. Artists who were at greatest risk for earning this label renounced it most fiercely. One artist I interviewed canceled a sale with collector Stephan Simcowitz,[27] whom the *New York Times* demonized as "The Art World's Patron Satan,"[28] after the artist learned that the collector had grown infamous for "flipping" artists' works at auction. Flipping, or quickly reselling work, is perceived as morally corrupt because it can accelerate a boom and bust cycle for an artist's work, as the price point can inflate at auction. While the artist was represented by a gallery that had the reputation of representing "hot emerging artists," the artist professed a clear rejection of this label, explaining, "A lot of people right now are serializing their paintings, and it's just a way for them to withstand an idea and make money off of it and sell their product. So, I was like, 'How can I defy that?'"

Artists also guard against another pejorative label, which others use to cast doubt on these artists' commitment to and deservingness of their careers: the "trust fund baby." Some artists whom I interviewed had family members in prominent positions in the art world or came from otherwise wealthy families. They downplayed these connections and the economic benefits they may have derived from them.[29] These attempts were not always successful. During an art event, an emerging artist, dressed in torn clothing, loudly discussed a protest for economic reforms that she had attended. Later, several other artists in attendance mocked her, claiming that her parents had purchased her a private island. On another occasion, a dealer expressed frustration after realizing that an artist had taken months to deposit a check the dealer had given her for her exhibition sales, after the artist had allegedly complained that the dealer had underpriced her works. The dealer vented that the artist was supported by her wealthy parents and clearly had not needed the money after all. Simon Moser owned real estate in Europe and New York, allegedly due to shrewd investments several decades earlier. Yet, on several occasions, I let him enter through emergency exit doors so that he could evade the $2.75 subway fare on his request and followed him into convenience stores so that he could ask the seller to give him expired food free of charge. While artists do not want to starve, they take pains to not appear extravagantly fed.

THE PUSH-PULL OF THE
ARTIST-DEALER RELATIONSHIP

While artists present themselves as the kinds of people capable of possessing creative visions, dealers portray themselves as supporters of artists' creative visions. In an established Chelsea gallery, a dealer explained her relationships with the artists represented by the gallery:

> We are not co-producers of the artwork. So, a good art dealer is not trying to in-fluence the way something is going to be created, because you are just going to cloud that. If that artist is looking to their art dealer for advice on how to paint something, there is no place for them in this art world. They need to trust their own visions. . . . So you can't be like, "You know, I think that should be blue."

She asserted that a "good" dealer does not intervene in the creative process, because good artists are true to their visions and these visions should not be muddied by others. Artists echoed this view of the ideal artist-dealer relation-ship as characterized by dealers' nonintervention. As one artist expressed, a good dealer will "stay out of my head." However, galleries ultimately rise or fall on their ability to sell artists' works. Dealers must maintain their role as true supporters of artists' creative visions, while also keeping the lights on. In their interactions with artists, they delicately negotiate three kinds of creative decisions: what kinds of work artists make, how to arrange these works in the exhibition space, and the exhibition timeline.

Dealers use oblique communication to intervene in the creative process without doing so explicitly.[30] During a book launch for dealer Edward Winkle-man's *Selling Contemporary Art*,[31] a primer for new dealers, a major collector interviewed Edward in front of a crowd peppered with dealers and collectors, asking, "If an artist has a show and sells well, how do you manage the desire to tell them to make more of that with the desire to tell them to go jump off a cliff creatively?" Edward replied, "Well, you can ask any of my artists in the room—and please correct me if I am wrong—I don't think I have ever told them what to make, but I will be honest with them. The most I will say is, I will tell the artist, 'This is selling,' or 'We can't move this, even though we tried.'" Edward explained that he placed the blame on the collectors, who did not properly appreciate the artist's creative vision. He communicated this to artists as information, rather than a mandate to produce a certain kind of work.[32] He retained at least the pretense of artists' autonomy in the creative process, while also providing artists with economic information to guide their decisions.

Occasionally, artists continue to make work that dealers do not personally like or do not think will sell. When this occurs, a dealer may try to postpone the exhibition, euphemistically stating that the work is in a "transitional" stage. But if the artist persists in wanting to exhibit the work and the dealer is invested in maintaining a good relationship with the artist, the dealer may exhibit the work despite personal misgivings. One Lower East Side dealer who represented emerging artists walked me through her gallery, stopping in front of a sculpture of what appeared to be an orifice in various shades of pink clay, with two horn-like shapes curling from the top. "I hate it!" she exclaimed. "He thinks it looks like a face, but I think it looks like ovaries. Who wants to buy ovaries? And he wants to put a whole wall full of them!" Renowned dealer Paula Cooper described how one artist that she represented insisted on showing a series of paintings for his first exhibition in Paris. She explained that she would never tell an artist what to produce. However, she did ask the artist to reconsider showing this particular series. This was to protect him from what she considered to be a self-destructive impulse. The artist did not relent and exhibited the work. The result was, in her view, "not good."

Dealers sometimes enthusiastically exhibit work that they do not expect to sell, such as a large pile of rubble on the gallery floor. When they find the work to have artistic merit, they also recognize that it shows audiences that they prioritize the aesthetic over the economic.[33] To maintain sales while also asserting their critical orientation, dealers often pair difficult works with more saleable works, such as small drawings or paintings. Furthermore, while some galleries are more oriented toward emerging or established artists as well as toward critical or commercial success, most dealers seek a distribution within their gallery's program—the roster of artists that each gallery represents. They balance critically successful artists who produce "difficult" works with bread-winning artists. Galleries that represent established artists also represent more emerging artists, which shows that they are willing to take risks to remain at the cutting edge.[34]

Dealers can intervene in the creative process without losing their legitimacy as supporters of creative visions if they do so at the behest of the artist and seem to elevate aesthetic concerns over economic ones. Miguel Abreu, a Lower East Side dealer known for his highly conceptual program, explained that while many of his artists simply delivered finished series to him, he maintained a more "intense" relationship with one artist:

> This artist, I used to go and see every one of his paintings when he was in the making, and we'd have these long sessions discussing composition, every-

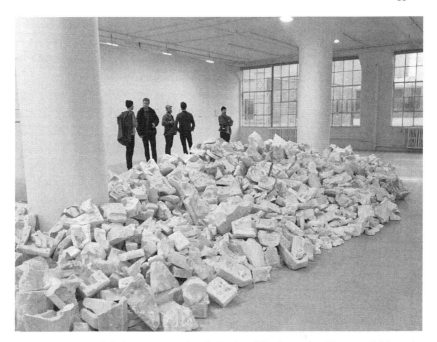

FIGURE 2.1. Exhibition-goers standing behind a "difficult" work, with more salable works behind them on the back wall.

thing. We would just basically have the discussion that would critically assess the image and the whole composition, and every gesture, and try to basically improve it through speaking. And he would actually work while I was there. And that was extremely—a very intense relationship.

Miguel is an unusual dealer in that he attended the same MFA program, California Institute of Arts, as many of the artists whom he represents. He retained his status as a purist dealer—one who does not sacrifice art for business—by critiquing work as a fellow artist and asserting that this critique is wholly concerned with aesthetically advancing the work.

Curators are particularly well positioned to intervene in artists' creative processes while maintaining their role as supporters of creative visions.[35] They are seen as less economically oriented than dealers because they are not directly involved in sales. Artist Katya Grokhovsky assembled her installation piece in Lesley Heller Gallery, where freelance curator Peter Gynd, who frequently exhibited Katya's work, was mounting a group exhibit. Piles of "found objects"—everyday things that others often cast off as "junk"—littered the floor, including wigs, paint-speckled blankets, a mannequin's leg, polka-

dotted pajamas, and a lumpy, testicular form made from nylons stuffed with cotton and covered in human hair. Katya began arranging the objects in a corner of the room, placing a pink doily on a bed of fabrics, but discarding it when Peter suggested that the doily felt "too specific." Later, Peter recommended that she "engage" the corner of the room, and she set a blanket in the corner, which Peter declared as "not right," until she included a pile of towels, pajamas, and underwear. This continued, with both of them occasionally stepping back to observe the installation, until Peter told Katya to "keep playing" while he hung the other artists' works.

Dealers' oblique style of interaction extends to communicating with artists over how to install exhibitions. Dealers have more experience than artists in installing exhibitions within their own gallery spaces. But artists have authority over the meaning of their work, and the reception of this meaning is shaped by how the work is exhibited. These competing claims of expertise require delicate negotiation. In the back room of Stanley Gallery, a Chelsea gallery that exhibits the work of emerging artists, Rebecca Stanley, who co-owns the gallery with her husband Charles Stanley, flipped through images on her laptop.[36] The images pictured a virtual installation of an upcoming exhibition in the gallery sent to her by the artist. The irregularly sized works were positioned in clusters, a departure from the usual practice of hanging works flush with one another and allowing ample breathing room between each work. She stated, "The artist thinks this is a done deal, but in my head, this is just a starting place."

Weeks later at the exhibition installation, I watched Rebecca and Charles ferry paintings back and forth across the gallery floor with the artist, arranging the paintings in different groupings and then standing back to observe in silence. Charles looked critically at a large orange painting propped up against one wall.

"I think this wall is overhung. If I were to get rid of a piece that is not totally essential, it would be this one," he sighed.

The artist's mouth twisted in disappointment as he replied, "I thought it worked well together. There is a great conversation between these two. I don't mind these two paired together."

Charles pushed back amicably: "Let's try taking it out. I can still see the transformation between the red one and this one."

Charles and the artist lugged the orange painting into the back room (later, Charles told me that he knows that orange paintings are more difficult to sell). Rebecca surveyed the room with narrowed eyes, an index finger pressed against her pursed lips.

She stated carefully, "I understand conceptually, it is all a part of the piece, but I don't think that they," she paused, "do each other a favor by being all smushed together. I think there is much more in here than should go on the wall, because they are *so* dense and *so* interesting, I don't want them competing with one another, and this one is *so* juicy, and they are like yin and yang." She tempered her assertion, "I'm not saying I can't be convinced."

The artist held fast, "I wouldn't mind breaking away from the way things are usually hung."

These tactful negotiations continued for several hours.

Charles lowered his voice, murmuring in my ear, "This is interesting, because we don't always have the artist here, and if he wasn't here this would be a totally different interaction; we would be much more frank. It would be like, this one here, this one here, not that one. To compound it further, he and [Rebecca] are very good friends, so that makes it complicated."

Later, the artist walked over to me and said, "I think I am more laid back than a lot of artists. I am willing to try different things. . . . And [Rebecca and Charles] have been great, they will go along with this piece or that piece, even though it is less consistent. They are not crazy concerned about sales."

For some artists, the creative act is in producing the works themselves, and they have little interest in drafting the press release or arranging works in a particular pattern on the wall. Others feel that the creative act extends to the exhibition setting and have rigid conceptions for how the works should be discussed and arranged. When working with the latter, dealers must do more interactional work to arrive at a solution that satisfies both themselves and the artist.

Dealers also cede some authority over the timeline of production. They juggle a schedule of group and solo exhibitions, each of which they show for four to eight weeks. Yet they argue that artists' creativity cannot be programmed like clockwork, but instead unpredictably ebbs and flows. Miguel Abreu explained how he avoided paying rent on an empty room:

We're operating like a business. We do art fairs, we push them, etcetera, etcetera. But there's always going to be a surprise—what they're going to shoot next. It's never quite sure. What you do is you have to develop a plan, so that you can allow these things to happen. So that other things can be pushed. Sometimes you just go, "Oh, shit, nothing is happening. All these people are in bad—not really producing much. So what am I gonna do, right?" Then all of a sudden you get lucky, and somebody just brings you something that all of a sudden is worth pushing, and then it just saves your year. Of course, if you have more

and more artists, these moments are easier to anticipate, but we're a very small group, so we're still in the wilderness.

As Miguel stated, artists' creative processes are both nonlinear and highly individualized. Dealers expect artists to have lags in production when artists exhaust one idea and are experimenting with new ideas. Artists also require different amounts of time to prepare exhibitions, based on the media, styles, and technical processes of their work, and even their personalities and approach to working. Dealers manage the nonlinearity and individualization of the creative process by forming flexible working relationships with artists. They account for idiosyncrasies in these variables when making exhibition schedules, planning more time between exhibitions for certain artists and checking in on their progress.

The higher an artist's status relative to the dealer or curator, the more leverage the artist has in bending the institution to his or her whims.[37] In 2016, the eminent performance and installation artist Vito Acconci had a retrospective—an exhibition devoted to showcasing an established artist's body of work by displaying work from multiple series—at the Queens outpost of MoMA, called MoMA PS1. In an article in the *New York Times*, Klaus Biesenbach, director of MoMA PS1 and organizer of the show, described the extreme adaptability required to mount the show, which "threatened to collapse under [Vito's] unpredictably evolving ideas and inspirations." He explained, "You have to think about him deciding 'Maybe I should go to China tomorrow.' . . . That's just how Vito is. With great artists—and Vito is one—sometimes you have to have unprecedented flexibility."[38] The director contended that Vito, as an artist with an exceptionally innovative creative vision, could not be constrained by institutional mandates, but must follow his creative impulses. Moreover, he asserted that the institutions involved in exhibiting Vito's work must adapt to this creative vision with "unprecedented flexibility," by undertaking the significant liability and inconvenience of negotiating the artist's volatile process.

Vito enjoyed an especially wide latitude in his interactions within the institution due to his critical prestige. He could continue to produce "difficult" work because he could rely on high-status institutional support to exhibit this work and expect an eager audience to view the work. Vito's reputation of having a unique creative vision insulated him from the risk, posed by his success, of being judged by others as a "sellout." In turn, the museum legitimated itself as a supporter of creative visions by exhibiting Vito's work and publicizing the erratic unfolding of the exhibition process.

Artists are precarious workers who engage in project-based, intermittently

paid labor in markets where success is unlikely and often short-lived.[39] A represented artist depends largely upon one dealer to sell his or her work, while a dealer distributes risk across his or her roster of artists. But dealers are precarious workers as well. While dealers rely on artists to produce the work that they sell, they cannot explicitly dictate what work artists produce or even when and how this work should be displayed in their own exhibition spaces.

By presenting themselves as true supporters of artists' creative visions, dealers help demarcate and legitimize artists' autonomy—even if incomplete—over the creative process.[40] However, dealers retain financial control over the work. While dealers must present themselves as not overly concerned about sales, artists' direct involvement in financial transactions is even more unacceptable, as artists are most intimately associated with creative visions. Dealers set the price of artists' work, with little input from artists, and they negotiate sales with collectors.[41] What artists gain in aesthetic autonomy, they lose in economic authority.

WORLDS COLLIDE

Like dealers, collectors present themselves as true supporters of artists' creative visions. Collectors want to know artists personally in order not only to better understand their work, but also to better inhabit their roles as artists' patrons. I was only a couple of miles from the Lower East Side bar party that I had attended with Simon, but I felt worlds away. Columns supported an open plan living room, furnished with a live edge wood table, velvet tufted sectional sofa, and granite countertops. The kitchen was staffed with an open bar, and servers whisked around trays of lobster rolls, lox on miniature toasts, and endive with blue cheese and walnuts. It was the week of the Frieze New York art fair, and a collector—a former investment banker—was hosting a VIP open house that also served as a salon in honor of a European artist whose work he and his wife wanted to introduce to curators and other collectors in New York. The artist's paintings were prominently hung in the living room. I made small talk with the other guests, some of whom I had interviewed previously or been introduced to at other events, and I followed them upstairs to tour more of the collection, as was typical at open houses. Artworks hung on every wall of the bedrooms and bathrooms, which were as immaculate as a fresh hotel room.

Downstairs, several artists mingled with collectors. They were easy to distinguish. The collectors were couples in their fifties to seventies, dressed in understated but refined clothing with hints of artistic flair in their round-rimmed glasses. The artists were more casually dressed and several decades younger.

I chatted with the artist for whom the party was being held, who wore Adidas sneakers, jeans, a sweater, and an orange backpack. When I asked him how he had met the collector, he struggled to remember.

"I think it was a studio visit that my English dealer set up," he recalled. "We met a few times over the year."

As we talked, he seemed puzzled as to why the collector would go through all this fuss for someone whom he had met less than a handful of times.

"I am surprised they did this for me. I'm not good at talking to collectors," he stated.

I knew what he meant. Despite my best efforts, I felt inadequately dressed and socially awkward. Earlier, my stomach had sunk when I managed to drop an endive on the floor. The thought of riding on Simon's handlebars felt down-right comforting compared to this, and I had much less at stake than the artist.

We discussed having studio visits with collectors in general, and he said, with raised eyebrows, "They love studio visits."

A friend of his, another artist whose work also hung on the collector's walls, laughed. "They do," he replied. "It can feel dirty."

In their role as patrons, collectors provide multiple forms of social and economic support to artists. High-status collectors who are deeply embedded in the art world introduce artists to dealers, curators, and other collectors. This is a symbiotic act, as collectors' works increase in value when artists are included in prestigious exhibitions and collections. Beyond the monetary support of purchasing artists' works, several collectors whom I interviewed let artists use their guesthouses or second homes as studio spaces for periods of time. They conceived of these arrangements as informal artist residencies that were free of charge save for an artwork from each artist that they often expected in return. Some collectors develop close, almost paternal, relationships with artists spanning decades as they purchase work from different series. Collectors also feel that it is their role to protect artists' careers by not reselling artists' works quickly and, when reselling, by offering galleries representing the artists the right of first refusal (to prevent works from going to auction, where the hammer price would be unpredictable).

Collectors describe their relationships with artists as an intellectually stimulating and fun part of the leisure pursuit of collecting. Yet, unlike collectors, artists feel more ambivalence about these relationships. They see their interactions with collectors as always, at least in part, work.[42] Artists explained to me that, while they genuinely liked many of the collectors whom they met and were grateful for their support, they were sometimes uneasy with collectors' seeming fascination with them as people. Some looked visibly uncomfortable

in collectors' elegant homes, which only brought into relief the economic asymmetry of their relationships.[43] Artists were all too aware that they depended on collectors' social and economic support, while collectors' careers did not depend on artists continuing to make art. For artists, this understanding infused collectors' cocktail parties with a shot of anxiety.

CREATIVE VISIONS LITE

Dealers, curators, and collectors interact with artists in ways that uphold the view that true artists have creative visions and that artists' autonomy in the creative process must be protected so that these visions can come to fruition. But not all artists are considered equally endowed with creative visions or entitled to this autonomy. I accompanied Hillary Fischer,[44] a self-described dealer for buyers (collectors who are seen as lower status), to a studio visit with an artist whose work she was assessing for a possible exhibition. Immediately upon entering the studio, Hillary clapped her hands together, exclaiming, "Oh, aren't these wonderful!" Less than a minute later, she offered the artist a show.

Hillary continued, "I like the horizontal, but I am not crazy about the vertical. I could really sell the shit out of these!"

The artist gave her a tight-lipped smile. "The other gallery told me that too. I appreciate the honesty. With the studio small, the vertical work is easier for me. But the dealer mentioned, 'I just want to point out that the last six were vertical,'" she said, cringing.

"Artists don't know. What do they care? They don't have to sell it!" Hillary exclaimed.

Dealers like Hillary, who sell work to lower-status collectors, tend to intervene in the creative process more explicitly and openly. These dealers have less latitude in the kinds of work they can profitably exhibit. They perceive that lower-status collectors tend to purchase less expensive, aesthetically pleasing work, limiting the possible size, media, and content of the work that they exhibit. They often encourage artists to produce moderately sized, aesthetically pleasing paintings.

Artists also have less autonomy when producing work for lower-status corporate commissions. Artist Antonio Murado prepared to pull an all-nighter in order to produce a work for a corporation that had commissioned him to produce two paintings for $200,000. Over the next twenty-four hours, he planned to pour diluted paint onto a painted canvas and slant the canvas as it slowly dried, so the paint pooled in a cloudlike shape. "Today is the deadline, and it was not ready," he explained, "But it is not a real deadline, because it

turns out they did not trust me, so now I have two weeks to get it done, whether I like it or not." Even more commercially oriented artists are not always trusted to deliver work on time.

As we stood in front of the glossy canvas, Antonio described how the art adviser for the company had chosen a "reference painting" from Antonio's previous works upon which he was supposed to base the commissioned work. He produced the contract for the commission, which read: "The Paintings will be reasonably consistent in artistic expression (including the concept, composition, and palette) with the representative paintings shown on Exhibit C annexed hereto and made a part hereof." Antonio explained that the client expected the reference, and yet, if he tried to imitate the reference too closely, the work always appeared lifeless. I joked that he could flee the country with the money instead, but then Antonio's face fell into a serious expression, as he said with a worn voice, "I feel trapped but, as a professional, I have to produce."

Antonio turned to the wall, where he was preparing a canvas for a $120,000 commission with another company, stating that this contract stipulated the exact percentage of the painting that he was allowed to cover with a mono-chromatic color.

"It's not like I would cheat," Antonio sulked.

Contemporary corporate contracts can be strikingly like those used centu-ries ago. For example, a contract in 1495, documented by art historian Michael Baxandall, similarly specified how an Italian artist should deal with empty space:

> The painter also undertakes to paint in the empty part of the pictures—or more precisely on the ground behind the figures—landscapes and skies [*paese et aiere*] and all other grounds too where colour is put: except for the frames, to which gold is to be applied . . .[45]

The patron wanted to ensure that the painter did not leave the background blank, but cover it with paintings of landscape and skies. For Antonio, corpo-rate culture, in which contractual details are stipulated in writing, clashed with art world culture, in which creative practices should not be stipulated at all.

Antonio gestured toward two stacks of canvases covered with white gloppy paint, like a stucco wall. He explained that, early in his career, he had made aesthetically pleasing works of abstract landscapes and flowers. Now, he felt "tainted," believing that the aesthetic appeal of the works had damaged his critical prestige. Antonio loved the look of the minimalist white canvases, but

FIGURE 2.2. The reference painting for Antonio Murado's commission. Photo courtesy of Antonio Murado.

he knew he would have to cover them with colorful paint in order to sell them. Collectors who bought paintings of landscapes and flowers, he perceived, were not interested in more difficult work. "I dug my own grave," he concluded.

There are many kinds of commissions in the art world, and some are viewed as higher status and afford more artistic autonomy than others. Commissions for large-scale works or performances for high-status cultural institutions, such as museums, biennials, or alternative art spaces, increase artists' visibility and prestige.[46] Indeed, artists often do such commissions for little to no monetary compensation.[47] Highly visible commissions or collaborations with those in other cultural fields, such as music or fashion, are more complicated. Audiences label artists as sellouts when they view artists as departing from their artistic practice for fame or monetary gain, although artists can sometimes avoid being stained by the association with popular culture if audiences view these themes as key to their creative visions.[48]

Commissions for low visibility and non-art institutions, like Antonio's corporate lobby, can pay well, but are typically seen as low status and provide less autonomy. Either artists do this work "on the D.L. [down low]," as one artist

put it, or they may face difficulties selling their work to higher-status collectors. Artists who work with galleries that cater to these collectors and on corporate commissions experience a constricted sphere of autonomy in the creative process. They are free to follow their muse, just so long as their muse does not direct them to produce vertical paintings or anything orange.

THE TRUE ARTIST

How can dealers and others in the art world see artists as, on the one hand, "psycho," "undependable," and in a "childlike state" and, on the other hand, as "inspiring" and "visionaries"? Artists do not merely portray themselves as possessing these qualities simultaneously, but rather present these seemingly incompatible qualities as two sides of the same coin. They display, to varying degrees, recurring traits: eccentricity, aesthetic obsession, and economic disinterest. Artists and others in the art world associate these qualities with the kind of artist who has a true creative vision.

In turn, dealers, curators, and collectors permit and even encourage these qualities because they see this as the cost of having a creative vision. They also interact with artists in ways that show that they are supporters of artists' creative visions. They portray themselves as prioritizing aesthetic concerns over economic ones and avoid explicitly intervening in artists' creative processes for economic reasons. They carve a space of aesthetic autonomy for artists. They allow artists to decide, within limits, what kinds of works to create and how to exhibit these works, while cutting artists out of involvement in economic transactions. They afford more latitude in these decisions to higher-status artists, whom they see as having truer creative visions.

Through their interactions in the art world, artists present themselves as having true creative visions, and dealers, curators, and collectors ascertain which artists have true creative visions. But what about the work itself? How do artists make their work? How do they develop understandings of their creative visions through the artistic process? To answer these questions, we must temporarily leave behind the downtown dance parties and uptown collectors' salons and step into the more secluded world of artists' studios.

Experimentation and Emotion: Developing Distinctive Creative Visions

I sat in the kitchen of B Wurtz's three-story Chinatown home, filled with dark wood floors and midcentury furniture. B had purchased the charming house decades ago, back when the neighborhood's reputation as crime-ridden kept home values low. Now trendy restaurants and bars squeezed between grocery stores and seafood stalls. B had a tall, wiry build and was dressed in a collared shirt and jeans. Nearing seventy, he had a mild-mannered, slightly hippie air that befitted his educational background at the University of California, Berkeley, and, later, the California Institute of the Arts. He spoke softly, often taking thoughtful pauses, about how his work had evolved over the decades. B told me about a piece that he viewed as pivotal to the development of his body of work. In 1973, he had painted a phrase in cursive script on a white canvas, reading "Three important things: 1. sleeping 2. eating 3. keeping warm," with his signature and the date scrawled on the corner. He described how this simple fragment had become the foundation for a lifetime of work. To B, the phrase pithily captured the basic necessities of life, suggesting that anything more was superfluous.

"What more do we need to be happy?" he asked me rhetorically.

This conceptual element of bare necessities became a guiding parameter for his work, but one that he held loosely. B gave the example of a series of paintings in which he drew a circle, indicating a face, and the letters "L," "I," "F," and "E," in the place of two eyes, a nose, and a mouth. The word "life" obliquely referenced bare necessities, but only in the broadest sense. As B produced more work, he also found himself returning to the same formal elements. He described, "I would use wire and strings, shoelaces and things that

are very linear. I started to combine some of my previous lines of work into more of one thing." B aimed to reconfigure materials used in the daily process of sleeping, eating, and keeping warm in a way that appeared elegant, even beautiful.

Walking into his living room, he pointed to a sculpture perched on a bookshelf, explaining that he viewed it as iconic of his work. The sculpture was composed of a sock standing upright on a metal can, which sat atop a roughly sanded wooden base. At first glance, the sock appeared to be cast in plaster. B clarified that, although viewers had often mistaken it for marble, it was an actual sock, held straight by a wire inserted inside of it. This sock-but-maybe-marble quality was part of what made the piece so ceaselessly compelling for B. The challenge, he explained, was to make the sock have a "monumental attitude." It was a challenge that he had spent his career pursuing.

Why had the phrase "1. sleeping, 2. eating, 3. keeping warm," provided the foundation for over forty years of work? Why did a work composed of a sock, wire, metal can, and wood base epitomize B's body of work? More broadly, when do artists come to see certain conceptual ideas as worthy of artistic ex-

FIGURE 3.1. Examples of B Wurtz's work, made with bottle caps, yogurt lids, mesh fruit bags, and other media.

ploration? When do they view formal elements as appropriately represent-
ing these abstract concepts? In a world where potentially anything can have
aesthetic value, how do artists make decisions during the creative process? I
trace the creative process from start to finish to start again, revealing a creative
cycle.[1] Artists' perceptions of their creative visions arise through the process of
experimentation, rather than being determined in advance and then straight-
forwardly executed. Artists rely upon particular emotions during the creative
process to make decisions about which formal and conceptual elements are
relevant and interesting to them. Through these moment-to-moment deci-
sions, artists develop specific consistencies and variations within their bodies
of work.

BEGINNINGS: LOW-STAKES EXPERIMENTATION

In an airy Brooklyn warehouse, artist Saint Clair Cemin sat next to me on a
modernist couch, dressed in a salmon-colored linen shirt, white pants, and
turquoise velvet loafers. Large abstract sculptures surrounded us. They looked
like loose tangles of ropes, some covered in clumpy plaster, still waiting to be
cast, and others finished with gleaming stainless steel. Saint Clair had begun
his career in the New York art world in the late seventies. He now operated
studios in Brooklyn and Beijing, each staffed by several assistants, and was
represented by the well-known Paul Kasmin Gallery in Chelsea.

Saint Clair explained the long process of creating his works, which typically
began from models as modest as a handheld ball of clay or a small sketch. He
recounted how he would gradually produce larger and larger models, tweaking
something here and there. When he was satisfied with the models, he would
ship them to China and travel to his second studio. With the help of several
studio assistants, he would mold the clay into boulder-sized clay models and
then encase the clay in plaster. Ultimately, he would use the plaster to cast steel.
The finished works would be shipped back across the ocean to be exhibited at
Paul Kasmin Gallery, only a few miles from where they were born.

I asked Saint Clair how he knew which models and sketches to make into
full-scale sculptures. He claimed that the choice was not fully his.

"Somehow, I'm more being exploited by those forms as if I'm the servant
of those forms. It's as if I'm an assistant to them. They want to be. They give
me signs that they want to exist," Saint Clair explained.

I tried again, asking him what happened when the models did not easily
translate into full-scale works.

His brow furrowing in frustration, he exclaimed, "It stays dormant for years. It stays around, and they don't pay rent, and they think they have all the rights in the world! They are ugly. The parasites of my studio are all over the place. I hide them. Come with me, and I'll show them to you."

Saint Clair led me past an assistant furiously typing on his laptop and into a small room. Shelves lined every wall from floor to ceiling, and small sculptures sat on each shelf. Some were in more rudimentary stages of roughly formed clay, while others were already cast in metal with detailed features. He explained that some of the models "screamed" to him, while others fell silent. The screamers were "taken care of," recreated as larger-scale works, while the mute ones were left to perish in the storage room, his purgatory for art.

I challenged Saint Clair, "But they don't have brains or think."

"Of course they have brains. They are borrowing mine," Saint Clair replied easily.

I was getting frustrated. As a sociologist, I wanted to discuss Saint Clair's concrete artistic practices, and his talk of screaming clay was testing my patience. At first, I chalked up Saint Clair's narrative to his efforts to maintain an idealized image of an artist with a true creative vision. Saint Clair expressed the romantic image of the muse, an external source of artistic inspiration guiding the artist who dutifully, almost helplessly, followed his or her aesthetic obsession. However, in Saint Clair's account, the muse was not some medieval goddess, but the material forms themselves. He was telling me that he experienced a lack of control over the creative process because the materials with which he experimented reacted in unpredictable ways.[2]

This unpredictability came with risks. Saint Clair's artistic practice required large investments of time, labor, and money. He needed this process to result in some works that he was willing to present to his dealer and that his dealer could exhibit and sell. Otherwise, he risked his career and his own faith in his work. To manage this uncertainty, Saint Clair made *low-stakes experiments*—low-stakes in that they required small investments of time, labor, and money, and experiments in that they allowed him to test ideas. Artists conserve time by producing smaller-scale versions of what they hope to materialize as full-scale works. They also economize materials by using inexpensive media. Saint Clair started with a small ball of clay, gradually making larger versions. He revised each one until he judged the model ready to be cast into costly steel.[3] Artists use various media for low-stakes experiments. Graphite pencils, charcoal, and watercolor paints dry more quickly and are less expensive than acrylic or oil paint. Through low-stakes experimentation, artists allow heightened uncer-

tainty early in the creative process. The "parasites" that seemed to plague Saint Clair were not the problem, but part of the solution.

These experiments solve not only the practical problem of limited resources, but also a cognitive hurdle. Ella Kruglyanskaya made large, cartoonish paintings of women. Represented by the prestigious Gavin Brown's Enterprise, she had a tight schedule of exhibitions and fairs, demanding even with the help of a studio assistant. Gesturing to a blank canvas on the wall of her studio, Ella explained how she managed to produce under pressure:

> So a canvas like this, even if you just prepare it, it takes a really long time and it's not cheap. So if you start thinking in those terms, you could be very nervous. You know, "Oh, my God. I just spent three days making this thing, and now it had better be good." But in a way, you can't think like that. You have to trick your mind into saying that it's just a throwaway piece of something. But of course, I don't want to be completely throwing it up in the air. In the drawing, it really doesn't matter. I can make something hideous.

Faced with an expensive canvas that cost her three days to fabricate, Ella perceived the task of executing her vision flawlessly onto the canvas to be daunting. Her sketchbook, with hundreds of small, ready-made sheets of paper, seemed significantly less intimidating. She used low-stakes experiments to trick herself into a low-stakes mentality.

Depending on media and techniques, artists focus their low-stakes experimentation at different stages of the creative process. Some artists, including Saint Clair and Ella, cannot afford many full-scale disasters, as they work with expensive materials and time-consuming techniques. Their studios are filled with the material traces of many low-stakes experiments: bookcases of sketchbooks, stacks of watercolor paintings, rooms of misshapen sculptures. For artists who use inexpensive materials and fast techniques, experimental moves can be easily done or undone. For example, artists who work with found objects often experiment by collecting, arranging, and rearranging these things. They produce few, if any, rudimentary sketches or models, and instead work directly with the materials for their full-scale works. These full-scale works are low-stakes experiments in themselves. However, the creative process is not necessarily quick. These artists may spend months conducting what they call "visual research"—gathering images and objects from books, the internet, and their home and surrounding neighborhood and then contemplating their meaning and significance.

Artists also modulate the timing of low-stakes experimentation based on exhibition schedules. While artists negotiate exhibition deadlines with their dealers, once set, artists are expected to deliver, and some deadlines—such as those for fairs and group shows—are nonnegotiable. During the lags in exhibition schedules, artists often explore a broad array of ideas through low-stakes experimentation. As deadlines approach, these periods are followed by more frenzied high-stakes execution.[4] Saint Clair referred to these deadlines in the same terms of being a servant to his materials, explaining, "Those pieces that have to be in the exhibit—they are aware more than I am that they need to be ready by a certain date, and they get really upset if you don't take care of them."

Artists spoke positively and negatively about the external pressures of exhibitions on experimentation. Some explained that the deadlines forced them to be more prolific. Others waxed nostalgically of past decades, recounting a slower-paced, less commercialized art world in which fewer fairs and longer exhibitions allowed artists to luxuriate in low-stakes exploratory phases. They worried that they had perhaps pushed works out of the studio prematurely. While one artist expressed confidence in her body of work as a whole, she questioned a few works that she had released under the pressure of a deadline, wondering if they were "redundant." She asked, "Is it acting on artistic will, or [is it that] I was pressured into it and just made something mechanically?" Of course, this is only a concern of artists with stacked exhibition schedules, while other artists often yearn for such a problem.

Cognitive scientists have argued that artists rarely make discoveries in dramatic "eureka" moments. Instead, they find that experimentation is driven by both "divergent thinking," during which ideas are widely generated, and "convergent" thinking, during which certain ideas are selected for further exploration.[5] Artists use divergent thinking when they consider a wide array of source material and test these possibilities in low-stakes experimentation. Convergent thinking, in which artists produce further iterations of certain low-stakes experiments, is just as critical. Saint Clair insisted that the parasites that he made into full-scale works were simply those that "screamed" at him. But which low-stakes experiments are more likely to call out to artists? How do artists decide when the results of further experimentation are satisfying or vexing?

The initial sparks of ideas do not always pan out as artists envision or hope. I visited Davina Semo's studio on a particularly muggy day in June. The cramped room lacked air conditioning, and beads of sweat gathered on my forehead. Davina wore cutoff jean shorts, a black tank top, and untied hiking boots. As we spoke, she periodically squirted her neck and bleached

hair with a spray bottle of water. A pungent odor bathed the room, emanating from the large pelts and scraps of leather that littered the floor and tables and hung from the walls. It was my second visit, and the leather took me by surprise. The first time I came to Davina's studio, I had found the floor covered with piles of shattered glass and rolls of chicken wire. At the time, Davina had been molding the glass and wire into square slabs of wet cement, which had a mosaic-like quality when dried. She explained that the glass and chicken wire had lacked a quality that the leather fulfilled. She saw her work as relating to the relationship between humans and industrial materials, and the leather was man-made while also possessing a skin-like quality. However, the leather posed a technical problem. Having never experimented with it before, she found it to behave "wildly" and needed to learn how to tame it.

While Davina reserved the leather pelts for full-scale works, she used the scraps for low-stakes experiments. They were cheap, she explained, as companies produced the leftovers when they cut the leather to be made into handbags. The manufacturers sold them in pounds, and anyone could buy them online. She wanted to understand how leather reacted at different thicknesses. She made thin rectangles of concrete—much smaller than the large squares she used for full-scale works—and molded the scraps of leather onto these strips. After testing various thicknesses, she knew which would adhere to the concrete and which would come unstuck.

But the results were not always as expected. Despite her low-stakes experiments, she produced one full-scale work in which the leather was too thick to properly adhere to the concrete and awkwardly sloughed off like wrinkled skin. In this case, altering the size of the work shifted variables in a way Davina had not foreseen. While she could have decided that she was satisfied with the work, even though it had not been what she expected, she defined the results as a technical mistake. Davina judged the leather to express the conceptual elements that she associated with it, but viewed the misfired technique to muddy this expression. To salvage some use from the materials, Davina recycled the full-scale work as test material for new low-stakes experiments. She described one such experiment, in which she had sketched on the leather with a white pencil, as "not at all interesting." Another experiment, in which she had drawn on the leather with a tattoo gun, she found to be more promising.

More common than technical mistakes were conceptual missteps, in which artists judged the formal elements to improperly express the concepts in which they were interested. Esperanza Mayobre had imagined a work composed of two fans with their backs facing one another, like those that dotted the landscape in her native country of Venezuela. She purchased two fans and fastened

FIGURES 3.2 AND 3.3. A work from Davina Semo's leather series (top). Leather test strips (bottom).

them together in her studio. Nothing went wrong, per se; but, like Davina, she judged the result to be dissatisfying. Esperanza explained:

> Something that's so vast and big and massive and putting it with two ugly already existing fans in the gallery, it's not my sensibility. I do work that's kind of minimal and elegant. It's just like two fans there are so cool in real life, because in real life it has a landscape and the trees and the beach. And, in the gallery, you're just taking it too much out of context. I feel like it's a bad appropriation of good reality. . . . I bought the fans, and I thought I would like the crappy look.

While Esperanza envisioned two fans standing starkly against the Venezuelan horizon, upon creating this imagined work, she was confronted with two fans sitting ungainly in her small studio. An artist who made assemblages of found objects might have appreciated the "crappy look," and Esperanza had not perceived there to be any technical mistakes in creating the fan sculpture; however, the work rubbed against her perception of what her works should look like. She felt that it was not relevant to her creative vision.

Considering why she was unhappy with the results, she imagined possibilities for revising the ideas in new works. She briefly fantasized about casting the fans in gleaming silver, but, as an emerging artist, quickly realized this was not in her budget. Anyway, she reasoned, making the work inexpensively was important for the concept. She stated, "I come from a very complicated place, so I just can't justify doing political work that costs a lot of money." Finally, she came up with another iteration—a simple black print image of the fans on white paper—which she judged as better suited to her aesthetic commitments. Drawing upon the image of the fan, Esperanza envisioned different possibilities for producing the fan sculpture, limiting herself to those that fit her budget and timeline. With each iteration, Esperanza produced an imagined version of the work and then assessed the disjuncture between the idealized work and the materialized result.

When I began interviewing artists, I asked several misguided questions: "Can you tell me about a work you made that was bad?" "What about a work that was good?" "How do you know the difference?" Artists patiently corrected me: Beyond what they saw as obvious technical issues, they did not think in terms of good and bad. Instead, they ask themselves, "Is it interesting?" "Is it relevant to me?" "Does it 'work'?" This distinction is not mere semantics, but reveals artists' orientations toward aesthetic judgment. Artists do not view their work as good or bad, as if there is a metric for aesthetic judgment that can be applied to all bodies of work. They perceive aesthetic

judgments as subjective and oriented inward toward their own bodies of work, as if each body of work has its own form of measurement. Artists judge formal and conceptual elements as worth pursuing or abandoning depending on whether or not they view those elements as meaningfully related to their creative visions. How do they identify which elements are interesting and relevant to these visions?

For artists, the distinction is not always immediately clear. B Wurtz led me to his upstairs workspace to show me an unfinished work: a pink plastic piece of a child's toy suspended from a thick wire, which stood straight atop a wooden platform. The plastic formed an O-ring from which clips dangled.

He explained, "I started with this because someone gave me this thing. Some friend had it and he thought 'Oh, B would like that,' and so he said, 'Oh, you can have it.' So he gave me that, and this is not something I would normally—well, OK, I use these kind of hanging things—but not like a pink one. So, this is a little different, a little weird."

"Yeah, it's a little too plasticky, fabricated," I replied.

B continued, "Yeah, kid-like. And so I thought, 'Oh, that is an interesting challenge. What can I do with it?' So, I had this idea: 'Okay, I think I'll hang wooden clothespins from it.' And then I thought, 'Now, how am I going to display it?' So, it was going to be like a smaller thing with something holding it. And then I thought, 'Well, I'll make this bigger structure.' And then, 'It needs more height.'"

The object was not a material that B usually used, but he chose to incorporate it as a challenge. He then tried to solve this aesthetic puzzle by incorporating other materials. He constructed an entire work around the toy, building a wooden table, putting a wire pole and wooden frame through the center from which the piece could be suspended, adjusting its height, and finally hanging clothespins from the toy. Yet B still felt that the object was not yet speaking in his voice. He had temporarily stopped working on it, hoping an idea would come to him as the work hovered in his peripheral vision.

Ella Kruglyanskaya described a similar feeling of ambivalence. A large painting that hung on the wall beside her worktable caught my eye. The painting was a close-up of a woman's face as she ate a banana. I had seen women eating bananas in Ella's other works, but the composition of this painting was less busy, with a monochromatic, green background covering much of the surface. It also had a coarser texture, as if the paint had been briskly coated on the canvas, with bits of white linen peeking through. The painting, Ella revealed, had been hanging there for months. She would not let it leave the studio. She struggled to explain her decision:

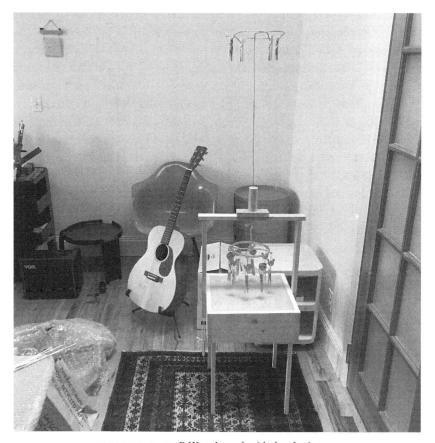

F I G U R E 3 . 4 . B Wurtz's work with the plastic toy.

I still don't know if I can describe it in specific words because it could also have to do with its difference from all the other works, the body of work. If they were going to a show, I [would feel] like it was kind of the odd one out, maybe, more rough, somehow. The other ones are more refined. This one, it felt more worked . . . it's somehow off. But it also changes with time. It's not like I will always feel this way.

Ella felt a grating ambivalence toward the work. There was something "off" about it. If it had felt too far off, she would have discarded it. The painting piqued her interest, yet she remained unresolved about how the painting fit into her broader body of work, how the painting would look "in conversation"—as artists often said—with the other works in the series. She dealt with this ambivalence by simply leaving the work hanging on her wall, suspended

in time and space. She explained, "You let it live, let it be like this in the studio. You do something else, and it's there in your periphery."

Artists feel ambivalent about work when they find the work interesting but are unsure of its relevance to their creative visions. The dissimilarity between the work in question and their other works is what makes the work surprising. But the intrigue can only be sustained if artists can formally and conceptually link the work to their previous works. As artists continue to consider and experiment with these unsettled works, their emotions toward the work shift. One artist explained, "It is very intuition based. It is me staring at a work for a long time and making a decision about it, whether it is making me cringe or not." Another stated:

> For me, when a painting is undone, I look at it and am like, "Ugh," and feel very on edge, and when I look at a painting and it's finished, I can look at it and feel rest. So I normally try to work on a painting until I feel that rest. Sometimes you have to wait longer to rest just by looking at it for another few weeks, so it is confusing.

Artists' emotional responses to the work can evolve without even touching it, as they make new conceptual connections between the work in question and their previous works. By considering the work, they can also elicit ideas of which formal changes might allow for these conceptual connections to be made clearer. However, work that remains on the wall without the artist making formal or conceptual connections will eventually expire. Over time, ambivalence may curdle to disinterest, tipping the work toward the storage unit, or bloom into excitement and a possible life beyond the studio.

DEVELOPING CREATIVE COMPETENCIES

As when they felt work was somehow "off," artists described judging a work to be worth pursuing as an emotional experience. When I asked one artist to explain the feeling, she said, "I feel . . . pleasant?" laughing with mild embarrassment at her difficulty articulating the emotion. Most described the emotion as a charge of excitement or as a warm feeling of joy.[6] They experienced the most immediate pleasure from formal elements—a star-like shape, a particular shade of red, a gravelly texture—which they then associated with conceptual elements.

Polly Apfelbaum had a small, cement *L*-shaped studio in Manhattan's Seaport District, with the short leg of the *L* serving as an apartment with a bed

and bathroom. She and her husband, an architect, resided mostly upstate, but they had lived in the apartment since the 1970s, when they fought various battles with their landlord and went for periods without heat or water. Bowls of ceramic beads sat atop several long tables. On the wall hung a series of velvet rectangular fabrics upon which she had spray-painted serpentine lines. "Why I am really excited about what's on the wall here is because I had worked with line before, and really, it didn't work. And I didn't understand why it didn't work," she said. On her computer, she pulled up an image of a serpentine line. Polly explained that the line had been an illustration in an antique book that her friend had given her. When she was working on a series of wallpaper works, her assistant had digitally drawn the shape. "Stop," she told him. "That's the work."

"And then I was so excited, so I came back to the studio . . . and then I just started spray-painting. . . . and really having a great time with it," she exclaimed. She had spray-painted one piece of fabric after another, until they filled a whole wall. Polly knew the spray-painted works excited her, but she was still working out their meaning: "I do know where this line comes from. I do know why I am happy with it. I do know—but I don't have yet—it's driving me crazy. I don't have another kind of logic." Polly had not amply articulated the conceptual meanings to herself. What would she title the work? "I am thinking *Snail Lines* or—because I took a wonderful picture of these snails that were scooting around. They scoot—I don't know. So I am thinking about them. I like them, and I am living with them."

For Polly, emotions were always somewhat unsettled and intermingling. Excitement could overtake ambivalence, or ambivalence could creep into excitement. She could feel happy with a work without having articulated every layer of meaning to herself. Sometimes, it was only when pushed to put together an exhibition—like an exhibition in Vienna that included work from six different series and an accompanying artist book—that she was forced to more fully identify the connections among her works. "I know myself enough now to sort of—but a lot of this is after the fact. . . . When you are so in it, you are talking one way. And ten years later, you have edited out and you've made the story, maybe what you are interested in now. Maybe you changed the story." The process of meaning-making was ongoing, sometimes for years after she had finished producing the work itself.

When artists experience excitement over a formal or conceptual element that they identify, they repeat this element in future works. Michael Mahalchick's studio and apartment in Crown Heights, Brooklyn, had low-slung ceiling and poor natural light, but was spacious, at least by New York stan-

FIGURE 3.5. Paintings from Polly Apfelbaum's tentatively titled *Snail Lines* series.

dards. From the looks of it, Michael was using every inch. Cartons and garbage bags were stacked to the ceiling against one wall, overflowing with fabrics and papers. Crates of records, along with paint cans and glue containers, were scattered across the floor. Latex molds of Halloween masks dangled from pieces of furniture and peeked out of boxes. Large works, composed of posters upon which Michael had pasted everything from bloodied Band-Aids to large foam numbers, were affixed to the wall and lay on the floor. Bizarre objects, including surgical masks and an inflatable frog, hung from the ceiling. As an artist who often worked with found objects, he had surrounded himself with potential media. And with his wild beard and long hair, Michael seemed to blend into the setting.

Michael explained that the extra space had enabled him to assemble works on the floor, ultimately producing larger works. He described how the poster series developed over time. First, the colors he painted on the posters changed. He realized that he could mix paint into the latex to make different colors, and he started adding more paint to the solution to produce more saturated hues. He also began combining multiple posters in each work, building borders around the new shapes. Confronted with these forms, his thinking about the

FIGURE 3.6. Michael Mahalchick in his studio.

concept of the works evolved. He explained to me how it struck him that the shapes represented signs and symbols. He liked how the works signified the meaning of the symbols, while simultaneously, when the viewer looked closer, evoking the additional meanings of the objects embedded within the shape.

The poster series gradually branched out into other works that developed into their own series. Michael had been going through his vinyl collection and removing any records that skipped. He employed the same technique that he used on the posters, painting on the album covers with latex. He rolled back the latex in certain spots, revealing faces and other objects pictured on the album art. In another poster work, the lamination on the poster caused the latex to unexpectedly peel off the surface. He was left with a translucent layer of latex punctured with a web of holes. He produced more latex skins in various thicknesses, learning how heavily he needed to paint the latex so that the medium separated from the posters while maintaining their shapes.

Michael identified elements that he perceived to be interesting and relevant to his body of work: the composition of the posters, the color of the latex and glue solution, the texture of the peeled-off latex. He made variations of

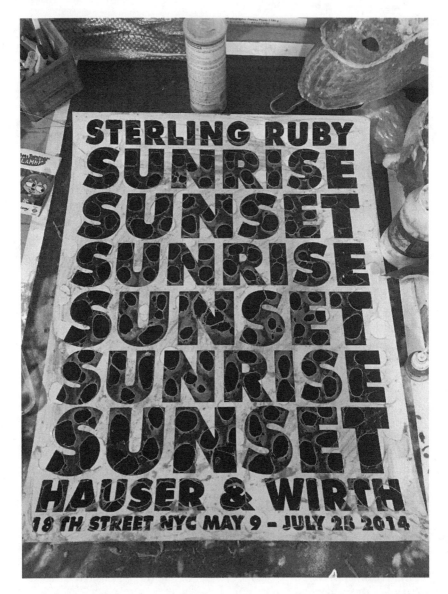

these elements by maintaining each element that he found interesting, while changing other elements in each work. By holding certain elements constant, Michael refined each element to create results that he judged as more formally satisfying. For example, when producing the poster works, he maintained the medium of latex mixed with paint, but modulated the amount of paint in the solution to produce different levels of saturation. Similarly, he varied

FIGURES 3.7 AND 3.8. An earlier work in Michael Mahalchick's latex poster series (left). A later work in the series (right).

the heaviness of the latex layers on the peeled-off works until he attained the desired level of thickness. He also created more formally complex works by maintaining consistencies. Once he knew what to expect from painting latex and pasting found objects on posters, he incorporated multiple posters into the same work. The resulting works were larger with more varied shapes.

Artists produce iterations by holding certain elements constant while varying others. Through this process, artists develop *creative competencies—* improved predictions of material results. By holding some elements constant, artists reduce the uncertainty in the effects of these elements, as they have already seen these results in previous works. Artists can then vary other elements to see their effect.[7]

Artists develop creative competencies not only in formal, technical effects, but also in conceptual understandings, both of which evolve from a long and iterative process of refining and adding complexity. Nancy Shaver lived in Jefferson, New York, where she divided her time between teaching sculpture at Bard College, running an antique store that she considered to be part business and part ongoing art installation in Hudson, New York, and producing work

to be exhibited at her New York gallery, Derek Eller, and elsewhere. We talked in the back of the antique store, which doubled as her studio, surrounded by sheets of cloth. Nancy was in the process of covering grids of wooden boxes with papers and fabrics that she had collected.

In terms of technical difficulty, the grids fell under the category of "things my four-year-old can do." For every work, Nancy maintained the same square grid of sixteen blocks. Once she figured out how to adhere the blocks and fabrics, the only key decisions were which fabrics and papers to use and in what pattern to configure them within each grid. She described the process of arranging the fabrics as "factory work":

Lots of work now is in blocks of wood covering with fabric: my factory work. I attend to it as factory work, and it is more meditative, and it is a pleasure of getting this bunch of supplies that I will have to think about. . . . I am acquiring material, and it is a satisfying activity. I am using my hands. I am using, in concert, my brain and hands, but in sort of a remote way. . . . It is an automatic gesture that I recognize as my working pattern.

Nancy experienced the process as automatic and embodied,[8] the work unfolding before her eyes not through conscious choices, but through ingrained patterns of movement and aesthetic sensibilities.[9] But she felt that she also learned a great deal about the conceptual meaning of her work through this process. She explained that spending hours upon hours cutting and arranging the Japanese prints had allowed her to more fully recognize the historical depth and visual complexity of these fabrics. As she collected other fabrics from the Salvation Army, she was struck by what she perceived to be the cheapness of the mass-produced fabrics, often in various animal prints, that were available to working-class American women. She began mixing blocks covered with mass-produced fabrics alongside the blocks covered with Japanese prints to visually express this stark juxtaposition. She stated, "I pitted these fabrics against Walmart fabric. That was so interesting! Like these beautiful patterns, against what we know of our culture that is nothing, nothing compared to that." While the process of arranging printed fabrics was no longer technically challenging, she asserted that it was still conceptually interesting. Moreover, she identified the works as relevant to her body of work, and this recognition brought pleasure to the process. "I am enjoying so much recognizing the thread or the pleasure of recognizing my system in a way," she said.

Nancy showed me her current work in progress. Sixteen blocks of Japanese and leopard print fabrics were interspersed between blocks coated in black

FIGURES 3.9 AND 3.10. A grid work by Nancy Shaver (left). A later iteration of the same work (right). Photographs courtesy of Nancy Shaver.

paint. She opened a file on her laptop to reveal a photograph of the same work at an earlier stage. The previous iteration was composed of a more frenzied juxtaposition of prints, with no muted space. She explained that she began the work by putting a block of floral Japanese print in the upper right-hand corner of the work. Because the eye was drawn to the colorful flower, the rest of the work needed to aesthetically balance this bold "gesture." However, even after adding more colorful printed blocks, she judged the work to be aesthetically unbalanced. She felt annoyed when looking at it. To solve this problem, she interspersed the "neutral" black blocks throughout the grid. She hoped that the busy and monochromatic blocks would guide the viewers' eyes around the work with a certain flow. Still, she judged the work as "not quite right." While Nancy knew how to build the grid and cover it with fabric, she believed that she was still developing creative competencies in terms of how to configure the patterns so that the form would "say what [she] wanted to say" on a conceptual level. The fabric grids remained exciting because they were both interesting, in that she experienced challenges in the production process, and relevant, in that she understood how they connected to her broader body of work.

Artists feel excited about elements that they believe are related to their creative visions, while also novel within their bodies of work. When artists experience this zest, they are motivated to repeat that element in future works. They imagine and test other possible iterations of the element, developing creative competencies by holding the element constant and changing other variables in new works.

As artists recognize consistencies as such, they increasingly associate these elements as central to their creative visions. Over time, these perceptions of consistencies begin to solidify in artists' minds, and these crystalizing senses of their creative visions shape how artists produce new work. For B Wurtz, the

concept of "sleeping, eating, and keeping warm" was broad enough to offer many solutions in the form of material results and could be explored through a lifetime of experimentation. It also served to channel the infinite possibilities of experimentation by requiring him to find solutions within certain parameters. B explained:

> I felt I needed to limit the scope of what was available to me in terms of found objects because it was just too overwhelming. There are so many found objects that are already really interesting that I wanted to challenge myself by taking really, really ordinary things that you wouldn't even notice. . . . And it makes you have more freedom in a way, because you have to be more inventive with what you do. If you limit it, then you have to think of other things to do.

B channeled endless source materials through the conceptual filter of "sleeping, eating, and keeping warm," believing that reducing the possibilities required him to think more creatively about how to use a narrower range of materials. By imposing this parameter, B created a problem that required a solution. He described how he found himself "gravitating" toward certain materials again and again, including wood, wire, string, and plastic bags. He judged these materials as associated with core conceptual consistency of "sleeping, eating and keeping warm," particularly in relation to wood as a tool for generating warmth. He also perceived them to be formally consistent with his aesthetic style of arranging quotidian materials in a way that appeared modest in their everydayness and their scale, yet also elegant.

In 2011, Metro Pictures Gallery had a retrospective exhibition of B's work. The exhibition filled the gallery's several rooms with work from different series spanning four decades. B explained, "I hadn't seen so much of it over such a long period together like that ever before. I was really surprised at how weirdly consistent I had been. And that was interesting to me, because I thought, 'This is really who I am.' But it wasn't just repeating either." Work continues to have a social life after artists finish making it, and artists reencounter their work both inside and outside of their studios. Through these interactions, they trace consistencies and view these consistencies as evidence of their authentic creative visions, their true selves as artists.

Artists observe and reconsider past works to articulate to themselves which consistencies are most fundamental to their work and how they can make further iterations of these consistencies that will interest them. Brent Owens' studio was a small box, scarcely ten feet by ten feet, in a large warehouse.

It was filled to the brim with materials and work. On one wall hung a work from a previous series made with carved poplar wood, designed to look like a neon sign picturing a blonde woman in a swimsuit. On another wall were plywood panels that he had carved into and painted with abstract images. A box on the floor was filled with logs and branches that he had recovered while fishing upstate. Surrounding us were several wood pieces upon which Brent had airbrushed objects, including human nipples and cans of beans. Brent told me that he had spent a lot of time thinking about what was consistent in his work. He explained the consistency as an "anthropomorphic impulse" to take natural objects, like wood, and stamp them with a human likeness. When I asked Brent how he recognized this impulse as the consistency, he replied:

> When you look back, you can see a thread of what is the most successful or interesting in the work. You are like, "Wow, this one works really well. What is it, exactly, that I was able to channel here, or harness?" But there's also a degree to which this is just what happens when you play with things for years and years, and themes emerge. And then you start to realize that there's a reason those themes are attractive to you and other people.

This process of looking back was both unavoidable and intentional. Brent's works filled his studio because he had nowhere else to put them, but he also deliberately reflected upon past works. Brent explained that, in addition to considering the work in his studio, he frequently flipped through sketchbooks from several years ago. Artists' works, from seemingly negligible scraps to celebrated public displays, are scattered around their studios and the art world. Artists access the "distributed object" of each body of work—all of their unfinished and finished works in digital and material form—to identify common threads weaving together the body of work.[10] Artists also watch how others engage with their works. Brent described how he elicited feedback from various sources. His artist friends and his wife often visited the studio to discuss his work. When he exhibited works in galleries and fairs, he observed reactions from friends and strangers. And then there was the internet. Brent posted images of sketches, works in progress, and finished works on Instagram and could see the relative numbers of "likes" each image received. It served as a rudimentary, but effortless, measure of social resonance. Artists most often continue to produce elements in future work when they recognize these elements as relevant to their own creative visions and as relevant to a broader audience.

CREATIVE EXHAUSTION AND RENEWAL

Artists repeat elements that excite them, but their enthusiasm can run dry, giving way to another emotion: boredom. Before meeting Nancy Shaver, I had reviewed images of her works on her website and noticed a stark shift from using found objects to producing sculptural works that she had fabricated. I inquired about the change during our conversation. She said bluntly, "I felt like if I used another [found] object, I would just throw up." When artists spoke of their boredom, they visibly manifested their emotions. In contrast to the animation with which they spoke about their excitement, their shoulders sagged and their voices went flat. I asked Nancy how she recognized that she had exhausted the variations in the found objects she used, and she replied, "Well, I was just bored, and that boredom is always a trigger for ambition in work—wanting to see something else in a different way." Since the series involved simply choosing and arranging found objects, Nancy ultimately perceived limited variations to be available. For Nancy, boredom pushed her to move to an entirely different series, as the element with which she was bored— the medium of found objects—was a defining element of the series.

In contrast, when artists experience boredom with an element that they judge as consistent within the series but not as defining the series, they can abandon this element while continuing the series. Michael Mahalchick explained that boredom drove him to stop producing works in which he used a single square or rectangular poster as the canvas: "I was tired of making these smaller square kind of things. They were kind of fast. They started to lose their excitement, you know. After doing them for so long, it was sort of like, 'Oh, yeah.' I got bored with the thing." As Michael produced more works in this series, they became too predictable, and he could not think of further variations that seemed significantly different from the posters he had already produced. Then Michael wondered, "What if I took a bunch of them and made them together and then just made them shapes and kind of broke away from that square idea?" He continued the series by changing the previously consistent element of the square poster, composing multiple posters to make a more complex shape. He imagined new shapes, and these shapes took on additional symbolic meanings for him. The works became exciting again.

Artists feel ambivalence when they see an element as surprising but are unsure of its relevance, and they pause the production of these works until they can make meaningful connections to their creative visions. They experience excitement when they view certain elements as surprising and relevant to their creative visions, and they produce further variations of these elements.

As artists develop creative competencies, they gain an increasing ability to control the material results by maintaining these elements in future works. By reducing uncertainty, the element of surprise dwindles. Boredom is the third key emotion in the creative process. Artists experience boredom when they perceive elements as relevant, but no longer interesting, and they stop producing elements with which they become bored. Creative competency shifts to creative exhaustion.

Creative exhaustion is not an objective threshold. As with feelings of excitement and ambivalence in the creative process, the feeling of boredom is relative. Michael continued to experiment with found objects, but Nancy grew tired of using found objects as her central media. One artist may maintain his or her interest by producing variations of elements that, for another artist, would constitute insufficient tweaks.[11] Artists come to understandings of what constitutes enough change within the context of their individual creative visions.

While artists commonly end series when they become bored, they have different temporal methods of moving from series to series. Some, like Nancy, make series in a sequential, almost methodical, fashion, neatly wrapping up one series before moving to the next. Artists who produce series sequentially continue to maintain consistencies until they feel boredom and judge the element to be creatively exhausted, although they may return to the idea later when they have formed new conceptual or formal connections. More commonly, artists take a seemingly haphazard approach by working on multiple series simultaneously. For example, Michael often moved between several series in a single day's work. Michael explained that he would glue objects on multiple poster works and then mix the paint into the latex to paint on the posters. By painting works with the same solution, the works had a shared palette, a "color connection." When he temporarily tired of working on the poster series, he might create a peeled-off latex work. Excitement for one series can at least temporarily overtake excitement for another. Works in different series also have different time horizons. Artists experience relief from the monotony and delayed gratification of producing a work that requires weeks or even months to complete by easily dashing through works that can be executed quickly.

Boredom drives artists to abandon certain consistencies and incorporate new elements into their work. But, as these new elements are inherently different from those that they already recognize as part of their creative visions, how do they come to see these elements as relevant to their creative visions? How do artists change their creative visions while still viewing these creative visions as representing their true identities as artists?

On my second visit to B's studio, he described a major new project. A nonprofit organization, Public Art Fund, commissioned him to make a public work. B described how the project was a significant departure from his usual work.

I'm actually gonna be doing a project with Public Art Fund. And that is so not in my realm, normally. I don't make really large things. I certainly don't make outdoor things. But I was asked to think about proposing something. And it was such an honor. And also, one needs to be challenged, either by someone else or by myself. . . . The tricky thing was to make something outdoors that would still be my work, not just blow up something big and make it bronze. I mean, that's not my work.

The public sculpture was to be displayed outside in Manhattan's City Hall Park, and this context posed a problem for B, even if it was one that he welcomed. The installation would need to be much larger than his previous works as well as waterproof. His normal materials of socks, paper plates, yogurt lids, and string would not be suitable. But the "monumental attitude" of large-scale marble or bronze works was exactly what he was trying to avoid. B showed me a sketch that looked like a column with spidery legs. The solution, he explained to me, was kitchenware. Kitchenware was waterproof—it was meant to be washed repeatedly—and it was a found object related to food and domesticity. Ultimately, working with a team of art fabricators, he produced *Kitchen Trees*. The work was composed of stacks of colanders, with metal poles extending from them in tree-like arcs, mimicking the park's historic fountains. Pots and pans were affixed to the ends of the branches, with each piece of kitchenware sprouting plastic fruits and vegetables. In this case, the challenge to incorporate new elements into the work—a change in scale and media—came from an exhibition opportunity in the art world. By altering the scale and media in ways that he judged as still related to the core conceptual consistency of bare necessities, B was able to expand his conception about what kind of work could be included in his creative vision.

In other cases, artists shifted their perception of the core consistency itself as they incorporated new elements. Polly Apfelbaum told me that she identifies primarily as a painter, even though there were no paintings—strictly speaking—in her studio. She used this designation, she explained, broadly to include not only surfaces that she painted but also printed fabrics that she cut and arranged into patterns on the floor. She had just returned from a yearlong artist residency in Rome and was now in a period of reassessing her work.

During her residency, she had begun making painted ceramic beads, initially conceiving of them as jewelry. But now she had started thinking differently about the beads. Polly stated:

> When I came back to New York, I said, "Oh, is there a place for these beads?" And then I started making my own beads . . . the way I had in my studio in Rome. So, how do I make these beads fit in? Conceptually and formally . . . I think, "Well, this is interesting. Why is it interesting? Is it interesting as far as a connection to my work?" And then I will think after the fact, and during. Always, as if I could turn it off . . . I know that there are patterns. And I think you are attuned to the patterns of how you work and the way you work and your fingerprint, your this, your that. And it's really important, almost your pulse. What makes you?

To incorporate the beads, Polly needed to see them not only as interesting but also as relevant to her "fingerprint"—her creative vision. To resolve her ambivalence, she enlisted the help of her peers, whom she invited for studio visits. She explained, "People were saying that the beads looked like they just popped off. I was making little circles, they looked like they just popped off . . . like a little drop of pigment. So I liked that I could make them into painting again . . . but a lot of this is after the fact." While Polly typically made the beads alone, the process was not completely solitary or asocial, as others helped her make connections between the new works and her creative vision. She used the feedback to conceptually transfigure a new medium—ceramics—back into painting, enfolding this element into her creative vision. In doing so, she further broadened her definition of painting itself, a parameter in her creative vision, thereby expanding the set of possible solutions for making an element relevant.

Artists change their creative visions when they incorporate new elements and conceptualize the connections between these elements and their creative visions. Often, the impetus to incorporate new elements comes from opportunities to present their work in new social contexts, such as artist residencies, themed group exhibitions, and site-specific exhibitions and commissions. Artists also elicit new elements through their own investigations. They make repositories of images from the internet, take photographs, rip out pages of magazines and newspapers, and collect found objects that they encounter. They use art historical references from past and present artists, following other artists on social media, attending exhibitions, and collecting art books. Some gather materials from more ethereal sources. One artist described how he kept

a pad of paper by his bed to record ideas that came to him in dreams. Another recounted using images that he had hallucinated by ingesting peyote, a psychoactive cactus.

Source materials do not filter unmediated through artists as if artists are sponges. Artists' perceptions of their identities—not only as artists with distinctive visions but as multifaceted people more broadly—influence their aesthetic commitments and interests. While artists' works cannot be reduced to their demographics, many artists conceive of race, gender, religion, political leanings, and other social categories as prominent themes in their work. Female artists often described gender, sexuality, and feminism as central influences. Similarly, artists of color frequently discussed elements of national and ethnic heritage, colonialism and slavery, racial inequality, and social justice as key themes.[12] Artists overwhelmingly identify as politically liberal.[13] When I returned to artists' studios after the 2016 presidential election, many had begun more explicitly including political elements.

In other cultural fields, creative producers make work that reflects their broader senses of self. For example, academics produce written work that they view as befitting their interests, commitments, and political leanings.[14] Similarly, chefs work to produce dishes that they perceive as coherent with their idealized images of themselves, because they place value in that type of cuisine, want to feel like authentic creatives, and wish to live up to their customers' expectations.[15] Depending on the status and reputation of their restaurants, chefs use ingredients that they view as associated with higher-status or lower-status dishes and contemporary or traditional styles of cooking. When chefs change restaurants, they adapt their cooking accordingly. In doing so, they produce dishes that they perceive as aligned with their positions in the broader culinary field.

Contemporary artists' perceptions of their identities influence how they produce their works. However, their creative visions cannot be described as mere collections of broad social categories and artistic genres that reflect their perceived identities and commitments. Instead, artists identify with more specific bundles of elements—such as socks, snail lines, or the idea of mass production—through the process of repeated experimentation. Artists emotionally react to and evaluate unexpected results, and they use the results to conceive of other possible variations. After producing these iterations, they look back upon these works and associate these consistencies with their bodies of work. Their works are shaped by their perceived identities, but also impose themselves onto their identities in ways that they cannot foresee.

THE CREATIVE CYCLE

When B Wurtz painted "Three important things: 1. sleeping 2. eating 3. keeping warm," on a canvas in 1973, he had not thought that he would spend the next four decades exploring the idea of bare necessities. As he pursued various iterations of this element, the conceptual element of bare necessities branched off in unexpected directions, and he continued to develop multiple series loosely related to this theme. B often looked back on his body of work, which was scattered in digitized images, sketches, notes, and unsold works tucked into bookshelves and hanging on walls around his house. His retrospective exhibition at Metro Pictures in 2011 allowed him to simultaneously view many of his works—those that he and Matthew Higgs, who curated the exhibit, judged to be the most significant to his creative vision. This experience reinforced his perceptions of the formal and conceptual consistencies composing his creative vision. B experimented with new materials, such as the pink plastic toy, based on his perception of what could be potentially relevant to his creative vision without being repetitive.

During the creative process, artists must stabilize two kinds of uncertainties in order to choose from infinite possibilities for source material, decide what to do with these materials, and assess the results. One kind of uncertainty is material: Artists can never completely predict the results of experimentation because materials react in ways they do not expect and because they are not fully conscious of their creative decisions before they make them. To lower the cost of uncertainty, they use low-stakes experiments to test variations. As they repeat certain variations, they build creative competencies, reducing the level of uncertainty for certain elements. The other kind of uncertainty is evaluative. Even when artists can adequately predict the results of experimentation, they must aesthetically judge these results in a field that lacks consensus as to what constitutes good work. Artists rely on specific emotions that arise during the creative process to interpret what is relevant and interesting in the context of their specific bodies of work.

These material and evaluative uncertainties are linked. Artists reduce material uncertainty through repetition, and, as they recognize the resulting consistencies, they perceive these elements as relevant to their creative visions. They place value on having distinctive creative visions, so they are motivated to maintain these elements in future works. Through this process, they reproduce formal and conceptual consistencies and come to view these consistencies as increasingly significant to their creative visions. Artists select new

source material that they test through low-stakes experimentation. By experimenting with variations, they decrease certainty in material results, allowing themselves to be surprised by results and to evaluate novel elements as interesting. As they then repeat some of these new elements, their view of what is relevant to their bodies of work changes. Certain elements that may have once seemed irrelevant become relevant. Centrifugal and centripetal forces drive the creative cycle as artists toggle between concentrating and evolving their bodies of work.

Artists draw upon their emotions to manage these uncertainties. In recent decades, social scientists have come to appreciate that emotions are central to decision-making,[16] but have yet to specify how particular emotions lead to different artistic decisions during the creative process. In cultural fields in which experimentation occurs in a collaborative environment, such as jazz bands, restaurant kitchens, or scientific research groups, social interactions during the creative process can generate emotional energy, leading to breakthroughs and innovations.[17] For example, interactions within tight-knit scientific communities elicit enthusiasm, heightened attention, and trust—moments of emotionality that allow scientists to conceive of and pursue novel ideas.[18]

In cultural fields in which producers are alone for much of the creative process, such as contemporary art, artists' emotions are also powerful influencers of aesthetic judgments.[19] Artists react to the evolving material results of their work.[20] Emotions are shaped by the degree of predictability and the perceived relevance of their material results. Artists feel ambivalence when they are surprised by an element but unsure of this element's relevance to their work, and they temporarily suspend these works until their emotions shift. Artists experience sparks of excitement when they are surprised by an element and judge this element to be relevant to their bodies of work. They reproduce these elements in future works. When artists judge the results of experimentation as too predictable, excitement can sour to boredom. The work is still relevant, but it is no longer interesting.

In the absence of objective or universal criteria for evaluating their work, ambivalence, excitement, and boredom serve as fulcrums for aesthetic judgment. Artists may experience emotion, like excitement, and then seek to connect the new element to their creative visions in order to make sense of the emotion. Alternatively, artists may intellectually identify an element as relevant and feel excited because of this recognition.[21] While artists usually narrate the experience as the former, in either case, artists associate the emotion (ambivalence, excitement, or boredom), the evaluation (interesting and/or relevant), and the artistic decision (pause, repeat, or abandon) with one another. Emo-

tions provide a charge, an affective motivation that gives direction and force to the artistic decision. The evaluation of relevance and interest offers a justification for the decision, which gives the decision staying power. Artists lean on this justification to make sense of why they paused, repeated, or stopped producing a particular element. In doing so, they articulate to themselves and others who they are as artists and what is important to them. Through emotion and evaluation, they both create and interpret their creative visions.[22]

Artists' perceptions of consistencies and variations within their bodies of work are key evaluations in the creative process. But to more fully understand how artists produce their work, we must explore how the reception of their work—specifically, audiences' perceptions of creative visions—affects the creative process. This requires leaving the studio behind to follow artists' works to galleries, art fairs, museums, and collectors' homes, where the work encounters larger audiences. These audiences perceive changes in artists' bodies of work over time and also interpret consistencies that allow them to look at a work and say, "That's a Pollock," or "That's a Wurtz." Their understandings of artists' creative visions affect how they exhibit, review, and collect artists' works. As these viewers communicate their interpretations to artists, their evaluations penetrate the solitary world of the studio.

CHAPTER 4

Interpretive Guides:
Exhibiting Work and Shaping Meaning

I stood in the main exhibition space of Half Gallery, an Upper East Side gallery on the second and third floor of a building accessed through a narrow alley. The gallery's dealer, Bill Powers, had invited me to observe the installation process of Ginny Casey's exhibition, which was opening in just a few days. Ginny knelt on the floor over an upside-down canvas, which she had removed from its stretcher to fit up the gallery's staircase. She was in her thirties, with a short ponytail of pink hair, a plaid shirt, and jeans covered in white dust. She described how the painting had ended up as part of the exhibition:

> The painting is different from the rest. I was going to have it in a show last year, and then it ended up not being in that show. It just didn't fit well with the others. I was adamant at first about it not being in this exhibition, but then after it was explained to me over and over [by Bill and his assistants], I started to see it through their eyes. So now it is going over there.

She pointed to a wall. Unable to see the face of the painting, I asked Ginny why she had thought that it did not belong in this exhibition. She explained that the painting, which pictured a chair and a metronome in front of a door, differed in its imagery from the other paintings in the exhibition. The works already hanging on the walls were surrealist oil paintings, featuring strangely shaped vessels and mangled looking keys in front of landscapes of muted blues and browns. The exhibition was titled "Skeleton Key."

"Well, the show has this image of the keys and the vessel, but then also I

think it is good that it is a little different, so it isn't just keys everywhere," she laughed.

Out of the millions of works in artists' studios throughout New York and around the world, a comparatively minuscule number trickle into one of the city's hundreds of galleries. Bill had an endlessly unfolding menu of artists from whom to choose—artists who were hungry for exhibition opportunities. The simple presence of Ginny and her work in the gallery seemed to be a small miracle. Why Ginny Casey, and why this painting, one that Ginny had initially resisted exhibiting? How did Bill understand and communicate the value and meaning of the painting and Ginny's broader creative vision?

Dealers play a double role in the art world: gatekeeper and supporter. As gatekeepers, dealers select artists and their works. Like all cultural intermediaries[1]— those who choose which creative works to distribute, such as book agents, television network programmers, and record label executives[2]— dealers' decision-making is uncertain. Dealers cannot know for sure that the works they exhibit will sell or even if these works are any good, as there is no objective "good" or "bad" upon which to rely. However, to do their jobs, they must pick the few out of the many. Dealers act as gatekeepers not only for collectors but also for other intermediaries in the art world: museum curators, who usually exhibit the work of artists who are already represented by galleries, and critics, who review exhibitions in galleries, museums, and other art institutions.[3] As supporters, dealers work to promote artists' bodies of work and communicate the meaning of artists' works to multiple audiences, such as other artists, critics, curators, and collectors. They choose works that they believe will resonate with these audiences in different exhibition contexts, and they express the meaning of artists' works through press releases, catalogs, and informal conversations.

How do dealers decide which artists to represent? How do dealers and curators communicate the meaning of artists' work to viewers? How do critics, whose job it is to interpret exhibitions, explain this meaning to their readerships? Dealers choose artists whom they perceive to "fit" with their galleries' programs in terms of aesthetic focus, peer networks, and status. They reinforce each gallery's distinctive but loose aesthetic sensibility—the gallery's own creative vision. Dealers and curators also work to create cohesive understandings of artists' creative visions among their viewers by showing work that they view as more or less representative of artists' creative visions, depending on the audience and exhibition space. Critics can reinforce or contest these portrayals of artists' creative visions through their own evaluations of exhibitions.

FINDING FIT

Half Gallery's dealer, Bill Powers, was in his early fifties but looked considerably younger in red Converse sneakers and a puffy jacket. He offered to show me the rest of the exhibition, which was on the upper floor of the gallery. I followed Bill up a spiral staircase into a second room full of Ginny's work, where we sat on the floor next to a rolled-up painting. In Bill's telling, Ginny's career was something of a Cinderella story. A few short years ago, Ginny had been working as a part-time art teacher at a local YMCA, and Bill had never heard of her. Bill did a studio visit with an artist named Ridley Howard, who was one of the cofounders of an artist-run gallery in Brooklyn, 106 Green. Ridley invited Bill to the gallery. Bill said he would go "sometime," not really thinking he would, until several months later when he happened to find himself a block away and decided to stop by as a professional courtesy. The gallery was exhibiting Ginny's works, and, as Bill described, something about them immediately struck him. Like many dealers, Bill had a small collection of his own. The paintings were relatively inexpensive, and he bought one on the spot. A week later, Ridley sent Bill a review of the exhibition in the *New York Times*. That was when Bill's interest shifted from that of a collector to that of a dealer. He invited Ginny to have a solo exhibition at Half Gallery.

Bill's meeting of Ginny was fortuitous, but not unusual. Dealers generally do not encounter artists through a blind review of submitted portfolios. Instead, they rely on their social networks for recommendations.[4] At an art fair several years before, I had visited Half Gallery's booth. Bill had given me a brief overview, showing me a large painting of a cherry blossom tree by Daniel Heidkamp. One side of the booth featured works by two other artists: small paintings of pastel blotches, which hung behind painted foam sculptures of arches. Bill had recounted how he had come to exhibit the arches, claiming that the painter had told him, "Hey, I would really like to have my buddy's sculptures exhibited alongside my work."

"He is giving his friend a little bit of his heat," Bill had said.

Dealers receive recommendations from curators, other dealers, and collectors, but they rely especially upon artists. They believe that artists have a privileged "on the ground" view of other artists who do not yet have gallery representation.[5] Dealers also want to maintain good relationships with the artists whom they represent by following up on their recommendations. In turn, artists are eager to do favors for members of their social and professional networks of peers, whom they meet through MFA programs, neighboring

studio spaces, artist residencies, group exhibitions, exhibition openings, and gallery representation.

Artists also access dealers by serving as art world "support personnel"[6]—those with jobs related to the production and circulation of artists' works outside of the role of the artist, such as artist assistants, studio managers, gallery assistants, and art handlers. Indeed, before Bill's painter had received "heat," he had worked for seven years as an art handler at Gagosian Gallery. Paula Cooper, a longtime dealer of established artists, described how she often began representing these artists earlier in their careers. Some of her represented artists, like Robert Gober and Justin Matherly, had worked at the gallery as art handlers, while others started their careers as assistants at the gallery. In other cases, artists already represented by the gallery introduced her to their studio assistants, whom the gallery ultimately came to represent. As support personnel, artists build relationships with dealers and with more established artists who can potentially connect them with dealers and curators. The most fortunate support personnel eventually become artists with support personnel of their own.[7]

At an exhibition opening afterparty, a dealer explained to me how social networks operated in the art world. In his analysis, the art world was divided into different "art tribes." There were the "big" galleries, the Gagosians and Barbara Gladstones of the world. Then there were the "vanity galleries"—here he pointed to a man a few feet away playing pool, telling me that the man was a European aristocrat, worth over a half-billion dollars, just "playing with money—not serious." There were the critically acclaimed galleries, like Gavin Brown, Greene Naftali, and Reena Spaulings. There were other circles as well, many more, that I imagined as dense nodes from which spidery lines sprouted in a vast web. He explained that, within each tribe, dealers saw each other as united both by a general aesthetic and also a social scene. He felt a kinship with another dealer because they had both come from middle-class and upper-middle-class families, which qualified as self-made in the money-drenched art world. Despite occasional intra-tribe squabbles, he claimed that dealers generally stuck together and had each other's backs, exhibiting each other's artists in group shows and passing along opportunities for press and sales. Indeed, at art fairs, I had seen other dealers compliment his booth and run over to alert him when an important collector, curator, or critic was on the way. However, dealers withhold information from those in their tribe when they think that it could damage their status. The dealer told me that he had recently made a sale to a collector who had an expensive collection, but he thought the collection

was "shit," so he would not be mentioning it to his peers. They might think that he did not belong.

When considering artists for gallery representation, dealers want to find artists that represent the desired "vibe" of the gallery and that fit in with the rest of the "tribe." Is an artist in question in the heady CalArts MFA scene, in the elite MFA recent graduate cohorts on the East Coast, or in the Berlin art world? Or is the artist a longtime fixture in New York, old enough to wax nostalgic about the way the art world used to be? What kinds of galleries have exhibited the artist's work in the past? Who are the artist's peers? Dealers view their galleries as having an identity composed not only of the kind of art that they exhibit, but also of the kind of people involved.

Beyond social fit, dealers also look for artists who match their gallery's status. Dealer Mark Beckman called me on a Tuesday afternoon. We had recently had a long email exchange about a potential opportunity for Mark to represent two different artists, and he wanted to explain the pros and cons in more detail. Mark felt that the artists had overlapping formal styles that were too similar for him to represent both artists. But he felt that their strikingly different cultural backgrounds imbued their bodies of work with different meaning and aesthetic value. He described the first as a young artist from a wealthy family who was represented by a European gallery, and the second as an older Armenian man, whose family was tragically killed in the genocide. For Mark, the former had a "surface-level" story that translated into superficial works, while the latter's works were wrought with layered meanings and anguished emotion. A sold-out show, he reasoned, required only five to seven collectors purchasing a couple works apiece. A handful of the right collectors could make the reputation of an artist, and, by extension, a gallery.[8] "Good art attracts good collectors," he stated, and good collectors would have a bigger impact on the artist's career. He would choose the Armenian artist, he concluded.

The choice reflected what he viewed as a broader pattern in the art world. Mark claimed that some dealers plucked artists from MFA senior thesis shows at Columbia and Yale, before they had accrued critical reviews or a robust exhibition history. In his view, it was a dangerous strategy. If the artist did not make a "big splash," the dealer would no longer represent the artist. It would be a hit to the dealer's reputation, but worse for the artist, who would be left out in the cold. Mark argued that it was better to choose artists with clout and try to convince a few respected collectors of the work's value.

Across creative industries, credentials, rankings, reviews, prizes, and prices serve as what sociologists refer to as "status signals" or "judgment devices." In the absence of an objective, standardized metric of measurement, people

use these status signals to arrive at reasoned decisions about the quality of creative works.[9] In the contemporary art world, status signals are especially important, as aesthetic value is extremely uncertain and artists' careers are still evolving. Salient status signals include MFA degrees, gallery representation, exhibition records, museum acquisitions, auction prices, critical reviews, and even city of residence, which artists record on their curricula vitae. Dealers look to these status signals to assess the quality of artists' works. They also reflexively judge how artists, dealers, curators, critics, and especially collectors will likely evaluate these status signals in order to predict the long-term impact on the gallery. Dealers appraise status signals differently, based on how they perceive their gallery's reputation. Dealers like Mark may place more value on backing "undervalued" older artists—and will want to show others that this is their priority—while other dealers may take pride in spotting talent early and acting as patrons for artists who have not yet attained critical success.

Importantly, dealers also look to represent artists who fit aesthetically with the gallery's program. Dealer Miguel Abreu explained what he saw as his gallery's aesthetic "value system":

> But in the end, because of your basic disposition, all these people are still kind of talking to each other. They still have a value system that's more or less acceptable for each. But I'd say there's maybe two camps in the gallery. One is very strong conceptual art—conception as a trend that people basically know it for. . . . And then the other, which is crazy things like this [Miguel gestured to a painting on the wall]. Some people think it is expressionism. It's strange, weird, almost surreal. But there is also a conceptual artist, by the way, who used to just work with language and then all of a sudden became a painter. . . . I think there's a consistency to what we do.

Another established Chelsea dealer stated that her gallery was known for the "technical virtuosity" of its artists. Still another characterized his gallery as exhibiting "socially relevant," political art.[10] Dealers described their programs as having one or more consistencies, such as conceptual art and expressionism, that connect their represented artists' bodies of work to each other. When looking for artists to represent, they pursue artists whom they view as relevant to their program's creative vision, just as artists seek relevance to their own creative visions as they experiment with new formal and conceptual elements. While artists' creative visions are composed of consistencies within their bodies of work, dealers' creative visions are made up of consistencies among the

bodies of work of the artists whom they represent and whose work they exhibit. The gallery's program is the dealer's body of work.

There are no professional credentialing programs specifically for becoming an art dealer. Instead, dealers enter the art world through various channels. Some have MFA degrees and were once aspiring artists, others learn the ropes by working for other dealers at major galleries, and still others are socialized even earlier through family members involved in the art world. Accordingly, most dealers are from socioeconomically privileged upbringings.[11] Their upbringings and paths into the art world influence their tastes and social networks. Miguel was a graduate of the CalArts MFA program, and the heavily intellectual style for which the program was known now characterized his own gallery. The MFA program not only nurtured Miguel's own aesthetic sensibility, but also provided him with a network of peers who reflected compatible creative visions, some of whom he now represented at his gallery. As he came to identify himself as a more critically oriented gallery, he worked to attract a collector base that shared this orientation and would be willing to purchase "difficult" work, like video art. Once he developed relationships with these collectors, they reinforced his creative vision, as he looked for artists who would appeal to collectors' tastes and reinforce his reputation.[12] As the dealer of a Chelsea gallery said of a particular artist whose work was currently being exhibited at the gallery: "Her work fits with the gallery. . . . I knew that my fellow directors and dealers at the gallery would likely have clients for the work. I mean, that's gotta be criteria number one."

Dealers' creative visions are not static. Dealers add and remove artists from gallery rosters (either of artists' own accord or because dealers decide to stop representing them), and artists' bodies of work evolve. Dealers do not want to represent artists who look too visually similar, as shown with Mark's dilemma regarding which of two artists to pursue. These artists would risk appearing less original, and the dealer's program may seem to lack dynamism. Miguel stated, "Each artist had to be a vector, right? And as intense as possible. And the next artist couldn't be a derivative or a variation of the same thing, right?" Furthermore, dealers sometimes represented artists that they viewed as likely to enhance their status or as a good social fit, even when these artists' creative visions were not as closely aligned with the gallery's program. As a result, dealers' programs do not have totalizing aesthetics, but instead looser constellations of consistencies one may better describe as "leaning toward" a particular perspective or aesthetic.

Dealers and artists alike characterized their relationship with each other as "marriages." And yet, like many romantic relationships, these unions did not

always end happily. An artist explained how his relationships with three galleries had disintegrated before he found a gallery with which he felt satisfied. In his telling, the first had been a poor aesthetic fit. The dealer had represented him primarily at the behest of the artist's friend who was one of the gallery's best-selling artists:

> I really wanted to show in his gallery. And [my friend] wound up forcing his dealer to take me on. And it just—it wasn't a good fit because that guy didn't choose me himself. . . . If the person feels like they've been pushed, every small interaction you'll have with that person, they'll remind you in a small way. Like—"Well, this really didn't fit, but I did a favor for my friend and that's why you're here"—kind of thing.

After leaving that gallery due to the dealer's perceived disinterest in his work, the artist had fumbled a relationship with a second gallery (by his own account, he had behaved inappropriately). Eventually, he landed at a third gallery. This time, he found the gallery to be a bad status fit. He stated, "It will never have a good reputation. . . . And they have the money to have a place [in New York], but they don't have the vision to bring together a stable of artists that mean anything in New York." He perceived the new dealers to be unable to attract respected artists because they had money, but not critical acclaim.

In dealers' view, marriages with artists sour when artists do not produce work that dealers like or can sell, or when artists regularly misbehave, as described in chapter 2. Artists perceive these marriages to turn when they view dealers as insufficiently promoting their work, either by not prioritizing artists' work or by lacking the social networks and status to effectively publicize it. Marriages are prone to failure when at least one party sees the marriage as incompatible in terms of aesthetics, status, or both. But while marriages last, it is dealers' job to actively promote artists' bodies of work by communicating artists' creative visions to multiple audiences.

THE FOUR PILLARS OF SUCCESS

Still sitting on the floor of Half Gallery, Bill told me that he would walk me through his strategy for advancing Ginny's career. He launched into a monologue, beginning from Ginny's first solo exhibition at Half Gallery. He referred to the exhibition as her "first New York solo show," given that her previous exhibitions had been in Brooklyn, where many collectors did not often venture. Bill recounted that the exhibition was a moderate success on some met-

rics, and a major success on others. He sold maybe half of the works—"not a run"—but the show earned a positive review from *Art in America*, a prestigious art magazine. The review led to a two-person exhibition at the Institute for Contemporary Art in Philadelphia, which received a review from *Artforum* that included both text and an image of one of the paintings. Bill applied for a solo booth at New Art Dealers Alliance (NADA) Miami, a fair for emerging dealers, where he piqued collectors' interests by telling them that he could sell them Ginny's work on the condition that they were willing to lend it to a major museum exhibition.[13] At NADA Miami, Bill sold several works to an art adviser and to a collector who was a board member for the New Museum. He also attracted the attention of Nino Mier, who wanted to have a solo exhibition of Ginny's work at his gallery in Los Angeles, consigned through Half Gallery.[14] A prominent artist and another museum board member purchased works from this exhibition.

That took us to where we now sat, installing Ginny's work for a second solo exhibition at Half Gallery in April 2018. Over the last two years, her larger paintings had increased in price from about $5,000 to between $16,000 and $18,000. Ginny was not a superstar, nor was her career trajectory cemented in stone, but she was doing well. Bill estimated that she would take home about $100,000 in sales that year.

"So," Bill concluded, "it goes back to the four pillars I've been telling you about." Bill had discussed his "four pillars" strategy with me in previous conversations. He enumerated the pillars on his fingers, giving examples of each. First, artistic support—selling works to artists, such as Brian Calvin and Jonas Wood. Second, critical support—the *Art in America* and *Art Forum* reviews. Third, institutional support—the Institute of Contemporary Art exhibition. (Bill noted that he also counted the sales to members of museum boards here, given their influence in museums' acquisitions and exhibitions: "It's not exactly the same, but kind of in a behind-the-scenes way.")[15] Fourth, commercial sales to collectors.

While other dealers arranged the pillars in slightly different ways, they generally agreed that they should work to garner not only commercial sales to collectors, but also critical support from critics and curators. Dealers simultaneously orient themselves toward multiple audiences, including other artists, critics, curators, and collectors. They hope that each audience will promote these artists in their own way—by connecting artists to new exhibition opportunities, by reviewing exhibitions in art magazines and newspapers, by exhibiting or acquiring work for museum collections, or by purchasing work for private collections. Without any one of these pillars, dealers fear that artists'

careers may wobble. Playing to multiple audiences helps dealers mitigate the uncertainties of both commercial and critical success.[16] Dealers use a "throw it up against a wall and see what sticks" strategy. If an exhibition does not receive a review, perhaps it will sell well. If it doesn't sell well, perhaps it will receive a critical review. If it doesn't receive either, perhaps it will attract attention from curators and other artists. Any of these pillars could, in sometimes unexpected ways, buttress the other pillars in the future.

Across cultural fields, sociologists typically view creative producers—such as novelists, film producers, and musicians—as having two possible career paths: critical and commercial. Critical success is marked by the validation of those who are positioned as experts or connoisseurs within the field, while commercial success is determined by the endorsement of the mass public. For example, film directors who win Oscars and garner positive reviews are seen as critically successful, while those who make blockbuster films are perceived as commercially successful.[17] Although directors can be seen as both critically and commercially successful, they often encounter a tradeoff between critical and commercial success, where critically acclaimed films lack appeal to mass audiences and directors of commercially successful films are pegged as "sellouts."[18]

In the art world, while some artists and dealers have more critical prestige and others have more commercial success, there are not two discrete career paths. Even different audiences cannot be neatly segmented into critical audiences or commercial audiences. Museums—where ticket sales actually do matter—sometimes have "blockbuster" exhibitions to appeal to mass audiences.[19] Collectors themselves may be seen as more commercially or critically oriented. Very high-status private collections rival those of some museums and confer similar prestige to artists when such collectors purchase artists' works.[20] Furthermore, dealers are not oriented to a mass audience. Artists' commercial success depends on getting a relatively small number of works into the hands of select collectors and museums. Finally, critical and commercial success can buttress one another. Collectors consider markers of critical success, such as reviews and museum exhibitions, when deciding which works to purchase. For example, artists who win the Turner Prize, awarded annually to a contemporary British artist, enjoy accelerated commercial success.[21] In turn, commercial success affects critical prestige. Collectors sit on museum boards where they quietly influence which works museums exhibit and acquire.[22]

Dealers try to draw the attention of multiple audiences in order to make sales while maintaining their statuses. They also work to mold these audiences' interpretations of their artists' creative visons by exhibiting work and

explaining the meaning of this work in written descriptions and informal conversations. In fairs, dealers primarily concentrate on making sales, while in brick and mortar gallery spaces, dealers are oriented toward collectors as well as curators and critics. As dealers attend to different audiences, they work to either reinforce what they view as core consistencies of artists' creative visions or expand viewers' perceptions of artists' creative visions.

THE WHITE CUBICLE AND THE WHITE CUBE

Mark Beckman called me again a couple of weeks before Art Basel Miami. He was exhibiting work at a satellite fair, and I would be attending the fair and helping in Mark's booth. Most galleries only showed one artist in the cramped white cubicle allotted to them by fair organizers, but Mark had decided to make a small group show, with several works from each of four artists whom he represented. Mark wanted to give me some talking points to memorize: one artist's exhibition had been named by *Artforum* as one of the best shows of the year, two artists' works had been purchased by major collectors, and another artist was receiving a national prize.

"Sounds like an academic conference," I joked.

"No, that is more about the idea," Mark replied, "This is more about adulations and accreditations."

Dealers can spend into six digits in fair fees, art shipping, and travel and staffing costs for each fair, which lasts only a few days.[23] Most galleries go out of business within a few years, and dealers have cited the rising costs of attending fairs and the proliferation of fairs as contributing to gallery closures.[24] Dealers cannot afford to opt out of fairs, as they make around 60 percent of their total sales at the several fairs that they attend each year.[25] In this relentlessly mercenary environment, dealers rivet their attention on collectors and compete for collectors' gazes.

During the course of gallery exhibitions, each of which were installed for up to two months, a prospective collector might visit the gallery up to four times before making a purchase, and he could have a longer conversation about the meaning of the work and situate the exhibition within the artist's larger body of work. The fair setting, Mark asserted, was completely different. Time was winnowed down to minutes and decisions reduced to snap judgments. Mark explained that he focused more on meaning when talking to curators and critics, even at fairs. He perceived that collectors wanted to feel like part of the current cultural "dialogue," like curators and critics, but needed more

"help" when selecting works. "How do you make them feel important within the space of two minutes?" Mark asked.

Mark believed that citing his artists' accolades made collectors feel more confident that the artists would continue to be prominent in the art world and that, by including these artists in their collections, they too would continue to be part of the conversation. Talk of meaning was secondary in the fair setting; when it occurred at all, it was fired off in bullet points. But dealers know that they will not get to deploy their bullet points unless they can get collectors to turn and pause. Ultimately, in the splash and pizzazz of the fair, images take precedence over words. Engaging in aesthetic one-upmanship, dealers work to go bolder than neighboring booths, exhibiting works that are large and bright or provocative in content. The fair becomes a visual cornucopia, with booths transformed into neon and glitter spectacles. Dealers often use the booth itself as a prop to add drama to the display, painting the walls in colorful prints, carpeting the floors, or, in one case, crisscrossing the space with clotheslines of dangling socks.

Dealers also try to stand out by exhibiting work that is most widely identifiable by their breadwinning artists. As Jane Cohan, a dealer at the established James Cohan Gallery, explained:

> We are particularly finding that with the art fair, with the very quick cycle of art fairs and the fact that generally at a fair you might just have one work by an artist. So you need that work to have some signature qualities to it so that it can be recognized—you know, if an artist has a reputation—so that it can be recognized for that. Art fairs are really bad places to introduce new—although we have been successful—new bodies of work that might move away from some of those qualities that make them recognizable.

Dealers privilege sought-after artists' iconic works—works that they view as including the core consistencies of artists' creative visions and therefore most representative of these visions.[26] They view this work as most saleable and most likely to draw collectors into their booth. As fairs are widely attended by collectors and the majority of gallery sales are made at fairs, dealers' practice of exhibiting iconic works of breadwinning artists significantly increases the visibility of these works and these artists' economic success. Iconic images also travel via analog and digital media, as dealers send physical postcards and digital press releases and images of the works to collectors who patronize their galleries so that these collectors may reserve works in advance of fairs and gallery exhibitions. When these works sell, they move into collectors' homes where

they are exhibited in rotating displays viewed by collectors and their guests. In this sense, dealers do not merely choose the iconic—they make the iconic.

In their brick and mortar, "white cube" gallery spaces, dealers tend to exhibit work that they view as most representative of artists' creative visions for artists' first solo exhibitions or their first solo exhibition in a certain geographical region. A dealer from an established Chelsea gallery gave an example of an artist who had initially wanted to present a new series in his upcoming exhibition, one that departed from his iconic work:

> I had this artist recently working on this museum show, and he hadn't shown in this particular region before, and we had a conversation about how he wanted to try a whole new body of work. But I thought maybe the work that he has really honed and that is really kind of central to his practice might be the work that he wants to focus on in the show in a new region. Because he is used to his work, but it hadn't been seen so much in that part of the world. . . . It's just a conversation about audience and about what would be most appropriate for them.

Had many of the viewers already been well acquainted with the artist's creative vision, she reasoned, the gallery could have presented the newer work as evolving from this creative vision. However, for many exhibition-goers in this new region, the exhibition would be their first contact with the artist's body of work. They would have no foundation for contextualizing the new series as part of a broader creative trajectory. She did not want to muddle collective perceptions of the artist's creative vision, should the new audience mistakenly interpret new variations as enduring consistencies.

Dealers privilege iconic works in artists' first solo exhibitions and first exhibitions in new regions, but they do not always or only choose iconic works. They use gallery exhibitions to introduce variations in artists' bodies of work. After Bill and I finished discussing his strategy as an art dealer, we stood in front of the paintings in the upstairs gallery. Bill explained what he perceived each painting to mean—the relationships among objects, the choice of color, the sense of humor. The largest work featured a wooden chair with a jacket hanging over the back. Two large blue hands protruded from the sleeves, although the rest of the body was absent. A small table sat next to the chair with a diary on top, and an oversized key lay on the floor.

I asked Bill how he and Ginny had decided which works to exhibit, and Bill said:

FIGURE 4.1. Ginny Casey's *Diary of a Chair*. Photo courtesy of Martin Parsekian and Half Gallery.

I always tell the artist, "We work for you." They have the final say. But I saw that work, and I thought it was a good idea. I liked how it had the clock and the chair, which are domestic like the keys and vessels [in the other paintings], but also different. I wanted to have some variation. I also liked that there were two images in each.

Bill and I headed back downstairs. Ginny and a gallery assistant had finished putting the painting back on the stretcher and had hung it on the wall, so that it confronted the viewer immediately upon entering the gallery. We stood in front of the painting, entitled *Keeping Time*. It pictured a neon green chair

F I G U R E 4.2. Ginny Casey's *Keeping Time*. Photo courtesy of Martin Parsekian and Half Gallery.

facing a giant ticking metronome in front of a purple wall and door. Ginny asked me if I thought it worked with the others.

"I like it," I said. "The green color makes the chair look like it is vibrating."

We discussed other works in the room and then circled back around to the painting with the green chair. Ginny looked slightly ambivalent and explained that she was moving away from neon, the "plastic" colors she could get from acrylic paints, and toward more muted tones and sharper lines. She had also begun to use oil paints, a slower medium due to the paint taking longer to dry.

After we finished discussing the work, Ginny and Bill went upstairs to view

the rest of the exhibition. Bill turned to Ginny and thanked her for adding the painting with the green chair.

"I didn't want to pressure you," he said, "But I just felt like it needed a little bit of variety."

Without the painting, Bill viewed the exhibition as too consistent. He did not want critics, curators, and collectors to see Ginny's work as lacking evolution and he wanted to appeal to collectors who might prefer different works. Bill was also looking toward the future. Before Ginny's exhibition, he had explained to me his strategy of exhibiting another artist's work. The artist, Nathaniel Mary Quinn, primarily worked by collaging paintings of faces, but was beginning a new series, consisting of sculptures of home exteriors. Bill exhibited one of the sculptures alongside the collages, telling me that he was leaving "breadcrumbs" for the viewers. When people asked about the sculptures, he could describe the conceptual connections. He had also produced a catalog, and at the next exhibition, he planned to use it to show that the series was a long-term endeavor, rather than a whim, and to further discuss the consistent conceptual threads between the series. By introducing variation within an exhibition, Bill hoped to show viewers that the body of work as a whole was coherent.

Curators have somewhat different concerns than dealers, as they are not directly involved in sales. Artists often use museum exhibitions to produce works that deviate from their iconic work or would be physically difficult to collect, such as large installations or work in "non-archival," decomposable media. Curators choose artists and works that they can legitimate as having art historical importance. Paulina Pobocha, a curator at MoMA, explained how she helped select works for Mexican artist Gabriel Orozco's retrospective exhibition. Gabriel Orozco is an established artist, but not a household name, and Paulina expected that most viewers would know little about his work or career. Paulina described her curatorial role as being a "translator." How could she distill a complex and sprawling body of work into an exhibition that would be meaningful and legible to those who had much less exposure to the artist's work? She had spent years studying Orozco's work, and the process of getting to a "checklist" of works to include in the exhibition took months.

Paulina described why she had thought it vital to include a work entitled *Yogurt Lids*, which was composed of a room with four yogurt lids, each placed in the middle of an otherwise empty wall. The work had originally been shown in 1994 at Marian Goodman Gallery as the only work on display at the gallery. It was Gabriel Orozco's New York debut, at a time when showing the work of Mexican artists was even rarer than it is today. On the heels of an economic

recession, mounting a basically unsellable show—as the one work was made of mundane objects—subverted audiences' expectations. Paulina stated, "This was a pretty radical gesture at the time. There was a lot of attention, a lot of press around it, and it was one of the exhibitions that really made him who he is as an artist. The work is essential to understanding his body of work, his character as an artist, his significance as an artist." In a later conversation, Paulina explained that *Yogurt Lids* was not necessarily Gabriel Orozco's most known work, but that it "laid out the conceptual concerns driving his practice at that particular moment of time." As a work that she felt was representative of a particular period—both in the artists' trajectory and in the social milieus—*Yogurt Lids* helped her tell a visual story about the artist's evolving creative vision.

In the end, the exhibition comprised both more and less iconic works. Paulina said, "You don't want it to be the only greatest hits. But the greatest hits are those for reasons, so you would want to include them, but you tell a richer story by including lesser-known objects." As the selection of *Yogurt Lids* reveals, iconicity is rooted in time. Artists have different elements that can emerge as iconic as their work evolves. Furthermore, iconic elements can be either formally or conceptually representative of artists' creative visions. Iconic elements are also subjective. For Paulina, *Yogurt Lids* was an iconic work of a certain period, but the work was not his most widely known. Curators, who decide which works to exhibit and frame the meanings of the works in catalogs and the text on museum walls, have more influence than the casual viewer over what other audience members will come to see as more or less iconic. Framing *Yogurt Lids* as an essential work helped make it an essential work in the eyes of museumgoers.

As in the case of fairs, gallery and museum exhibitions are accompanied by written and verbal statements about the meaning of the works, which I call *style scripts.*[27] Style scripts include press releases, artist statements, catalog text, and informal conversations. Dealers circulate press releases for each exhibition by publishing them on their websites, emailing them to their mailing lists, and leaving printed copies at the gallery front desks. The press release usually includes an image of one work in the exhibition, followed by a written interpretation of the exhibition and the artist's larger body of work, with a final paragraph enumerating the artist's key accolades. Half Gallery's press release of Ginny Casey's exhibition read:

> "Skeleton Key" marks Ginny Casey's second solo exhibition with Half Gallery since her September 2016 debut. The title makes reference to the master key

of fantasy and lore, but also the strange biomorphic shapes the artist often employs in her "bulbous, raunchy" paintings as *Artforum* described the work on the eve of her two-person show at ICA Philadelphia alongside Jessi Reaves. Perhaps both women could be regarded as making furniture sculpture, only one of them exclusively in two-dimensional form.

Viewers will note Ginny Casey's interplay between the organic and man-made; however this binary can prove overly reductive. A question of consciousness arises with her new paintings specifically when examining her latest armchair and copulating keys. Whose volition do they operate on if indeed they are animated at all? Does the ribcage—in Beetlejuice fashion—admire itself in front of a full-length mirror? And why are the mirror's feet suddenly hands? Ginny Casey makes such jumps in logic a natural perversion. An *Art in America* review from her first Half Gallery exhibition noted the apparent influence of Phillip Guston, Giorgio Morandi and Milton Avery.

Ginny Casey has exhibited at Nino Mier Gallery in Los Angeles and at 106 Green in Brooklyn. She received her MFA from R.I.S.D. where she was a T.A. under Dike Blair.[28]

Part curriculum vitae and part curatorial statement, the press release for Ginny's exhibition emphasized core consistencies in her creative vision. It cited "the strange biomorphic shapes the artist often employs in her 'bulbous, raunchy' paintings," implying with the word "often" that biomorphic shapes were an element that Ginny had employed in previously exhibited works. At the same time, it highlighted new formal elements—the armchair and the keys—and connected these formal elements to the broad conceptual theme of "consciousness." Dealers use style scripts to emphasize which formal elements are most salient and how these formal elements signify conceptual elements. They want audiences to understand which elements make artists' creative visions distinctive, how particular works relate to this creative vision, and how each artist's body of work is important in the broader art historical conversation.

Without style scripts to stabilize interpretation, the value and meaning of art would be too untethered, but dealers also do not want to shut the door to interpretation. I sat in the back of Bridget Donahue Gallery in an irregularly shaped foam chair, waiting for artist Susan Cianciolo to arrive to install her upcoming exhibition, titled "if God COMes to visit You, HOW will you know? (the great tetrahedral kite)." The exhibition would feature works including handmade zines (small-circulation magazines), costumes, and a series of collaged boxes, with various objects inside of them, placed on quilts. Bridget explained to me

that she had struggled to write the exhibition press release because Susan's body of work was so diverse. Writing a press release, she told me, was a difficult task, "You don't want it to be overdetermined: that just sets yourself up for reviewers to be like, 'Well, the press release said this, but that is bullshit.' But also you don't want it to be horribly misinterpreted."

Turning series of artworks into strings of words is a task rife with difficulties. First, many artists do not consider themselves wordsmiths and believe that their work is not reducible to language. An attempt at encompassing the meaning fully in words would make the work seem deceptively facile. Artists and those who exhibit their work also do not want to "overdetermine" the meaning because they feel that this might provoke a negative reaction from others who disagree and may also prevent viewers from making associations that would allow the works to resonate with their own experiences.[29] Furthermore, artists worry that future works might fall uncomfortably outside the neat paragraph that describes the body of work.

Ultimately, Bridget had asked one of her artist friends to write the press release, believing that, as an artist, he would be better positioned to explain the connections. While we sat there, she emailed me the not yet published press release. It stated:

> For the past twenty years, Susan Cianciolo has moved between fields and formats—from fashion to craft, from performance to filmmaking—works presented in if God COMes to visit You, HOW will you know? (the great tetrahedral kite) speak to this restlessness. Cianciolo has produced a body of work that willfully evades categorization, exploiting the false dichotomies of construction and deconstruction, art and design, event and document. This exhibition offers a glimpse into the material flux of an archive being unbuilt in an ongoing and endless process of reformulation.

The press release described certain elements of Susan's work, such as its merging of high and low art forms. However, it also emphasized the difficulty of defining Susan's work, stating that Susan "moved between fields and formats," with a "restlessness" that "willfully evades classification." In other words, Susan's creative vision was characterized by the uncharacterizable.

If the artist's creative vision was everything, then what was it not? It is easy to mock such a description, and press releases in general, as absurdly expansive and vague. For years, *Hyperallergic*, an online arts magazine, published an annual article in which they lampooned the "unpalatable salad" of words in a chosen "worst" press release of the year.[30] Indeed, MFA students and art

historians alike are raised on a steady diet of esoteric theory texts. Their later writings often emulate this style, reinforcing the notorious language of "Artspeak." However, artist statements and press releases also serve as style scripts. Dealers and curators work to draw threads among works, connecting the dots with words, while also not flattening the works through this linguistic exercise. They try to leave room for evolution in the body of work by emphasizing broad conceptual themes that could take on many forms and by indicating how a new series may have changed from a previous series. Moreover, they leave interpretation partially open to viewers by describing work in nebulous terms and by cautioning viewers that even these terms do not adequately capture the body of work.

THE CRITIC'S PEN

Dealers act as key gatekeepers and interpretive guides by choosing artists to represent and using exhibitions accompanied by style scripts to frame the meanings of artists' works. Professional critics then select exhibitions to review, contributing style scripts of their own.[31] As with dealers, there is no credentialing body for becoming an art critic; however, unlike dealers, most critics are not primarily employed as such, but instead combine this role with other occupations in the fields of contemporary art and journalism. In the contemporary art world, dealers, curators, and private collectors generally have more power than critics to confer critical prestige on artists.[32] Nevertheless, dealers highlight positive reviews to collectors, and collectors are more likely to attend an exhibition that receives a positive review from a respected critic (although they argue that they will not buy work on this basis alone).

To understand how critics craft style scripts of exhibitions, I analyzed 377 reviews from the *New York Times, Artforum, Art in America,* and *ARTnews*— four of the leading venues for contemporary art reviews in the United States— which together composed all reviews of solo contemporary art exhibitions in New York City within a calendar year.[33] Among the four periodicals, the *New York Times* is the only one written for a broad audience, while the other periodicals are directed toward those with specialized knowledge of art.[34] Reviews in all four periodicals contained the same themes and structure. However, the *New York Times* reviews were, on average, shorter than reviews in the other three periodicals and devoted a higher proportion of each review to describing the formal qualities of the works; in contrast, reviews in *Artforum, Art in America,* and *ARTnews* apportioned more space to discussing biographical

information, art historical references, the process of producing the works, and the exhibition setting.[35]

How do critics interpret the meaning of an exhibition for their readers? Critics identify salient formal qualities and use these qualities to construe conceptual meaning. Across these four periodicals, they reviewed exhibitions in a wide range of media, including painting, drawing, sculpture, installations, video, and works in multiple media. Almost all reviews portrayed formal qualities in florid terms. Colors were "clean," "saturated," or "proudly wrong" and were affixed to vivid adjectives—"sickly" beige, "acid" yellow, and "smoked" chartreuse. Critics made similarly evocative textural descriptions of texture, shape, line, and scale. They discussed the imagery or composition of particular works in detail, especially when describing paintings or drawings that included recognizable figurative objects. Critic Will Heinrich described Bonnie Lucas' exhibition in the *New York Times*:

> "White Rock," a four-foot-high assemblage, is even more direct: Against a background of gauzy pink clothing and yarn, white gloves and fake pearls, a plush female doll is attached upside down, as if crucified like St. Peter, but on a welter of contradictory demands and impossible expectations. From her spread legs rises a kitschy, thrift-store Easter egg that pictures a sweet domestic scene of anthropomorphized yellow ducks; above the egg rises a blond knock-off of Betty Boop giving a come-hither wink.[36]

Critics discussed artists' processes of producing works, particularly when artists had unusual or technically complex processes and when artists had sustained these processes over long periods. Critic Barry Schwabsky explained Ena Swansea's process in *Artforum*, "Swansea has developed an unusual technique of painting on a graphite-infused ground, which seems to situate everything in a darkly glimmering, indistinct twilit space."[37] Critics sometimes detailed the physical exhibition space as well, stating that the installation was "spare," "densely hung," or "salon-style."[38] They spent more time describing the exhibition space when works were arranged in an unusual way, when an immersive site-specific installation filled the space, or when critics thought that the arrangement of the exhibition deepened the appreciation of the works.

Critics located conceptual meaning in formal qualities. This meaning could be an emotion evoked or affective charge: "The painting's eerie atmosphere derives less from the inscrutable nature of its unspecified underlying narrative than from the disquieting way the artist manipulates the modulations of tone and color."[39] Meaning could also be about the act of perception and relation-

ship among formal qualities themselves: "As much a tool for formal invention as a method of classification, the knot presents a radical challenge to classical sculpture's division between interior and exterior, opening up new possibilities for reckoning with—or even systematizing—surface, form, and matter."[40] Alternatively, meaning could be in regards to a theoretical idea: "A scrupulous document of what might initially seem like nothing much at all, Memory is, in fact, a beautifully plainspoken consideration of the conditions of attention and of presentness—one whose meditation on the fugitive, finespun quality of recollection has only deepened as its particulars have faded over time."[41]

Critics contextualize these formal and conceptual elements by discussing how each exhibition relates to the artist's broader creative vision and how this creative vision is associated with those of other artists. Across the four periodicals, critics described consistencies between the exhibition and artists' previous work:

> A consistent strategy of Erlich's is this skewing and undermining of familiar spaces and places to create a puzzled, giddy sense of disorientation and displacement, often with humor. Audience participation is another trademark, although some installations are more dependent on spectators than others for activation.[42]

Critics also explained how the exhibition marked an evolution of the artist's creative vision by introducing new elements. In the *New York Times*, critic Roberta Smith described Susan Cianciolo's exhibition at Bridget Donahue's gallery: "The artist's signature accumulations of small found objects, collages and improvised artworks, previously presented in boxes meant to be sifted through, are now part of more outgoing displays placed in houselike frameworks dedicated to the activities of the show's title."[43]

Critics contextualized artists' creative visions in artists' broader social and artistic milieus. They referenced artists' biographical information, especially when they viewed the work as influenced by artists' biographies and when artists had lived outside of the United States and Western Europe. As the *New York Times* critic Holland Cotter described Tiffany Chung's exhibition:

> Decades before the present outward flood of people from Africa and the Middle East, there was another newsworthy exodus, equally catastrophic, the one from postwar Vietnam. Almost two million people fled; by some reckonings almost a third died at sea. The artist Tiffany Chung, born in Danang,

Vietnam, in 1969, was among the refugees, and she has made the phenomenon of forced migration her primary subject.[44]

Critics also situated each exhibition in a lineage and network of creative visions. Colors, shapes, textures, or compositions were described as "Matissean," "Duchampian," or "Goyaesque." They cited both similarities and differences between the artist's body of work and those of other artists. For example, Michael Wilson, writing for *Artforum*, described Matt Johnson's exhibition:

> There's a clear echo here of photographs of similarly combined, and similarly prosaic, objects by Peter Fischli and David Weiss, of Jeff Koons's liking for high-end craftsmanship in the creation of mass-market goods, and even of Duane Hanson's eerily believable representations of workaday Americans. But whereas Koons, say, often focuses on gaudy kitsch, Johnson moves in the other direction, toward commonplace but unassuming instances of product and packaging.[45]

Critics made passing mentions of genres, locating artists' work among multiple "references," ranging from broad categories, like Pop and Minimalism, to more fine-grained classifications, such as California Photoconceptualism.

Critics not only interpret exhibitions, but also evaluate them. How do they justify exhibitions as worthy or not worthy of seeing? While artists do not describe their work as objectively good, but as subjectively interesting and relevant with regard to their creative visions, critics do express positive and negative evaluations of exhibitions.[46] Most reviews contained explicitly positive descriptors, and only a handful of reviews were largely negative. Phong Bui, a curator, writer, and cofounder of an arts periodical, the *Brooklyn Rail*, explained to me that he declined to review exhibitions that he disliked, because "it's not interesting to me to spend my time to explain why I'm not interested" and "it doesn't help the artist." Critics claimed to avoid writing many negative reviews because they find it intellectually unsatisfying and they do not want to harm the careers of artists, particularly emerging artists. Furthermore, they are motivated to preserve personal and professional relationships in the densely networked art world, especially given that critics usually wear multiple hats.[47] A critic writing a review for a show in the fall may be curating an exhibition for the same gallery come spring. Within the four periodicals, critics evaluated exhibitions either positively or negatively on the basis of social relevance, artistic

relevance, formal and conceptual complexity, progression of creative visions, and commitment to creative visions.[48]

Critics praised exhibitions that they viewed as socially or politically relevant to contemporary society. Political and social themes, including racism, sexism, homophobia, consumerism, globalization, immigration, and police brutality, appeared in over half of the reviews. Critics unanimously interpreted artists' works through a liberal worldview. They perceived artists' works as potential acts of resistance against the presidency of Donald Trump and conservatism more broadly. As the *New York Times* critic Holland Cotter argued of Anthony Hernandez's exhibition, "The complete series is one of the most moving in contemporary American photography, and is absolutely pertinent to the present moment of debates about immigration and border crossings."[49] Sometimes, they turned their reproach toward the art world itself, characterizing female artists and artists of color as formerly "overlooked" and exhibitions of their work as offering a "timely corrective." However, they took strident issue with works they viewed as failing to express social or political issues appropriately. In *Art in America*, critic Rachel Wetzler argues that Dara Friedman's videos of Native Americans are exotifying: "Though Mother Drum is formally stunning, it unfortunately treats Native American cultures as a single, undifferentiated entity that exists out of time."[50]

Critics also legitimated works that they viewed as relevant to art historical conversations. The *New York Times*' Roberta Smith described Flora Crockett's exhibition:

> They pull together several strands—Surrealism, biomorphism, a prescient Pop Art buoyancy—in ways that almost always seem just right, supported by an unerring color sense and broad knowledge of the various ways oil paint can be applied to canvas. This all seems remarkably up-to-date: Several paintings could easily be from our new century.[51]

In contrast, they censured artists whose works they viewed as unoriginal, perceiving these artists to emulate the works of other artists without progressing the conversation. The *New York Times* critic Martha Schwendener derided Darren Bader's exhibition of sound art, consisting of the sound of a "thrumming drone":

> There are many relevant touchstones for this kind of work: Luigi Russolo's 1913 manifesto, "The Art of Noises," and his concerts with noise-making devices (and speakers); La Monte Young's immersive installations; Glenn Bran-

ca's symphony for 100 guitars or Rhys Chatham's Guitar Army; and all the varieties of heavy-death-black-metal music. Compared with these, Mr. Bader's gesture feels like sophomoric sonic carpet-bombing. It's extreme, but it's not extreme enough.[52]

Beyond social and artistic relevance, critics evaluated works positively when they viewed them as formally sophisticated and conceptually complex. They described works as formally sophisticated when they believed that the works required technical skill to produce and that viewers should spend substantial time examining the formal qualities to appreciate their complexity. As Roberta Smith stated of Louis Fratino's exhibition, "And they are hot too with painterly attention and erudition—inviting a similar scrutiny from the viewer. Nearly every brush stroke and mark, every detail of furnishings and body hair, has a life of its own."[53] Critics lauded works that fell into the "so bad it's good" category when they believed that artists had purposely produced formal qualities that appeared unskilled to some positive conceptual end. In *Artforum*, critic Cat Kron claimed this of Austė's exhibition: "But its sheer offness, its florid bad taste and unabashed disinterest in the conventions of serious painting, remains successfully unnerving."[54]

Critics acclaimed exhibitions that they viewed as conceptually complex, whether the concept was a theoretical idea or an emotional sensation. For example, the *New York Times* critic Martha Schwendener described Joan Wallace's exhibition as "a tour de force of appropriation and feminist critique,"[55] while Barry Schwabsky's *Artforum* review of Ernest Mancoba's exhibition focused on the "energy" emanating from the works: "Individually, however, these vignettes have moments of crackling energy and sensitive texture."[56] Critics argued that exhibitions were strong when they viewed the formal qualities of the work as appropriately representing the concept of the work. In *Artforum*, critic Alex Kitnick praised Heji Shin's photographs of births, asserting that the lens' close focus on the moment of crowning lent itself to the concept of "tortured universality":

Context has been meticulously cut out. We don't feel like we are anywhere really in front of these scenes. Soft focus dissolves rooms and onlookers, such as the doulas, doctors, and nurses. The photographs' white mats and stained-maple frames do some kind of distancing work, too (as do the three crude "political" sculpture-tchotchkes on pedestals that you see when you first walk into the gallery). Minus the specifics, we are asked to confront the horrible

head of being, a kind of tortured universality, not the family but the fuck you of man. Can I say that it might be one of the best shows I've seen in a long time?[57]

And yet, critics did not require the concept to be fully legible for them to view the exhibition as good, but instead conceived of multiple possible meanings as a sign of conceptual complexity or novelty.[58] In *Artforum*, critic Barry Schwabsky said of Marisa Merz's exhibition:

And yet I don't think Merz cares to make anything whole. Imbued as it may be with art's past, hers does not look back. In each of her many marvelous drawings on paper or canvas, crisscrossing lines divide the surface into countless facets that seem to keep reinventing the face as something new, never seen before, and yet recognizable and reassuring of manifold possibilities.[59]

Critics also argued that works were formally or conceptually sophisticated by pointing to the juxtaposition of formal or conceptual qualities, which they viewed as generating a productive tension for the viewer. They highlighted juxtapositions between formal qualities ("explores relatively unfamiliar ground in the gap between abstraction and representation, pushing toward both illustration and pure geometry"[60]) and conceptual qualities ("this meditative but piercing show"[61]).

As critics viewed the formal qualities of work as significant only insofar as they related to the conceptual meaning of the exhibition, critics derided works whose formal qualities exposed a lack of conceptual complexity. The *New York Times* critic Martha Schwendener denigrated Henrique Oliveira's new works as formally sophisticated, but conceptually "vapid":

Unlike revelatory works in São Paulo last year, where wood was implicated in everything from ancient rituals and slavery to colonialism and globalization, Mr. Oliveira's work feels like a slightly vapid curiosity. It might be, as the news release says, a comment on the "disequilibrium of nature and society." Or it might be a handsome woodworking project that showcases excellent craftsmanship, yet lacks the rigor of ambitious art.[62]

Just as critics disparaged works that they perceived to lack conceptual meaning, they also found obvious concepts to be problematic,[63] amounting to what one critic termed a conceptual "clunk on the head."[64] Critic Michael Wilson panned Vik Muniz's exhibition, part of which contained prints of but-

tons, interspersed with actual buttons, "Conceptually, the strategy is so simple as to feel, once discovered, almost offensive."[65]

Critics did not evaluate the formal and conceptual elements of artists' exhibitions discretely, but looked at how these elements related to artists' broader creative visions. They positively evaluated exhibitions that they viewed as productively progressing artists' creative visions. Roberta Smith described Rochelle Goldberg's exhibition as displaying a strengthening of the artist's creative vision by incorporating new elements, while maintaining the valuable elements of the creative vision:

> Never less than ambitious, Rochelle Goldberg's sculpture installations suggestively combine low-lying ceramic forms and organic substances, including moss and chia seeds. With "Intralocutors," her extensive show at the Miguel Abreu Gallery on the Lower East Side, Ms. Goldberg considerably ups the ante, incorporating the figure and cribbing from art history and the Bible. The result is a tantalizing if fragmented narrative rescued from inscrutability by the intensity of its materials, forms and styles.[66]

Critics used artists' perceived commitment to their creative visions to positively evaluate creative visions that they viewed as both expansive and narrow. For example, *Artforum*'s critic Barry Schwabsky argued that Marisa Merz's wide-ranging conceptual interests displayed her willingness to follow her artistic intuition:

> Actually, her work shows the very demand for a "theoretical core" to be misguided. It's Merz's willingness to keep "following my intuition toward intuition" that we can intuit in turn as her fidelity to art's calling.
>
> If Merz's oeuvre lacks a theoretical core, it certainly has a central image or metaphor: the head or face—always female.[67]

The same critic writing for the same issue of *Artforum* argued that Edward Clark's colorful, abstract paintings of thick, horizontal brushstrokes showcased the artist's unwavering fidelity to his creative vision.

> And far from falling into routine, Clark continually wrests unexpected nuances from his storm clouds of color. That he has persisted for so long without losing heart despite, until quite recently, a woeful lack of response from the mainstream (that is, white) art world only makes his sustained tenacity that much more remarkable.[68]

In contrast, when critics view artists as deviating from their creative visions in unproductive ways, they question artists' commitment to their creative visions. In *Art in America*, Rachel Wetzler critiques artist Petra Cortright's move from YouTube videos to large video displays that hung on walls like traditional paintings as a digression from her creative vision:

> Cortright still makes digital videos, GIFs, and other works that live primarily online. But over the past few years, she has increasingly turned her attention to gallery-bound pieces that she refers to as paintings: frenetic digital collages printed on various supports—silk, plexiglass, aluminum, linen—and hung on the wall. . . . Her computer-made versions merely simulate painting, using throwback genres and formats that attempt to convey some link to a grand tradition rather than meaningfully engaging with the question of how visual experience has been transformed by the internet and screens. More cynically, their large scale and nods to past masterpieces, and the frisson of novelty provided by her use of digital tools, make them ideally suited to an overheated market.[69]

The critic argues that the exhibition is at best conceptually vacuous, and at worst the product of selling out to an "overheated market." When critics negatively evaluate an exhibition, they not only judge the work itself to be aesthetically insufficient, but also view the artist as morally suspect. Negative reviews undercut style scripts of artists and those who exhibit their work and, more detrimentally, challenge whether these artists have authentic creative visions at all.

INTERMEDIARIES AS INTERPRETIVE GUIDES

In the run-up to the exhibition opening, Bill posted the images of Ginny's work on both the gallery's landing page and the gallery's Instagram account, which had around ninety-five thousand followers at the time. Attached to most of the Instagram images, he wrote a brief invitation to the gallery opening. One image showed a painting of a chair and table, with a twisted hammer on the table. It was the painting that Bill had purchased for himself, the one that initiated the working relationship between him and Ginny. The accompanying text read: "I bought this #GinnyCasey painting from her first show at @gallery106green (a terrific artist-run space in Greenpoint) February 2016. The hammer reminded me of Lee Lozano and only later I realized that her table echoed the table in Duchamp's Chocolate Grinder."

The exhibition opening was well attended, and, in terms of critical atten-

tion, the exhibition was a success. The *New Yorker* and the *New York Times* both reviewed Ginny Casey's exhibition. The *New Yorker* review stated:

> Imagine a short story by Franz Kafka, illustrated by Gahan Wilson in collaboration with Milton Avery, and you get a sense of this young painter's work. Shadowy blue-green interiors assume claustrophobic dimensions in big square paintings, in which a lime-green easy chair shares the frame with an oversized metronome and a wooden door meets disproportionately large keys. In the show's standout painting, two beautifully rendered blue hands extend from the cuffs of an unbuttoned shirt, which is draped over the back of a suspiciously corporeal chair.[70]

The *New York Times* review read similarly:

> A pocket-size gallery that lives up to its name, Half Gallery shows a solid lineup of young painters who approach the canvas with conviction and a twisted vision. In Ginny Casey's "Skeleton Key," the murky-hued paintings are populated with curvy, vaguely surrealistic objects, like a chair with arms, a metronome the size of an armoire or a key too large for any human's door.[71]

The reviews in themselves were status signals for both Ginny and Half Gallery. Moreover, they reinforced Bill's style scripts of Ginny's creative vision. Both reviews cited the painting with blue hands, the *New Yorker* review proclaiming it to be the "standout" work of the show. This painting was the very image that Bill had chosen to accompany the statement in the press release. The critics also discussed the painting with a green chair and metronome and mentioned the keys as a recurring object. The critics linked together multiple works in the exhibition by citing core consistencies: the "shadowy blue-green interiors," "murky-hued paintings," and "vaguely surrealistic objects." Immediately after the publication of each review, an additional image from the exhibition that was affixed to a quote from the review appeared on Half Gallery's Instagram account. Bill folded the critics' style scripts into his own.

As gatekeepers, dealers like Bill affect which artists' bodies of works become visible to multiple audiences in the art world. Each gallery's creative vision is composed of the formal and conceptual elements that they view as overlapping and salient among their represented artists. Dealers represent artists whom they view as having aligning creative visions, or as serving the gallery in other ways, such as boosting the status of the gallery or fitting into the social scene. In selecting artists, dealers respond to the perceived tastes of the multiple

audiences who attend their exhibitions, especially collectors. For example, dealers choose artists that fit aesthetically with their programs at least in part because this is what they believe will resonate with the particular collectors who frequent their galleries.

However, as supporters of artists' creative visions, dealers also work to create these tastes by acting as interpretive guides for their viewers.[72] They see it as part of their job to educate collectors and the wider public as to which are the core qualities of an artist's creative vision, which qualities constitute a meaningful change in this vision, and how this vision is distinctive from those of other artists. Dealers guide viewers' understandings through their negotiations with artists about which works to exhibit and the style scripts that they pair with these works. Other cultural intermediaries, such as critics, produce their own style scripts. These style scripts can reinforce those produced by artists and dealers. But when critics negatively evaluate exhibitions or emphasize different elements of artists' work, they can challenge these style scripts. By circulating multiple and sometimes competing style scripts, cultural intermediaries negotiate aesthetic judgments and make particular creative visions collectively understood as such.

Works continue to have social lives after they are removed from exhibition walls. Just as we cannot reduce dealers' decisions to the demands of collectors, we also cannot reduce collectors' choices to the interpretive guidance of dealers. Collectors actively work to develop their aesthetic tastes and make choices about which works to collect.[73] To understand how artists' participation in the art world influences their creative decisions and collective perceptions of their creative visions, we must accompany private collectors to the fairs and galleries where they purchase works and travel to their homes, where they display these collections.

Eyes and Ears:
Collecting Work and Maintaining
Connoisseurship

I arrived at the Armory Show, one of New York's two biggest contemporary art fairs, hours before it opened to the general public.[1] I passed the ticket booths and walked toward the VIP entrance. The head of VIP hospitality met me at the entrance, smiling and shaking my hand. Without asking for my ticket, she ushered me into the fair. I was accompanied by Sherry and Joel Mallin, whom the head of VIP hospitality warmly greeted by name. The Mallins were fair-going veterans whose vast collection was housed in storage units, museum exhibitions, and their several properties, including a private home, a fifteen-acre sculpture park, and a ten-thousand-square-foot facility that they referred to as the "Art Barn."[2] The fair organizers provided each exhibiting gallery with a set number of VIP tickets to attend the preview of the fair, which the galleries mailed to their regular clients before the event. Multiple galleries had sent VIP tickets to the Mallins, whom I had previously interviewed, and they had offered me one of their extra tickets.

Sherry instructed me, as if it were my first day on the job, "I always wear sensible shoes. You can tell a serious collector because they are dressed nicely, but comfort comes first. When you see someone wearing heels, you know they are not a serious collector, because they are not going to walk around from twelve to eight in heels." Indeed, below a flattering maroon pantsuit, she wore a pair of functional black sneakers. I was glad that I had chosen flats.

The Mallins seemed to know everyone. Upon entering the fair, throngs of collectors engulfed the couple with kisses on the cheek and familiar greetings. The Mallins repeatedly stopped to chat with their friends. Occasionally, Sherry muttered to me that she had no idea who the person who had just kissed her

was. She had warned me that more people would recognize her than vice versa. Beyond the gaggle of more conservatively dressed middle-aged and older collectors, the crowd rivaled the art with their polka-dotted suits, asymmetrical designer dresses, and spiky stilettos. Finally, Joel exclaimed in good-natured frustration, "I have been here for a half-hour, and I haven't seen anything!"

We started down an endless row of booths. If Sherry had trouble recognizing some of the people, she had no problem identifying artworks from several booths away. As we passed various works, she explained to me which artists' works they owned or what she thought of their recent artistic direction. Every few minutes, we paused to chat with another collector, dealer, or artist, sometimes just to exchange pleasantries and other times to talk business. At one booth, Sherry leaned into the dealer, whispering discreetly, "You should look at this artist. She is looking to move galleries and she mentioned your name." The dealer replied, "I am sure if you say I should, then I should," and she scribbled down the name. Sherry was known for hosting breakfasts at her home during which she paired artists with prospective dealers or collectors.

At the booth for James Cohan Gallery, dealer James Cohan said to the Mallins, "Do me a favor: Next time you go in, there is a sculpture in the back of the gallery. It is very special—I would love for you to see it." James displayed on his iPad a large sculpture by artist Xu Zhen, featuring a Hellenistic sculpture of a woman's body propped upside down on top of a Buddha sculpture. The Mallins had purchased work from James Cohan for years, and James knew their collection well enough to match them with works that he believed they, specifically, would want to purchase.[3]

Passing by booth after booth, the Mallins' potential options seemed overwhelming. The Armory Show housed booths for around 200 galleries, with dealers competing for juried spots. While we attended the fair, around ten satellite fairs simultaneously exhibited the works of emerging artists in other locations around New York. And this was only one stop on the global art fair circuit.[4] The Mallins traveled to several fairs every year, perceiving the fairs as an effective way to see work from many galleries at the same time. Beyond the fairs, they attended exhibitions in galleries and museums every week, visited artists' studios, viewed other private collections, read reviews, and stayed in contact with a host of artists, dealers, curators, and other collectors both in New York and around the world.

No collector can see the work of every artist, but collectors like the Mallins see quite a lot. Collectors sift through thousands of artists' works, choosing a comparatively tiny fraction to add to their collections. How do collectors develop tastes for certain kinds of contemporary art? Among the artists whose

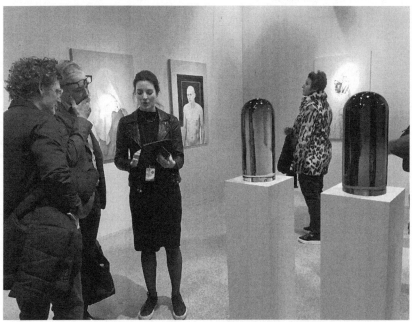

FIGURES 5.1 AND 5.2. Visitors at the 2018 Armory Show.

bodies of work they recognize as aligned with their tastes, how do they select certain works for their collections? Given that aesthetic value is uncertain and subjective, how do they legitimate themselves to others in the art world as "serious" collectors? Collectors do not think about collecting discrete works. Instead, they view themselves as collecting artists' creative visions, while also expressing their own creative visions through their collections. This perspective shapes which artists' bodies of work they select, which works they purchase within these bodies of work, and how they claim status as collectors.

DEVELOPING AN EYE

Months before the fair, I sat in the Mallins' apartment, and Sherry explained to me how she and her husband had started collecting. Both Sherry and Joel attended the Bronx High School of Science, a top New York public high school, and, later, Cornell University. Although they had dated in high school, they went their separate ways in college and each had long marriages with now deceased spouses. Thirty years later, they reunited and married each other. Both viewed themselves as having general predilections for art. Joel, an attorney, had begun collecting surrealist art during his first marriage, and Sherry, a day trader, had a background in dance. However, neither knew much about contemporary art. They enrolled in an art education course that took them to galleries around New York during their lunch hours, and, over time, they became well informed about art history and contemporary art. They began collecting art, starting with relatively low-priced works of emerging artists and gradually purchasing the works of more established artists. Over several decades, the Mallins built one of the premier private collections in the country.

About a third of the collectors I interviewed were "major" collectors who had been listed at least once in *ARTnews*' annual global list of the "Top 200 Collectors," held VIP open houses of their collections during major art fairs, and owned many works by "blue-chip" artists. The others were less widely known and possessed fewer works by highly established artists, although nearly all of them invested a substantial amount of their leisure time in viewing contemporary art, acquired works frequently, and had close relationships with others in the art world. Both groups differentiated themselves from lower-status collectors, whom they called "buyers," viewing these collectors as purchasing work mostly for decoration and as lacking expertise and taste. The collectors ranged in age from early thirties to mid-seventies and almost all were white. They socialized in distinct, but often overlapping, generational social

circles: older collectors were more likely to work in finance, real estate, and business, while middle-aged and younger collectors were usually involved in technology start-ups or had inherited wealth. They were universally affluent.[5]

New York City is one of the world's wealthiest and economically unequal cities: the top 10 percent of households—715,800 households total—have an annual income of over $200,000, while over two-thirds of households live on under $100,000 per year.[6] Given that most wealthy New Yorkers are not involved in the contemporary art market, why do some become collectors? The collectors whom I interviewed discussed three key social influences that put them on the path to collecting and shaped their tastes: their upbringings, mentorship by others in the art world, and relationships with domestic partners.

Most of the collectors with whom I spoke had grown up in or near New York, and they spoke fondly of their introductions to the art world. Megan Green, a collector in her early thirties whose parents were prominent contemporary art collectors, described how her parents brought her to art exhibitions and other collectors' homes as a young child. Each year, her mother allowed her—with some guidance—to pick one work for the family collection that was "hers," giving Megan a sense of personal engagement with the process of collecting. Megan described her high school AP Art History course as a "turning point" that provided her with a greater appreciation for contemporary art. In college, she decided to minor in art history, and, on her father's insistence that she study something practical, majored in economics. When she chose to start her own collection, her parents funded the collection, albeit with less expensive works than those that they owned. For her college graduation from Stanford University, they gifted her a more significant work, which she loaned to a series of museum exhibitions. Megan's early and continual immersion in the art world gave her an art historical background and aesthetic sensibility that she experienced as innate, tacit knowledge:

> It was so much in my DNA. It was a really important part of my parents' life, and from a really young age they were taking me to galleries and to museums and to auctions. And it was funny—they used to be a little embarrassed because I would walk around and I would be able to point out different artists when I was like five. . . . It's like people say, "Well, how did you learn to speak French?" Well, my parents are French versus having to really teach it to yourself. It was always very innate, I just sort of always knew what was in different collections, and I think that kind of exposure from a very young age was very critical. . . . I see it a lot with my friends now, so many of them come from families [where] this is sort of ingrained in them.

The collectors I interviewed who had engaged in the art world since childhood particularly experienced the development of their taste as "ingrained" and "in their DNA." This was especially true for the collectors in their thirties and forties, all of whom had parents who were collectors. Those who entered the art world later in life, after getting married or establishing their careers, were often introduced by domestic partners or friends. Both collectors who had engaged in the art world since childhood and those who entered in adulthood asserted the importance of informal and formal mentors in the art world; however, this mentorship was particularly crucial for those who became involved in the art world in adulthood. These mentors included friends who were curators, dealers, or other collectors, those who taught courses in contemporary art or gave guided gallery tours, and art advisers.

Art advisers play a prominent and explicit role in the development of taste for collectors who use them.[7] Advisers explained that they brought their clients to various galleries and fairs and showed them images of artworks in a sometimes months-long process of assessing clients' tastes.[8] They would then show clients "undervalued" works—works that they viewed to be better investments in terms of status signals, such as critical reviews, museum exhibitions, and auction records[9]—that they viewed as aesthetically similar to those that clients had expressed liking. Lowell Pettit, who owns an art advising practice along with his wife, stated that clients would tell him that they found works compelling but could not articulate why, or that they did not respond to certain works and wondered why these works were important. Lowell asserted that he explained artists' careers and positions in the art historical landscape with responses like, "Well, that's interesting to me, because that is a hard artist, we consider this artist with this movement, we consider this artist part of an important avant-garde that grew after postwar France, he tried to patent [*sic*] to some degree of success with his own colors."

Domestic partners who are already involved in collecting also play a formative role in both introducing their partners to the art world and shaping their tastes. Moreover, collectors with domestic partners must negotiate with these partners about which works to purchase. Many collectors attend exhibitions and fairs with their partners. While partners can be more or less involved in the contemporary art world, all collectors with whom I spoke purportedly gave their partners veto power over works, reasonably assuming that their partners would not want to live in a home full of artworks that they disliked.[10] At the NADA New York fair, I accompanied Douglas Maxwell, an art adviser and collector.[11] He photographed a sculpture that he was interested in purchasing and emailed the image to his wife on his cellphone. While we continued to

meander through various booths, he received a one-sentence reply: "It's nice but not something I want to live with."

"So that's that," Douglas said matter-of-factly. He would not be purchasing the work.

Collectors noted occasional disagreements in taste between themselves and their partners, but they emphasized that their aesthetic compatibility far eclipsed their differences. During our interview, Sherry Mallin explained:

> I would tell you that we agree on, at this point in life, 95 percent of what we buy. Not only do we agree, but if an artist is of interest to us, and [Joel] sees it separately from me, of the eight pieces or paintings in the room, if we probably pick two that we like, certainly one will be the same. If we pick three, probably two out of three will be the same. We're very close in what we would pick at this stage. Because now we've developed a whole relationship with contemporary art together and in the same time period. So we're not far off. But there's always a part of him and a part of me emotionally and practically speaking that's different.

Collectors develop aesthetic sensibilities through their cultural backgrounds, mentorship experiences, and relationships with domestic partners. Taken together, these social factors are characteristic of a high socioeconomic upbringing: living near or in major metropolitan areas, having elite educational opportunities, possessing money to invest in art, and maintaining access to family members, friends, and romantic partners involved in the art world. Collectors' tastes in contemporary art are part of what Pierre Bourdieu refers to as one's habitus, a system of ingrained tastes, skills, habits, and dispositions that one learns through formal education and informal socialization, including everything from how one walks down the street to how one decorates one's home.[12] While taste in contemporary art is deeply influenced by class, collectors experience their tastes as innate expressions of their identities because they form these tastes through extensive exposure to the art world.

CULTIVATING AN AESTHETIC

A year after I accompanied Sherry and Joel Mallin to the Armory Show, I attended their VIP open house for the second time. As with most VIP events in the art world, the definition of Very Important Person was applied loosely, with over 400 guests invited. Some were personally unknown to the Mallins, placed on the list by the Armory Show organizers, who annually organized

and staffed the VIP open houses of major collectors during the fair. The guests meandered through each room on self-guided tours, aided by a list of artists whose works were on display. They paused to chat in small clusters and to gaze out of a long window at the vista of snow-covered Central Park. Eventually, the Mallins called everyone to gather around, and Sherry described their collecting philosophy:

> To us, art is personal. We don't have an adviser, we don't have any staff, we have no curator; we only buy what speaks to our hearts. We have no agenda. Joel once bought a fourteen-foot tall work when we had nine-foot ceilings. I said, "We don't have anywhere to put this!" Joel said, "In time we will." And we did. We built an art barn and we put it there. We still have a lot of things we can't display at the same time. At any time, between our house, the Art Barn, our children's houses, museum loans all over the world—and over 70 percent of our collection is in storage. Our art tells you something about us. We are not a museum.

While the Mallins' collection rivaled those of some museums, Sherry differentiated their private collection from a public collection. Public collections, she suggested, were impersonal. Indeed, a curator at the Whitney Museum of American Art explained to me that, for a museum to acquire a work, the curators must successfully argue to the acquisitions committee that the work has art historical importance. The curators' personal tastes were not seen as valid factors. The curator explained that the museum often declined collectors' donations when they deemed the work to lack art historical significance.[13] In contrast, Sherry claimed that the Mallins' collection was deeply personal. The collection was not composed of the best work representing a particular time period or artistic movement, but was instead a reflection of the identities, interests, and tastes of the people who lived with it.

Sherry asserted that the Mallins' vision was not only personal, but also shared between them. She recounted a story with the small audience gathered around her. In her telling, a dealer from a gallery where they had purchased many works over the years called them, saying that he had a work that the Mallins had to see. The dealer felt that it would be perfect for their collection. As Sherry claimed, she and Joel had already spent their agreed-upon budget on art for the year, but they went anyway, in part to be polite. The dealer set up a private viewing room with comfortable seats. Sherry and Joel sat in front of the painting and then caught each other's eye. The dealer said that he would leave them alone together to discuss.

"That's unnecessary," Sherry recounted. "We've already had our conversation."

The dealer had allegedly protested, "But you didn't say a word."

"We didn't need to. We looked at each other, and we had our conversation. We are prepared to buy it, but not prepared to pay for it," Sherry had replied.

Sherry explained that the dealer had then given them the work with a generous discount, telling them they could take as long as they wanted to pay him—years, if necessary.[14]

Sherry's narrative demonstrated to the assembled collectors that the Mallins had an irrepressible passion for art.[15] They argued that when they found a piece they really loved, they would exceed their planned budget to buy it because they did not just want, but needed, to own it. The story also presented Joel and Sherry as having overlapping tastes that coalesced into a joint creative vision that transcended the need for verbal communication. This shared creative vision represented the strong union of the couple and the joint identities, commitments, and perspectives that they had developed together. They portrayed their eye-to-eye aesthetic judgments as representative of something deeper than their taste in art—as proof of their compatible partnership more broadly.

When collectors liked a work, they often described the experience as an intuitive and automatic reaction, much like how artists explained their own aesthetic judgments during the creative process. At one fair, a collector told me that he had bought several works from a gallery the day before. When I asked how he had chosen which to buy, he explained that he had walked into the booth and said, "That one, that one, that one," stabbing the air with his index finger. Collectors often perceived their aesthetic judgments to resist social scientific study. When I explained my research to one collector, she exclaimed, "But it is so personal!" Several others asked if I had discovered a method to their madness.

Just as artists express their creative visions through their bodies of work and dealers display their creative visions through their galleries' programs, collectors want to showcase their own creative visions through their collections. Each collection comprises a body of work from many artists' bodies of work. Collectors typically rotate their works annually, bringing works to and from their storage units. With every rehanging, they create an immersive exhibition experience for themselves and their guests. In this way, collection becomes an act of creation.[16] As collectors purchase more works, they begin to think of works not as individual purchases, but in terms of how each purchase shapes the collection as a whole. Collector Susan Marco stated, "The pieces

come together. We started going out to fairs, and I think making studio visits, because then you start to see your collection and say, 'Is this an artist that you want to add to the collection? Will they fit in your collection?'" Her husband, David, replied:

> You start to have a sense of how you see and you should see things. And what kind of things are important to you. So, I think that collectors, most of the collectors that I can identify with, they are like curators at the same time. They have a sense of their own aesthetic and what they want their aesthetic to look like. It's not just having the piece, it's enjoying the piece, but also having a sense of what am I doing with this work, the conversation of the different works with each other. . . . I think that, really, collectors that I am impressed with are those that have their own kind of vision. They are defining what their vision is.

The Marcos viewed having a perceptible creative vision as the mark of a good collector. They identified consistencies among their works, perceiving the works to be "in conversation" with each other. Viewing certain consistencies as central threads in their creative vision, they purchased more works that maintained these formal and conceptual elements, thereby reinforcing these consistencies.

Unlike collectors who focus on previous art historical periods, collectors of contemporary art choose work from a canon that is still open and in flux. Accordingly, they asserted that they wanted to collect what they viewed as most interesting at that moment, unrestricted by boundaries of media and style. None of the collections that I viewed adhered exclusively to an easily identifiable rule, such as being composed only of works in greyscale, photographs, or abstract expressionist paintings. However, this did not mean that collectors saw themselves as having no specific vision. One collector defined his collection as "generally abstract and invariably colorful" and another as having "a conceptual point of view." Collectors described their tastes as broad sensibilities from which they sometimes strayed.

Collectors also emphasized that they were attracted to many of the works they chose because of personal connections. During our interview, Sherry Mallin saw me eyeing a work on her wall that was composed of a rectangular white base upon which a grid of lightbulbs protruded.

"You want to know what that's about?" she chuckled. "I'll turn it on for you."

She plugged in a cord snaking from the base of the work and the lightbulbs blazed to life, blue on one side and green on the other, with both sides fading

to white in the center. Sherry explained that the work became physically hotter and hotter the longer the lightbulbs were turned on. The artist, Jim Hodges, had made the work to represent his relationship with his partner, with whom he had since separated. Sherry asserted that the work resonated with her and Joel:

> It's very romantic. I was very taken with the concept of using a variety of collected bulbs and this concept of the two together. Each remain separate, but in a sense they have a really [shared] ground, and it's something that Joel and I believe [in], as opposed to two people married and becoming one. We don't believe that; we believe that you remain you and I remain me, and we have a common life that we share.

For Sherry, each artwork had a story, and often the story was about how the works related to the Mallins' lives. Sherry turned to another wall upon which hung a painting by pop artist John Wesley. The painting pictured a mustached man kissing a woman, who stared impassively at the viewer. She explained that Joel used to have a mustache just like it; it reminded her warmly of him at that time.[17] She was also amused by it. The way that the woman stared out at the viewer, rather than at her lover, had made her laugh aloud.

Collectors seek works that they view as fitting with their distinctive visions, which rely on their personal experiences and exposure to the art world. This experience of resonance is shaped by their identities. Reflective of the economic and cultural elite more broadly, major collectors are predominantly white and are male or heterosexual couples.[18] The collectors with whom I spoke had generally liberal worldviews, and they expressed support of female artists and artists of color. During my visits, I saw that most collectors had works of female artists and artists of color exhibited, and they proudly discussed these works.[19] However, none of the collectors I interviewed focused their collections primarily around these artists or mentioned race or gender as primary themes in their visions of their collections. In general, the numbers of works by male and white artists outweighed those of female artists and artists of color, perhaps in part due to the underrepresentation of female artists and artists of color in galleries[20] and auction houses as well as in other major collections that collectors viewed.[21]

At a private party of a couple who were collectors, a Black artist showed me his work—a graphic sculpture referencing slavery—which the collectors, who were white, had recently acquired. He told me that when the collector

had brought the work home, the collector's wife had hated it. "She doesn't like work that makes her uncomfortable," he explained. The artist recounted that the wife said it "had to go." The couple was planning to donate the work to a museum. The artist explained that he was happy enough with the outcome, given that he was paid for the work and could list the museum acquisition on his curriculum vitae. However, the incident reveals how some collectors—even those who want to support female artists and artists of color—may be less likely to purchase works by these artists. Female artists and artists of color rarely view their work as only about gender or race, but they often find these social categories to be important to their creative visions, just as they are salient in their broader social lives.[22] As collectors are predominantly single white men or white heterosexual couples,[23] who buy only work that appeals to both members of the couple, female artists and artists of color can find themselves at a disadvantage. The work that collectors admire on gallery walls is not necessarily the same as the work with which they choose to live, because collectors select works that they view as resonating with their personal lives.[24] Aesthetics map onto demographics.[25]

Female artists and artists of color frequently find their patrons among collectors who match these social categories. Sociologist Patricia Banks shows that Black collectors often purchase works by Black artists in a political project to ameliorate their dearth of representation in the art world.[26] At the same time, these collectors choose among the work of Black artists, selecting work that matches with genres and themes of personal interest to them, such as figuration and feminism. While Black collectors have been more prominent champions of Black artists, white collectors do sometimes find that the works of Black artists and other artists of color resonate with their own creative visions. One white male collector I interviewed explained why he purchased a print of a barbershop by Black artist Mark Bradford, stating that hair was symbolically important in Black culture and the artist's mother owned a salon, so the work also connected to the artist's biography. The collector felt that the work fit aesthetically with his collection and also that the work captured something of the zeitgeist of the times (his collection contained other works with political and social commentary, such as one Bush-era print that read "Impeach").

Collectors purchase works that aesthetically fit with their collections formally and conceptually. Aesthetic fit overlaps with the demographic fit, while also being irreducible to it. Collectors also value what they view as authentic creative visions of artists who do not match their demographics, and they often conceive of this authenticity as relating to race, gender, and class. However,

they purchase these works only if they can formulate connections between the works and their own creative visions, including stylistic features of the work, the broader social milieus, or more specific personal experiences.

Collectors' search for work that resonates with their creative visions influences how they form enduring relationships with artists and dealers. While some collectors pride themselves on visiting the studios of unrepresented artists, most find artists through galleries. Susan Marco explained how she and her husband filtered through hundreds of galleries in New York alone:

> You have some of the better-known galleries, so you are there and you see a lot that way, but I do think the galleries themselves, their slate of artists, sometimes there is a certain aesthetic, and so that you can continually—you like a lot of shows. Then you develop a relationship, and then from there they will say, "Oh, I am showing a new artist." So then you may develop a working relationship with them. So that happens with a few galleries, and then they may change, and then what we are looking at may change.

Her husband, David Marco, added, "And people move around."

As Susan described, the Marcos attended exhibitions at galleries for emerging and established artists whom they viewed as aligned with their particular creative vision. Once they found an exhibition that they liked, they would begin frequenting the gallery in hopes that the work of other artists in the gallery's program might also appeal to them. As dealers become acquainted with collectors' tastes and collections, they often contact collectors directly with emailed PDF images of works in upcoming exhibitions. They try to match artists and collectors by suggesting works that they believe will fit into particular collections. Collectors become connected to certain dealers, who, in turn, connect collectors to artists.

Dealers offer incentives to collectors who are loyal clients, giving discounts to repeat collectors and placing them higher on waiting lists for the works of artists who are in high demand.[27] Sometimes, galleries require collectors to buy the works of several artists in their program before giving them access to a particularly vied-after body of work. One collector explained that he could only now purchase works from Gavin Brown, a famous and established dealer, because he supported the gallery in its early years: "If you never bought from Gavin over the last fifteen years or however long we've been doing it—forget it. To me, you weren't on the bench."

Once formed, relationships between galleries and collectors are not static.

FIGURE 5.3. Collectors and other exhibition-goers at a gallery exhibition opening.

Collectors make itineraries of different galleries, often geographically clustered in the same neighborhoods of Chelsea or the Lower East Side, that they visit regularly. When galleries move locations, they bring collectors into contact with galleries that had not been previously in their path. Often, dealers working for one gallery begin working for others or start their own galleries. Turnover is fast, as galleries often go out of business. Artists also move from being represented by one gallery to being represented by another. With each transition, collectors may follow dealers and artists to other galleries and become acquainted with artists represented by these galleries.

Aesthetic fits are not simply one-off realizations by collectors that a particular work suits their collections. Instead, as collectors recognize aesthetic matches with particular works, they form relationships with artists and dealers. These relationships often become lasting and lead to aesthetic matches with the works of other artists. In the process, collectors develop new relationships with artists and dealers. Aesthetic matches become aesthetic clusters—networks of social connections based on the recognition of shared aesthetic sensibilities—akin to what a dealer in chapter 4 described as "art tribes."

CHOOSING CREATIVE VISIONS

Collectors choose works that they view as aesthetically fitting their creative visions, but they experience aesthetic fit with more works than they can include in their collections. Ultimately, they must choose among the works that they view as aesthetic fits. Two years after attending the Armory Show with the Mallins, I accompanied collector Oliver Frankel to another edition of the Armory Show. Oliver stopped in front of a booth of photorealistic paintings. He was unimpressed.

"You have to look at all of the works together," he explained. "This is all you get, because you don't know everything he has ever made."

He stood for a while in front of a painting of a woman sitting and said, "This one is nearly a masterpiece—the artist captured something here. But it's not in the others. It's just a one-off."

He moved on.

Collectors assess artists' creative visions, rather than discrete works. Although collectors often like certain series more or less, they rarely buy an individual work that they like unless they admire the artist's body of work more broadly. Oliver himself noted that collectors are actually judging subsections of these bodies of work, a slice of the "distributed object,"[28] as they cannot see every work that artists produce, many of which never leave the studio.

Collectors choose to buy works from artists whom they view as having true creative visions by assessing the consistencies and variations among the works. Specifically, they look for bodies of work that they perceive as representing distinctive creative visions. In a Lower East Side gallery, art adviser and collector Marcia Eitelberg stared up at a large canvas covered in neatly printed numbers. Marcia, who primarily collected and advised clients to purchase the work of emerging artists, concluded dismissively, "Derivative of On Kawara." She explained, "I like to see things that are new, something I haven't seen before." On the hunt for both herself and her clients, she strode outside and threaded her way through the narrow streets to the next gallery. Marcia used the word "derivative" often. It was a prime offense to artists whose reputations were staked on establishing distinctiveness. If collectors view the formal and conceptual elements of artists' bodies of work as overlapping too much with those of other artists, they see artists' creative visions as unoriginal and superfluous.

Collectors perceive artists as having distinctive creative visions not only when they interpret these formal and conceptual elements as different from those of other artists, but also as sustained within artists' bodies of work. In another gallery, Marcia stopped in the back room of a gallery to view a sculpture

of a plastic statue of *The Thinker* with a VHS tape tied to his back. The dealer flipped through the artist's portfolio, showing Marcia images from a series of stockings stretched over boards. When we left, Marcia proclaimed that she liked his body of work, but the diversity of media and styles showed that the artist had not yet "matured," so she would have to "keep an eye on him."

Collectors seek artists whose creative visions they view to be more "mature," expecting increasing development and sophistication with more established artists. They often judge emerging artists who vary formal and conceptual elements as still in gestation, having yet to fully emerge from the wombs of MFA programs. When collectors perceive new work as consistent with artists' previous bodies of work, they are more likely to be able to identify artists' work easily in a crowded fair, especially if the consistencies are predominantly formal. More importantly, collectors view consistent bodies of work as representing mature creative visions in which artists more fully understand and can speak in their distinctive languages. They associate enduring consistencies with artists' commitments to developed creative visions.[29]

While collectors want to see consistency in artists' bodies of work, they shy away from buying work that they view as too consistent with artists' previous works. As we walked past booths in the Armory Show, Sherry Mallin commented with enthusiasm or displeasure at the direction of artists' new work. She impatiently waved at a painting in one gallery's booth and continued on. "He hasn't changed enough," she said with irritation, telling me that they owned one of his paintings. Sherry was uninterested in buying another work of the artist whom she judged as remaining overly consistent, because she believed that the work appeared too similar to work that she already owned and would be superfluous in her collection. Furthermore, she believed that the artist had failed to further develop his creative vision. Collectors often sympathetically perceived that artists whose work remained highly consistent had fallen prey to the fast turnover of fairs and availability of much-needed income. However, they viewed these creative visions as suspect. Joel compared the artist unfavorably to another artist, who, he explained, had not exhibited any works in eighteen months, although the Mallins wanted to purchase more of the artist's works. "That's good," Sherry replied. "If that is what it takes to go to the next level, that's what they should do."

Collectors want to purchase work from artists whom they view as hitting the sweet spot between too much consistency and too much variation within their bodies of work. At Art Basel Miami, I accompanied Peter Hort, a major collector from a family of collectors who ran the Hort Mann Foundation, a nonprofit organization that gave small grants to emerging artists. Peter was giv-

ing an informal tour of the fair to several of his friends who had comparatively minor collections. He walked into the booth of David Kordansky Gallery and turned toward a colorful abstract painting with a gravelly texture, upon which the artist had swiped a thick paintbrush up and down over the center. Peter declared to his friends:

> That's a Jon Pestoni. It has that look. It doesn't look like anyone else. I could tell right away, just by glancing. He added cat litter to his paintings to give it a wonderful, rough texture. It brought it up a notch. . . . What makes a great artist, you progress. He struggles, if you talk to him, he is like, "I don't know," and with any artist, not everything he makes is incredible, but he self-edits.

Earlier works by Pestoni had the same palette and abstract composition. The new works added the gritty texture, while maintaining the recognizable qualities of his previous works. In Peter's view, the work was a progression of, not a deviation from, the artist's creative vision. Rather than view Pestoni's apparent doubt about some of his work as a lack of confidence in his creative vision, Peter saw this as evidence that Pestoni was unafraid to experiment and even occasionally flounder. He viewed Pestoni to be committed to a distinctive creative vision, while continuing to develop and refine this vision.

Collectors often speak of artists whom they view as changing enough, but not too much, as having "beautiful trajectories"—in which each new series incorporates new elements, while maintaining visible threads of consistency. While collectors appreciate that some artists explore formal and conceptual elements deeply while others experiment more expansively, they look for artists who they believe demonstrate both commitment to and continued exploration of their creative visions. When collectors perceive too much consistency, they believe that artists are sellouts who favor branding their work over innovation; when they perceive too much variation, they think that artists lack a distinctive creative vision and an authentic commitment to this vision.

Once collectors judge an artist as having a distinctive creative vision, they must choose which works within the artist's body of work to purchase. I talked with collector Michael Levine at Paula Cooper's exhibition opening for Mark di Suvero, a famed artist best known for his large outdoor sculptures. The exhibition had contained only two works: a hulking sculpture of wood, scrap metal, and steel that took up the entire gallery space, and a colorful painting on one wall. Later, in Michael's Park Avenue apartment, he explained why he did not purchase the di Suvero painting that we had seen together the previous week:

For me, if an artist is known for X—now you get a dichotomy because you don't want the artist to do the same thing all the time—but if he's known for X, and now he's doing Y, and Y is radically different from X, I don't necessarily not want Y, but I want to have an X first, so that you have a collection. And there's some things that artists do that are one-off that are amazing. . . . The painting is the perfect example, the di Suvero painting. I thought it was amazing. But to have a di Suvero painting and no di Suvero sculptures makes no sense . . . (A) because you just don't know if this is ever gonna go anywhere, because sometimes artists go off on tangents and then come back, and (B) because if you have the opportunity to collect the artist in-depth, the way to do it is not to have three of the same thing but to have one here, one here, one here, so you want to have the first one first.

While Michael proclaimed the di Suvero to be "amazing," he explained that he did not buy it because he judged the painting to appear too visually dissimilar from the elements he deemed as more representative of di Suvero's creative vision, such as the medium of sculpture. Michael further explained that when he bought an artist's work for the first time, he selected works that he viewed as conforming to the artist's creative vision. In contrast, he tended to purchase works that were less representative of an artist's creative vision only if he collected "in depth," purchasing multiple works of the artist over time. In these cases, he chose subsequent works from other major series, so that the collection captured key nodes that traced the artist's creative trajectory.

But iconicity is unstable and uncertain. Contemporary artists, especially more emerging ones, have open-ended bodies of work. Collectors Lesley Lana and her husband, Phillip Heimlich, discussed a group exhibition at Morgan Lehman Gallery that they had attended the previous week, an exhibition that I had also seen. They had been longtime patrons of the gallery and had followed the career of one of the show's artists, Barbara Takenaga, for a decade. The show had two of her small acrylic paintings on paper. One had a mossy green background with rows of white dots in the foreground, which created a billowing amoebic form. The other had a bright red background with the same green in the foreground covered by white strands that formed an algae-like shape. Lesley was partial to the former; Phillip preferred the latter. Lesley explained:

I said the green one because it had those undulating white dots, which is one of her signatures. And plus, I liked the green and gold hues in the whole frame. Even though the red one was absolutely magnificent. . . . I just thought, I look at the green one and I am like, "That's a Barbara Takenaga."

Phillip responded that, while he liked the green painting as well, he felt that the red painting captured her future direction:

I felt that the red piece had a little bit more energy and was almost like she was going in a different way. And her last show—it seemed more—she was going a little bit different than the dots and everything. So I think it's kind of her next step. So I am thinking—yes, you are correct—that's her signature right now. But I have a feeling that the red piece, that's where her new thinking is going, so I was thinking that may be the piece that is going to be one of her jumping-off points.

Lesley explained why she usually purchased iconic works:

I tend to lean toward the iconic. Just because I am familiar with it, it's the reason I like the artist. And then, in the back of my mind . . . I am always thinking in terms of investing. Well, what if I go in the new direction and what if—let's just say, hypothetically, years down the road—everyone is like: "Oh god, remember when he was doing that, went in that one direction. Ugh."

Lesley and Phillip stated that when they wanted to collect multiple works by an artist but were unsure if a new direction would be sustained, they would "pause" until they could see future exhibitions. Sometimes they later filled in the gaps in the artist's creative trajectory within their collection.

Pierre Bourdieu has argued that it is the signature of renowned artists that collectors seek.[30] Collectors want to own a work by famous abstract expressionist Jackson Pollock because it is "a Pollock." The name itself confers prestige on the object, and, by extension, the collector. But not all Pollocks are created equal. To be viewed as a knowledgeable collector, one must not only own the actual signature of an artist with a true creative vision, but also a work with the signature qualities of the artist's creative vision. Most collectors would prefer to buy an iconic splatter painting over one of Pollock's early surrealist works, believing that the splatter paintings represent the apex of Pollock's creative vision. And collectors would likely view someone who chooses a surrealist work over a splatter painting—given that this imagined collector was offered and could afford both—as lacking a "practiced" eye. Collectors perceive artists' creative visions as best captured through their iconic work, as these works contain the core formal and conceptual elements of their creative visions. At the same time, they recognize that other collectors also prefer iconic works, and they believe that these works are most likely to re-

main economically valuable and in demand. Therefore, they often view iconic works as more aesthetically valuable and safer economic investments. With contemporary artists whose bodies of work are still evolving, collectors must decide between choosing works containing what they view as the artists' most recognizable qualities at the present, or works that represent what may become iconic qualities in the future.

Under certain circumstances, collectors purchase work that they recognize as less iconic. When they want to purchase an artist's work but find themselves behind others on the waiting list, collectors sometimes settle for work that they believe to be iconic enough. I first met Megan Green at a book launch for artist Chris Succo, held in the penthouse of a Manhattan hotel,[31] where waiters whisked by with trays of tiny food and lavender-scented cocktails. Megan told me that she had recently purchased one of Chris Succo's paintings, a canvas covered with globs of white paint, for around $10,000. The work was hard to access, as the artist was in high demand at the time. Megan recounted that she had to convince the dealer to sell it to her by telling him which other works she owned, as he wanted to confirm that she was not one to quickly flip the work and would be an appropriate placement for the work. In our later interview, we further discussed how she chose which of Chris Succo's work to purchase:

> I actually think the series I bought might not be as iconic as his white paintings, so I am taking a chance that the new body of work is also iconic, and I think this is a time where I've definitely taken a bit more of a risk, but I liked the new work and I knew how hard it was to get, and it's not so different. I think it's just different enough. And when I was talking to him, I was asking him about it and why he took this slight departure from the past, and he really liked this series, and in my mind, this series is very recognizable in [its] composition— I thought they were consistent in a really beautiful way—and he's done the series a few times. It seems like a series he is really committed to, and so that made me also really comfortable with the idea. I mean, it's definitely a little bit of a flier, but that's OK.

While Megan viewed certain works as even more iconic to Chris Succo's body of work, these were unavailable to her. She perceived the element of thick white brushstrokes to be sufficiently iconic. She had seen the artist use that element in the past, and his conversation with her convinced her that he would likely continue to incorporate it. Collectors also purchase less iconic works when they consider them to be inexpensive, as they are less concerned about whether these works will retain economic value, and also when they

feel a personal connection to less iconic works. Megan, who worked in music-related fields in the technology industry, explained that she once purchased a work by Richard Pettibone that contained an image of a lightbulb and a phrase about music being a dirge. While she did not view it as the most iconic of the artist's works, she found it to resonate with her interest in music.

Like dealers and curators, collectors generally privilege iconic work, wanting to first own what they view as most representative of artists' creative visions. In doing so, they increase demand for these works and communicate this demand to artists and dealers. As they invite guests into their homes and discuss the works on display, they also further reinforce the visibility of iconic qualities and help solidify collective perceptions regarding the iconic elements of each artist's creative vision.

DISPLAYING DISTINCTIVENESS

Collectors buy works with which they want to live. But their private collections are also public to the extent that they loan or donate works to museums and that they give tours of their collections to others in the art world. Collectors wish to be respected as "serious" collectors. While they want to own iconic works that represent artists' creative visions, if they all buy iconic works from artists who are legitimated by status signals, their collections will appear very similar and will do little to display their distinctive creative visions as collectors. As one collector stated, "I like to see quirky collections whereupon it's unpredictable. . . . You wonder, 'Gee, who's that?' . . . I don't want to walk into someone's home to see everything that was bought by an art adviser, that's obviously been rubberstamped by the hedge fund crowd as being a money-maker." Collectors must navigate how to build collections that they and others in the art world will view as both distinctive and aesthetically valuable.

After Sherry gave the guests at their VIP open house a short speech about how she and Joel had developed a collection, she added, "We have work that costs $100, work that costs $1,000, and work that costs $1 million, and we put them together in our home—they are all equal to us." She emphasized that they hung relatively low-priced and high-priced works side by side, as if they were on symbolically equal footing, claiming that she valued the works not for their economic worth, but for their aesthetic worth. This aesthetic worth, she asserted, could not be reflected by price, as it was based on their personal taste, rather than collective consensus.

Addressing the guests, Sherry ignored the "serious buys"—the expensive works by established artists—such as the Donald Judd sculpture on one wall.

Instead, she detailed each small sculpture on the coffee table, naming the artists and describing how they acquired the works, some of which were gifts from the artists. She highlighted works that were less significant, in terms of both price and status, in comparison to most works in the Mallins' collection. Less iconic works and "early buys"—works collectors purchase early in artists' careers—render collections more distinctive, as these works are not widely recognizable or present in many other collections. By exhibiting early buys alongside serious buys and less iconic works among more iconic works, collectors show that they primarily value work aesthetically, not economically.[32] However, each serious buy remains more visible, as collectors rotate different early buys annually, while often keeping serious buys on display long-term.

Collectors orient themselves differently to purchasing early buys and serious buys. Michael Levine stated that he considered works below $30,000 to be impulse buys, whereas works that climbed above $100,000 he viewed as serious buys. After the serious buy threshold, Michael explained that he began musing about what else he could purchase with that money: two remodeled bathrooms, a car, a year or more of his children's college tuition? Like artists' low-stakes experiments, collectors invest few resources in early buys, viewing future outcomes regarding these works as highly unpredictable. Collectors hope, but do not expect, early buys to increase in value, and they recognize that there may not ever be a secondary market for these works. They often told me that it was especially important to buy the work of emerging artists for love, not money, because they may well be left with love alone.

For each collector, the price threshold between early buys and serious buys is relative, but they share the general practice of considering economic value more critically when purchasing works above the serious buy threshold. Once work cleared this threshold, collectors assess it not only as art, but also as an investment.[33] While collectors very rarely discussed purchasing serious buys that they did not like, they claimed that they only bought these works if they expected them to maintain, or modestly increase in, economic value.[34] Major collector Zoe Dictrow explained how she and her husband evaluated serious buys:

> Joel is more concerned with finance. I am more concerned with survival. I'm like, "We can't afford that!" When we buy something expensive, we do put on that cap. When it is under that number—without saying what that number is—it's less important. We say, "Is this a gallery-represented artist?"

Zoe explained that she found it more fun to collect early buys because she did not enjoy this process of economic valuation. Collectors often purchase early buys with little formal research, especially when they view the works as particularly low-priced. However, they use additional status signals beyond iconicity to assess serious buys by gathering information about artists' MFA-granting institutions, gallery representation, exhibitions histories, critical reviews, and auction records.[35] Serious buys are the making of major collections, cementing the prestige of collectors' reputations. They also increase the visibility of collections within the art world, as curators are more likely to request major works for loans to museum exhibitions.[36] Collectors balance early buys and serious buys as well as more and less iconic works to create collections that are simultaneously quirky and esteemed.

Collectors validate their choices through their display of works themselves and by framing these decisions by discussing why they selected each piece. They legitimate not only their specific decisions, but also their broader orientations toward collecting. Specifically, collectors argue that they are distinct from inauthentic collectors, first because they are driven by love over money, and second because they have what I call *aesthetic confidence*, or a willingness to purchase works based on their belief in their distinctive and cultivated taste.[37]

When I asked Sherry Mallin how she chose which works to purchase, she replied simply, "I buy with my heart." She then recounted how she had chosen, or rather not chosen, a particular work six weeks before. The Mallins had seen an artist's show in Paris and liked the works; however, the two works that they were most interested in purchasing were already held on reserve by other collectors. The artist's main dealer in London, with whom the Mallins had done much business over the years, arrived. He told them that he would be exhibiting the artist's works in two weeks and showed them digitized images of these works. The Mallins reserved work that they thought was the strongest based on the images. However, after their trip, they worried that they would feel differently about the actual work. The dealer had described the work as pink, but they perceived the work in the photo as more purplish. The Mallins decided to fly to London for the day, just to see the work. They reasoned that the two plane tickets were a small fraction of the work's price, which was well into six figures. They arrived the day before the exhibition opened, and the dealer offered them the pick of the litter. Indeed, when the Mallins saw their reserved work in person, they "did not love it." Instead, they chose one that they liked "infinitely better" and returned home satisfied. To many, it would seem fanatical to cross the Atlantic Ocean merely to see a painting whose

image they could already view from the comfort of their own home. Yet the Mallins thought it completely reasonable, even practical. This was just what one did for love.

Collectors repeatedly used the same metaphor when discussing how they selected works, asserting that they bought with their "eyes" or with their "hearts."[38] Collectors employ this metaphor to emphasize that they, like artists, experience aesthetic obsession and that they have aesthetic confidence, in that they are willing to follow their own creative visions rather than those of others.[39] As one prominent collector stated:

> I have confidence. I buy what I like and hang it on my wall, and if you don't like it, that's okay with me. If you do like it, it's fine with me too. I don't ask permission. . . . But a lot of people follow, and because we have a very public collection, and because we are confident, and we purchase things that don't need a stamp of approval—these things that are very early—and then other people jump in and comment and pick things up. I guess you default to being a tastemaker.

Collectors explained that when early buys increased in economic value, this validated their feelings that their personal taste was also good taste. Phillip Heimlich described how his aesthetic confidence grew when he and his wife purchased works that subsequently increased in economic value and received curatorial attention: "So that kind of says to you, 'You did a good job.' It's been published, it is in books and everything. And you did a good job. I think that's what made me buy that last piece." When collectors purchased early buys that appreciated in value, they also felt that they had influenced the art historical conversation through their patronage. As one collector stated, "We like buying artists when they are up and coming, and they are coming up at this point. This way we are hoping to shape the history, we are part of the history, we are helping to write it." By purchasing early buys and highlighting these buys in their collections, collectors display that they have independent and sophisticated tastes. As I accompanied a collector from booth to booth in an art fair, he pointed out to me which artists' works he owned, exclaiming, "I collected all of these guys before they were big!"

But buying early was relative. During one interview, a collector paused to attend to three art handlers who were rearranging works in his dining room in order to hang several recent purchases. One of the works was produced by a more established artist, and the collector mentioned offhandedly that he "missed the boat" on that artist. When I asked him why he bought it if he felt

that he had missed the boat, he explained that he sometimes broke his own rules by buying works from more established artists. He also claimed that he occasionally purchased the work of lesser-known artists who had been actively exhibiting for a long time but who he felt were still somewhat "underappreciated." The collector explained, "His career is being relaunched, so to speak. So, you see, you can be an emerging artist when you're eighty, or you can be an emerging artist when you are twenty-four, right?" Is it still an "early buy" if the artist has been reviewed in *Artforum*, or has representation at a respected gallery, or has had multiple solo exhibitions? Collectors had leeway in asserting that they bought early because the terms "emerging" and "early" are subjective in themselves.

Collectors also assert their aesthetic confidence by downplaying their reliance on status signals, especially recommendations from other collectors. In an extension of the eye metaphor, they argue that they do not buy with their "ears." Carol Dorsky, a collector and art adviser, stated, "I don't like to buy with my ears. I like to buy with my eyes. I will never buy something because someone I know thinks it's terrific. I have lots of friends who are collectors. But I think that at this point I have definitely developed my own palette." Although some collectors acknowledge that they also listened to their ears, they assert the primacy of their eyes. Carol continued:

> Well, I use my own gut and my own eyes, and, in addition, I like to know is there someone else besides me that thinks it is interesting work. So I look at their resume to see where they've shown, where they've gone to school, who their references are in the work, and they have to be able to talk about the work.

Carol stated that, while she attended to various signals of economic value, she used her ears as an additional filter only after assessing which works she aesthetically appreciated.

Collectors often acknowledge that they received recommendations from other collectors by talking to them and viewing their collections. However, they frame these interactions as primarily characterized by friendship and fun. A major collector explained:

> You know, friends and things like that, friends I know in the art world. I go around, and we travel sometimes with museum groups, whenever we get invited to people's collections, and that's always fun and interesting. . . . It's remarkable what you see at a fair. You see a lot of good art at once. I think it's a lot of fun. And first, it's a part of our community. You know, we've become a

real big part of the community. So there's people who are friends, and it's a way of connecting with a lot of people whom we really like.

This collector asserted that he merely happened to receive recommendations as an organic byproduct of his friendships with other collectors.[40] Similarly, at a lunch with the Mallins and another couple who were collectors, I asked Sherry from whom they received recommendations. "No one," she replied. The other female collector replied, "That's not true," and Sherry quickly amended her statement, saying, "Well, I talk to other people, but informally. If we meet socially, someone might say you have to check out this work at this gallery, and I will say, 'OK,' and then I will go and see it." Sherry claimed that she used recommendations only as an initial filter and still made her independent aesthetic judgments.

While collectors downplayed the role of their own ears in decision-making, they emphasized that others relied excessively on their ears. Sometimes, collectors claimed that the so-called early buys of other collectors were not so early after all. They argued that the collectors in question were actually emulating their own purchases, as they had previously purchased work by the same artist. Other times, they suggested that other collectors chose work through even more ethically dubious means. One collector claimed that another collector "must have someone whispering in her ear, because she keeps buying up artists right before they get major museum exhibits." The collector insinuated that the other collector knew a museum board member who was giving her tips.[41] In these cases, collectors alleged that other collectors' early buys did not display true aesthetic confidence, because they came from using their ears.

Collectors who did not use art advisers also contrasted their use of their ears with those who did use art advisers. They accused the latter of having to buy their taste instead of having it ingrained through their upbringing or cultivating it by viewing exhibitions. Sherry Mallin told me that younger couples interested in starting a collection often asked her if they should hire an art adviser. She would ask them if they had previously used interior designers to decorate their homes, and if they answered affirmatively, she would recommend that they use advisers, as this displayed to her that they lacked confidence in their taste. In turn, collectors who used advisers made further distinctions between themselves and other collectors with advisers. One collector who had an art adviser said:

I was with [my art adviser] at the Armory Show, and there was another collector there. And all she cared [about] was, would this look good in her new living

room? And everything that she picked was blue, blue, blue. I said something to [my art adviser] like, "She's going to have a lot of blue." And she said, "She is redecorating her room." That's not a collector.

By validating and invalidating other collectors' claims of aesthetic confidence, collectors solidified their status as authentic collectors.[42]

Affluent individuals use an array of consumption practices to portray themselves as having better cultural tastes than less affluent individuals and to protect themselves from moral sanction.[43] Sociologist Rachel Sherman shows how wealthy New Yorkers try to normalize their spending on home renovations and other expenses.[44] They describe these purchases as within reasonable limits, rationalizing even luxury purchases, such as designer handbags, as necessary.[45] They distance themselves from other affluent New Yorkers whom they portray as profligate and conspicuous consumers. In contrast, while collectors purchase contemporary artwork with their disposable income, they view these purchases as morally honorable, not morally suspect.[46] Collectors of contemporary art perceive themselves as arts philanthropists, and therefore portray collecting as ethical consumption.[47] They distinguish themselves from lower-status collectors and non-collectors not by claiming that they are restrained in their spending, but by asserting that they cannot stop buying work due to their passion for collecting. Furthermore, they differentiate themselves from other collectors by claiming that they select artworks based on their aesthetic confidence in their distinctive creative visions. Distinction from other collectors rests on the distinctiveness of their collections.

CONSUMING CREATIVE VISIONS

The most expensive works in the Mallins' collection ran into seven digits, but they did not make any major purchases on that day at the Armory Show. In the booth of the Parisian Galerie Daniel Templon, the Mallins purchased a work by artist Chiharu Shiota for $9,000, after a 15 percent discount for collectors who had previously purchased work from the gallery. The work was composed of strings woven together in a cobweb and affixed to a canvas, a more modest version of the massive cobweb installation that the artist planned to produce for the upcoming Venice Biennale, where, as the dealer explained, the artist would represent Japan.

The booth for Ronald Feldman Fine Arts featured a decade-long series by the artist Brandon Ballengée, in which the artist cut out the figures of extinct animals from Audubon-style prints and burned the figure, selling the cut-out

print along with an urn filled with the ashes of the paper animal. At around $3,000 apiece, the works were among the least expensive at the fair, and the Mallins decided easily to purchase a print of a bird, or rather, the absence of a bird. "It makes a strong statement," Sherry Mallin explained to me.

After six hours at the Armory Show, my feet hurt, despite my sensible footwear. My eyes ached as well. Colors from various works seemed to pop off the canvases and whirl together in a nauseating cacophony of neon. The fair, with its flashy artworks and flashier people, epitomized the art market in overdrive. And it was only the tip of the iceberg, the most visible sliver of the art market, revealing the artists who had made it to the top. Within and beneath it lay a vast web of relationships, extended down and crosswise into various aesthetic networks of artists, dealers, curators, collectors, art advisers, and other art world personnel.

How do collectors select works from this overcrowded field to add to their collections? Through their upbringings and exposure to the art world, they form commitments toward collecting and a sense of their aesthetic interests and sensibilities. They seek bodies of work that resonate with their creative visions, developing enduring connections with artists and galleries as they search for aesthetic fit and solidify perceptions of their creative visions. Among artists' bodies of work that collectors judge to align with their own creative visions, collectors choose those that they view as representing distinctive, but evolving, creative visions. Collectors typically judge these bodies of work as maintaining core elements of artists' creative visions, while varying other elements in subsequent series. While collectors' perceptions of what constitutes a progression of or a deviation from artists' creative visions are subjective, these interpretations are guided by style scripts that frame the meaning of the work.

Once collectors decide that they are interested in an artist, they must choose which work to purchase. They typically select an iconic work, the work that they believe best encapsulates the core qualities of this creative vision, as they value the artist for his or her creative vision. Collectors buy less iconic works when they cannot access more iconic works, already own more iconic works, or feel that the less iconic works better connect to their personal interests, especially if the work in question is an early buy. In privileging the iconic, collectors reinforce collective perceptions of what constitutes each artist's creative vision.

Collectors legitimate themselves to others in the art world as "real" collectors by including both early and serious buys as well as more and less iconic work in their collections, and by highlighting their distinctive interests and personal connections to the work. In doing so, they work to develop collections that both portray their creative visions and are consecrated by the art

world. Furthermore, collectors present themselves as serious collectors by emphasizing their orientations toward collecting. They argue that they are driven by a love of art and that they have aesthetic confidence, or a willingness to select works by following their distinctive tastes. Collectors use these claims to distinguish themselves from those whom they view as lower-status collectors, solidifying a status hierarchy that benefits collectors with more economic, cultural, and social resources.

As works circulate through exhibitions and collections, dealers, curators, critics, collectors, and art advisers communicate to each other about which creative visions are distinctive and aesthetically valuable, which elements are central to each creative vision, and which elements constitute meaningful change within each creative vision. Together, they contribute to and sustain collective perceptions of each creative vision, which may coincide or diverge from artists' own views. As artists interact in the art world and then return to their studios, they bring with them their understandings of how others in the art world have interpreted and evaluated their creative visions. Following artists back into their studios, we can now examine how the dissemination of artists' work influences the way in which artists produce new works over the course of their careers.

CHAPTER 6

Producing Creative Visions:
Presenting Evolving Trajectories
over Careers

I sat among a group of artists at a monthly lecture series in a muggy third-floor Brooklyn studio, the window fans doing little to cut through the humid summer air. Every session, two artists would give a PowerPoint presentation expressing their creative vision to their peers. They typically showed chronological images of their work and exhibitions, and explained how the content of their work had evolved over time. For this session, artist Daniel Dove, a Los Angeles–based artist who was an associate professor at California State University, Long Beach, presented his work. Projecting images from each series, he explained that upon beginning the series, he had become extremely excited and believed that he would spend the rest of his career making variations of this work. But these feelings repeatedly changed:

> This happens again and again, I find something, and I think it will be my thing, and then I do five, and then I feel dead inside, and I move to something else. And this is not even a virtue, I think it is a neurological defect. It can really impinge upon a career in an art world where people prize developing a motif and sticking with a theme.

The other artists scoffed and rolled their eyes in support of not "sticking with a theme." During the question and answer segment, I raised my hand and asked why he had stopped producing each series, after initially thinking that the series would define the rest of his career. Daniel replied:

If you are trying to be a professional artist . . . you can't help but notice that successful professional artists tend to make one kind of work and then every possible variation of that work. Fuck-loads of work in every possible variation. And it is just not in my nature. After about five of those, I make one and it is just not good, and that is it. And it just takes an immense amount of time to build up the next thing, and there is a ton of work, all of the half-baked work in between, and I don't show that, because it is just like whited out. And so it is a pragmatic thing, but not just pragmatic, because part of you thinks maybe it is worthy of that amount of attention, but does the world need fifty of these paintings? Probably not. It takes me a while to realize that.

As Daniel explained, he had spent ample time developing each series, but stopped producing the series when he experienced boredom. As chapter 3 revealed, artists experience aesthetic judgment intuitively during the creative process. In particular, they feel excitement, ambivalence, and boredom, and they respond to these emotions by repeating elements, pausing production of elements, or abandoning elements, respectively. But the studio is not hermetically sealed from the art world. Chapters 4 and 5 showed how dealers, curators, collectors, and others in the art world communicate their expectations for how artists should present their creative visions in general and what consistencies represent each artist's particular creative vision. Whether Daniel viewed himself as conforming to these expectations or resisting them, he nevertheless had to confront the apparent effect of his creative decisions on his career trajectory.

Each artist's body of work is a "distributed object"[1] of all of the works that the artist has created over time, which are disseminated in space throughout the studio and the art world. This distributed object also marks an artist's career, with individual works produced at different points along the artist's career trajectory.[2] Over the course of their careers, how do artists understand viewers' expectations regarding their creative visions? How do artists gain access to different exhibition resources as their careers develop? How do they consider these expectations and use these resources to present their creative visions differently at various moments in their careers? While artists' careers do not always progress linearly,[3] I discuss artists' careers in three stages: uninitiated, emerging, and established.[4] "Uninitiated" artists are typically unrepresented artists who have had few or no solo exhibitions in reputable New York City galleries (in the art world, these artists are usually collapsed into the emerging artist category, although their exhibition resources and strategies for presenting their creative visions are different from those of artists whom I

discuss as emerging).[5] "Emerging" artists are those with gallery representation and multiple solo exhibitions. "Established" artists are those who are represented by high-status galleries and have had many solo exhibitions at both galleries and museums.[6] At each stage, artists use distinctive approaches for presenting consistencies and variations within their bodies of work.

GAINING RECOGNITION

Artist Jairo Alfonso had recently emigrated from Cuba and was trying to gain a foothold in the New York art world. He currently lived with his girlfriend in an apartment in Jersey City, located across the Hudson River from Manhattan with substantially cheaper rents. I spoke to Jairo in his bedroom, which doubled as his studio. I asked him what he had been working on since moving to the United States. From under his bed, he pulled out a series of large detailed drawings, which pictured consumer goods piled on top of one another, filling the space. On his laptop, he showed me a series of stop-motion animation videos in which he stacked objects, from beer bottles to cassettes, in long columns. He explained that the drawings and videos were connected by the shared theme of hoarding, assembling, and disassembling consumer goods.

Later in our conversation, Jairo flipped through a portfolio of his work in a large binder composed of images ranging from terra cotta sculpture installations to surreal photographs. I asked him why these images were not on his website, which presented images of his drawings on the homepage and images of the drawings and videos on the "Works" page. His girlfriend translated from Spanish, "He is thinking about including a selection of the previous work, but he wants to focus on the recent work, so people don't get confused." Alfonso replied, with a guilty laugh, "It's marketing, it's marketing—my idea at this moment." His girlfriend elaborated, "So that people know him with these new works." Alfonso believed that showing his older work alongside his newer work would muddle his conceptual focus. A few months later, he included six older works on the bottom of his images page, which displayed thirty recent works, clearly demarcated from the newer work under a label "Previous Works (Selection)."

How do artists like Jairo—who have recently graduated from MFA programs or moved from other places—begin to make a name for themselves in the sprawling landscape of the New York art world? Uninitiated artists do not enter the art world as blank slates. In MFA programs, students learn through discussions with their professors and peers that they must display distinctive "voices" through their work and that their work should not appear repetitive

FIGURE 6.1. A closeup of Jairo Alfonso's drawing.

of others' bodies of work.[7] While they begin to develop these voices through the bodies of work that they prepare during their programs, typically culminating in thesis exhibitions, they must eventually exhibit their work in galleries. For uninitiated artists, group exhibitions are most accessible, as these exhibitions are less prestigious and as galleries expend fewer resources on any one artist. Many group exhibitions occur in the summer off-season, when collectors often spend time traveling and living in their second homes outside New York. These exhibitions provide relatively little exposure, but they can be important stepping stones in careers, as group exhibits can lead to solo exhibitions, which can lead to gallery representation.[8] Group exhibitions permit space for each artist to exhibit only one or several works, allowing artists to show examples of their work but not display the breadth of their bodies of work.

Solo exhibitions at reputable galleries are uninitiated artists' first major opportunities to put their marks on the art world map. Artist Reuven Israel discussed how he chose which works to exhibit in his first solo exhibition. He had recently immigrated to the United States with a reputation that was too nascent to travel with him. In his native country of Israel, he had primarily exhibited wooden sculptures coated with car paint, which he rested on the floor. When

we met during an installation of a group show at a Lower East Side gallery, he was exhibiting work from a new series of similar wooden shapes covered with car paint that he placed on metal poles balanced diagonally against walls. Months later, he was preparing for his first solo exhibition in New York at another Lower East Side gallery, and he decided to stop producing his other works to focus only on these "skewer" sculptures:

> I decided that with the skewers, I needed to spend some more time and make a body of work around this theme . . . it is like I paused the rest of these things. . . . And also, maybe it was less naive than what I am pretending. I did think it was a bit of a tactic to do this one thing that people recognize, so that they will relate my name to a specific thing. They will say, "Reuven: skewers." And I think to try to enter the art scene on the tip of a needle pin, with one thing to be recognized and then to start there and to expand. Also, because I think the reason that you will identify them so easily is because there is something a bit more unique about them to the rest of my work.

Reuven explained that he used the first solo exhibition to show only his skewer sculptures because he considered the formal element of the skewers to be most distinctive in comparison to other artists' creative visions. He prioritized consistency over variation, as he believed that viewers must recognize him as having a distinctive creative vision before he could expand upon it. Uninitiated artists often privilege narrow formal consistencies, especially in an element that they view as unusual. As they are finding their voices and seeking to make these voices heard, they see these qualities as most recognizable. In addition, they have limited exhibition opportunities for displaying breadth in their bodies of work. They aim for their creative visions to make *strong statements.*

However, in presenting these strong statements, uninitiated artists also think toward the future, asking themselves how what they exhibit now might affect their creative and career opportunities in five, ten, or twenty years. Here, style scripts are particularly important. Artist Kambui Olujimi gave an example: "If you make something in denim and you say, I work with denim, then people will say great, and then the next thing you do, they will say, 'Why isn't it denim?' so you say, 'I work with the concept of time.' Or you have people say, 'My work is about race, class, and gender.'" Kambui twirled his index finger in a circle, indicating that these concepts are flexible and widely encompassing. Kambui's own artist statement read: "Olujimi works within the realm of ideas rather than within an exclusive medium. Although he has directed a

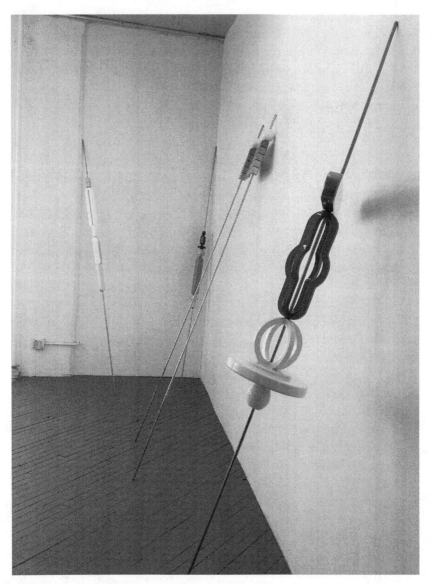

FIGURE 6.2. Reuven Israel's skewer sculptures.

great deal of work in film, his is truly a multi-media practice. He crafts potent social commentary from delicate wisps of myth and whimsy mixed with real-world narrative."[9] Uninitiated artists use style scripts to emphasize conceptual consistencies, claiming that their creative visions could be incarnated in other forms. They work to make a strong statement by displaying works with dis-

tinctive formal consistencies, while highlighting conceptual consistencies in an effort to render these statements open to future formal variations.

DEVELOPING RECOGNITION

An artist's first solo exhibition at a reputable gallery is like a dot on a map without a vector. Each subsequent exhibition places another dot on the map of the artist's creative trajectory. Artist Lauren Luloff explained why she selected recent work during a studio visit with dealers from Halsey McKay Gallery, who represented her after the visit.

"I showed them finished work. They were paintings that were more traditional, more stretched museum paintings with collage background and paints, and it was a relatively new series that I had been working on for a year at that point," Lauren asserted.

I questioned, "And was there work that you didn't put out?"

"Oh, God. Thousands of paintings." Lauren replied.

"How did you decide what to show out of your whole body of work?" I asked.

"Well, I feel like when you have a studio visit, you usually show the work that you are working toward and your current body of work. Like something that you were making three years ago isn't relevant to show unless it was something you were still working on . . . or if it was directly related." Lauren explained.

"Why wouldn't it be relevant?" I pressed.

Lauren elaborated, "I feel like there is always this very sensitive balance between what you have shown and what you want to show to continue that dialogue that you are doing something different and fresh but while still continuing it."

During studio visits with prospective dealers, curators, and collectors, emerging artists typically show their newest series. Just as artists assess relevance to their creative visions during experimentation, they expect viewers to evaluate relevance to these creative visions as well. They believe that visitors will view the current series as being most relevant to artists' creative visions, as this represents the trajectory that artists are most likely to continue along in the future. They want the new series to appear both distinctive from past work and as a natural progression of their creative visions.[10] Emerging artists struggle to maintain this "sensitive balance" as they create and exhibit new series.

This tension between consistency and variation often comes to a head after several solo exhibitions, when artists have enough recognition for viewers to have some preconceptions of artists' creative visions and to expect evolution in

these creative visions. Gina Beavers made abstract paintings throughout graduate school before shifting to representational paintings of Instagram images. She used what she coined her "relief painting" method, involving building up acrylic paint so thickly that it formed sculptural shapes of the objects that she represented. Her first two solo exhibitions focused on recreated images of food and bodies. Both exhibitions were reviewed by prominent periodicals, including *Artforum*, the *New Yorker*, and the *New York Times*, and collectors began to purchase the work. For Gina, recognition was both welcome and anxiety-inducing.

She explained, "Overcoming success—that was a really stressful thing. How do I get past it? How do I make something interesting, still, that is interesting to me, that is interesting to other people?"

I asked, "Did you think about what expectations people had about your work based on the first show, and then how to move forward from there?"

Gina said, "Yeah, I mean that was the hugest thing. Because it was like after food and bodies, what else is there? How am I going to find a way to communicate the same kind of visceral something, but also keep it true to what I am interested in? And then I ended up finding these tutorials that are still like a body, and then they are more abstract. And they sort of work for me because they are still in the same vein. But it was weird, because I stumbled around in the dark. And then I just started realizing—some of it is subconscious—the things that I am interested in. And these things are popping up on social media in the same way that the food photos are. And then these have these added elements, like composition and artistry, that people are making their own compositions and making their own still lifes when they are taking these photographs."

Gina worked to continue communicating the same "visceral" quality that represented her creative vision. At the same time, she wanted to explore new elements, and she knew that she could not keep showing the same food and body paintings in future solo exhibitions. After a period of flailing about for a new idea, she latched onto makeup tutorial images on Instagram. She thought that this subject similarly related to her interest in the representation of bodies and social media, while using different imagery. She also experimented with the composition, adding a grid pattern. She presented the series in solo exhibitions at her representing galleries in New York and Los Angeles. Eventually, some of the works moved from the wall to the floor as she fabricated large sculptural cubes with relief paintings on each side, which she displayed at Frieze Art Fair 2016 in New York.

Like Lauren, Gina sometimes felt ambivalent about whether she was strik-

FIGURE 6.3. A work from Gina Beavers' bodies series.

ing the right balance between consistency and variation. For a recent studio visit with a prominent curator, she had decided to show the food series and makeup tutorial series, while "hiding" her previous work.

Gina stated, "So I was like, 'This is what I am working on, this is something I am looking at in the future,' just to give her a picture of a broader—but then

sometimes, you are like, 'Is that good?' Should I have just been incredibly specific—like, 'This is what I make now'?"

"What do you think the benefits are of being broad, on the one hand, and specific, on the other hand?" I asked.

Gina explained, "Just showing that you are thinking and that you are not a fixed point. So that they don't have a fixed thing for me to—so they have more in their imagination or you have more in your imagination. Like things that you are interested in and things that could become—and if they are thinking about a couple of different shows, or they are thinking of a group show, there are some more ways that you could fit in or something. And then the positive of being really focused is that it seems like you are serious and that it seems like you are disciplined and focused. Which can be a really good thing too. Those are the two sides of it. And it's tough sometimes to know."

As emerging artists' exhibition opportunities expand to multiple solo exhibitions, they have more space and occasions to display these variations. At the same time, they must still strive to be recognized and to make a distinctive mark on the art world. Emerging artists make different kinds of formal changes, such as by varying media or adding complexity to media, as Gina did when she turned her relief paintings into sculptural cubes. They may also incorporate different imagery as they move to new series, such as switching from food porn to makeup tutorials. At the same time, they maintain certain formal elements, like Gina's relief painting style, as well as broad conceptual associations.

Style scripts help emerging artists establish particular elements as enduring, while also signaling certain variations as potentially becoming more salient within their creative visions. Lauren Luloff's first solo exhibition with Halsey McKay featured large canvases of collaged fabrics upon which she had painted with bleach. The press release established key formal and conceptual consistencies within the creative vision, but did not indicate changes over time:

> Richly layered, complex activity propels the construction of these works as the artist layers bleach-stained bed sheets, muslin, transparent fabric and varying viscosities of oil paint. . . . her works are steeped in an accumulation of personal memories and images. The application of her ordinarily domesticated materials and approaches add boldly feminine strokes to the lineage.[11]

The press release for her second solo exhibition with the gallery, which was written by curator and gallerist Kendra Patrick, reinforced the conceptual element of domesticity and the formal element of bleach on fabric:

Reviewing the way that Luloff has explored domesticity—arguably her portfo-
lio's seminal concept—provides useful insight into the way that she commands
in tandem the various aspects of her practice. . . . Luloff, has been working
with bed sheets for fifteen years now; with bleach for four. This long standing
commitment to mastering her materials pushes the work toward truth in a way
that only earnest devotion can.[12]

Lauren's third solo exhibition at the gallery included a selection of clay
sculptures alongside her more recognized collages. The press release stated:

> In her new paintings, Luloff continues to combine layers of fabric with hand
> painted patterns and plant life into compositions that float like ethereal visages
> on their stretcher bars. . . . For the first time Luloff will exhibit her ongoing
> body of ceramic works. These hardened clay abstractions serve as a dense foil
> to her gossamer-light pictures, elevating earth to air as floating segments of
> glazed stoneware punctuate the walls.[13]

The press release stressed that Lauren was continuing her well-known col-
lages, while presenting a new series of sculptures. It connected the two series
by suggesting that they acted as counterweights to one another, with the solid-
ity of the sculptures juxtaposed to the airiness of the collages. Lauren's fourth
solo exhibition at the gallery introduced yet another media: acrylic paintings.
As with her third solo exhibition, the press release highlighted these changes,
while connecting the new works to elements of the collages. The press re-
lease read:

> Made in tandem with her silk and fabric based works, Luloff's acrylic on raw
> canvas paintings hold the same mastery of color, composition and playfulness
> on a more intimate scale. While still rooted in nature these paintings draw
> more from Luloff's imagination than observation.[14]

The press release suggested that both series were similar in color, compo-
sition, tone, and source material, while the paintings introduced a new media,
smaller scale, and increased abstraction.

Emerging artists present *connected candidates for iconicity*. Formal and con-
ceptual elements are "candidates" for iconicity in the sense that emerging art-
ists' creative visions are understood as still relatively open and evolving, so it is
uncertain which elements will eventually become seen as most representative
of their bodies of work. Emerging artists identify multiple elements as poten-

FIGURE 6.4. Lauren Luloff's bleach-stained fabric collages hanging in her studio.

tially iconic. They work with their dealers to display works and accompanying style scripts that emphasize these candidates for iconicity. With each series, they show the development and breadth of their creative visions by presenting new candidates for iconicity and by explaining these variations in style scripts.

THE PROMISES AND PERILS OF SUCCESS

For emerging artists, "overcoming" an initial bout of success—as Gina Beavers put it—entails creating new series that maintain potentially iconic elements of their creative visions, while also experimenting with new elements for which they may also become known in the future. Established artists face a different problem: how to withstand audiences' already solidified perceptions of the iconic elements of their creative visions. Established artists who develop what they and others see as formally narrow creative visions must decide whether to keep producing or to deviate from these iconic elements. Artist Ran Ortner chose the former route. Ran's works began selling for around $250,000 after he won ArtPrize—an art competition in Grand Rapids, Michigan, in which the public votes on their favorite artwork—for a photorealist painting of ocean waves. Ran is not represented by a gallery, but sells his work directly to collectors and has produced commissioned work for the United Nations and other

organizations. He explained that his earlier work did not sell well in comparison to his ocean paintings.

"You mentioned that there are some works that you haven't sold from earlier in your career. Which are these?" I asked.

"Works from each phase in my production. I did a lot of assemblage, a lot of abstract work, a lot of installations that have pieces and stuff. The installations are all in a storage area in the back," Ran replied.

"Do you find anyone interested in those earlier works?" I questioned further.

Ran explained, "In the art world, we refer to the signature style. If you look at the idea of investing in art, what you're really trying to buy when you buy art is a piece of art that is the very most like that artist it can be. What is the essence of what this person has come to be known as? . . . You want to get that thing that's the essence of who they are. So collectors know that. That's what they're looking at. What people will buy from me is those iconic paintings."

Ran noted that collectors who came to the studio tended to purchase work that comprised the core formal elements of his wave paintings, such as the frothy surf. They wanted to own his iconic work. Ran's process of producing ocean paintings was expensive and time-consuming, requiring several assistants to complete about three paintings per year. Whether or not he creatively

FIGURE 6.5. A studio assistant working on one of Ran Ortner's iconic wave paintings.

justified other work to be worth pursuing, his artistic practice limited the time he could spend on other work while ensuring economic success.

Other established artists who become known for certain formal elements choose to later deviate from these iconic qualities. While those who continue to produce iconic qualities risk being judged as sellouts by their peers, those who diverge from these elements also face social consequences. Artist Katherine Bernhardt, who was represented by the critically acclaimed CANADA gallery, became known for a series of sloppily painted fashion models. The series had sold well and received positive reviews. She explained to me that she felt that she was finished with the series, and she began making collaborative works with her husband, consisting of collaging African textiles on canvas. She connected the collages to her previous paintings by calling this series "rug paintings," and therefore claiming that these mixed media works could be paintings, in a way. CANADA declined to exhibit the series, but arranged to have the works exhibited at a different gallery, The Hole. The exhibit was praised by the *New York Times* critic Roberta Smith, who mentioned the visual departure from her earlier work, while explaining that the new works were made with Katherine's "characteristic verve."[15] However, as Katherine claimed, the exhibition garnered no sales. Despite Katherine's description of the collages as paintings and Smith's enthusiastic statement that the new works were consistent in spirit, collectors apparently did not buy this interpretation.

Katherine ultimately returned to producing series in her more recognizable painting style and exhibiting them at CANADA. CANADA's website displayed sixty-six images of Katherine's work, all of them featuring paintings in her iconic sloppy painting style. We sat in Katherine's studio in Flatbush, Brooklyn, surrounded by rolled-up canvases, with her toddler son running circles around our chairs and occasionally dousing us both with his squirt gun. Katherine showed me her new series: paintings patterned with cigarettes, basketballs, and juice boxes, the paint trickling messily down white canvases as in her previous series of models. This series sold out. Roberta Smith hailed the exhibition as "terrific" and as "lay[ing] the groundwork for even better ones."[16] Katherine continued to show paintings in this style. In a later series of neon, drippy paintings, Katherine placed icons like Mickey Mouse and Garfield in the foreground, with her familiar patterns in the background.

A year later, I walked into CANADA's booth at the Frieze New York art fair. Two of Katherine's brightly colored paintings of Nike shoes, tacos, and toilet paper rolls hung on one wall, and three rug collages were exhibited on the opposite wall. I asked the dealer the price of the works, and he replied that

FIGURE 6.6. Katherine Bernhardt and her son in her studio, with paintings in her signature messy style and a rug collage in the background.

the paintings cost $25,000 and $30,000, but that the rug collages were only $6,000 each.

"Why the price discrepancy?" I questioned, "They are about the same size."

He explained, "Well, she is really more noted for these kinds of paintings."

In terms of the formal qualities of contemporary artworks, size is the strongest predictor of price.[17] Dealers tend to price every work of the same size and medium within an artist's exhibition at the same price point. As artists continue to exhibit their work and accrue other status signals, like reviews and museum exhibitions, dealers incrementally raise the price point. Dealers may mention to collectors which works are their personal favorites or about which works the artist feels particularly strongly, especially if collectors themselves seem to lean toward these works. But, as sociologist Olav Velthuis has argued, they generally do not price works of the same size and medium differently, because this would suggest that the works are of unequal aesthetic quality.[18] They also avoid pricing work too low or decreasing the price of works, as this would signal to collectors that the work was not valuable. To contend with varying demand for different bodies of work, dealers find strategic ways to reduce prices while not seeming to do so, such as awarding discounts to loyal clients or increasing the size of works while maintaining the same price. The perceived iconicity of work can also affect price. In Katherine's case, while the rug paintings and more traditional paintings differed in media, the dealer had apparently priced them differently based on public perceptions of the works' iconicity.

Established artists who stop producing iconic qualities risk losing the interest of dealers and collectors. How do these artists work to manage these consequences? Cheryl Donegan became known for her 1993 video entitled, in an allusion to fellatio, *Head*. In the video, the artist, wearing a leotard and lipstick, voraciously drinks milk that spurts from a hole in a jug. The milk flows down her chin and chest as she repeatedly spits it back into the jug and onto the adjacent wall. The work was reviewed by *Artforum* and other periodicals and acquired by MoMA. Decades later, *Head* remained Cheryl's most prominent work. I asked her why she had not made other variations of *Head*.

She stated, "I felt like to say, 'I am gonna do that with *Head*—and now it's orange juice, and now it's wine, and now it's hot chocolate,' would be ridiculous. It would be idiotic."

Cheryl continued to make feminist video and performance art. However, in the last decade, she broadened her practice, experimenting primarily with

paint on canvas by spray-painting in acrylic plaid patterns and collaging ging-ham cotton cloths. She also ventured into the world of fashion, designing dresses that accompanied the paintings and creating installations involving the clothing. I noted that her website, which now featured two separate pages for her older videos and newer paintings, had omitted *Head*. Cheryl explained:

> I don't want to be overly defined by *Head*. . . . I just feel like in that sense it's a limit as well as a promotion. . . . And so, even though it is a calling card for people, it can also be a distraction because of that limit. And because it's very easy to search, it always comes up like right in the first couple of lines or images when you search for me, so I sort of feel like it is really easy to find. What I have been doing now, I feel like it's less easy to find, but I think when people come to it, you know, and *Head* isn't leading the way necessarily, they see so many things that could be said to be similar, even the color, the mood. There is a lot of parallels, it is just in a different form.

Apparently, Google's algorithm had strongly associated Cheryl's name with *Head*. In this sense, she felt that the prominence of *Head* limited her, even as it had earned and continued to give her exposure. She decided to prominently display her lesser-known paintings on her website in order to encourage her audience to contend with this series and view it as also representative of her creative vision. Artists earlier in their careers, like Jairo Alfonso, may omit past works on their websites in order to emphasize distinctive formal elements for which they would like to become known. In contrast, established artists, like Cheryl Donegan, may exclude previous works in order to downplay distinctive formal elements by which they feel they have become "overly defined."

Cheryl's artist statement further highlighted the connections between her older videos and newer paintings:

> Donegan's work integrates the time-based, gestural forms of performance and video with forms such as painting, drawing, and installation. Direct, irreverent, and infused with an ironic eroticism, Donegan's works put a subversive spin on issues relating to sex, gender, art-making and art history. Using her body as metaphor in her earlier works, Donegan's performative actions before the camera often resulted in or related to process paintings and drawings. More recently, the paintings often lead the video work as Donegan derives abstraction from debased images of consumer objects and spaces. As critic Nick Still-

man writes in *Artforum*: "Donegan's recent work remains acidic, but it has turned abstract."

In the statement, Cheryl argued that the older works gave rise to the new works, asserting that the abstraction in the paintings derived from the "debased images of consumer objects and spaces" that characterized her videos. In particular, she stressed the conceptual consistencies between her videos and paintings, plucking the reference to her "acidic" tone.

From her early days as a video and performance artist, Cheryl's work had been critically acclaimed, but she had struggled with commercial success. Video art and performance art are difficult media in which to sell works. Many collectors do not like to invest in reproducible objects that will become technologically obsolete, and although artists sometimes sell props from performances, collectors do not see these objects as the same as the work itself. Furthermore, Cheryl exhibited her work at more critically oriented galleries and experienced the common misfortune of being represented by several galleries that had gone out of business. However, she managed to make a career as a video artist and to sustain this career when she began exhibiting works in other media. Like the videos and performance pieces, her new works achieved significant critical success with reviews in top magazines and newspapers. In 2015, the New Museum gave Cheryl a retrospective. She paired her videos with newer paintings and fashion designs. The curatorial statement read: "Working across video, painting, and performance, Cheryl Donegan (b. 1962, New Haven, CT) explores the production and consumption of images in mass culture, middlebrow design, and art history."[19] The statement described Cheryl's creative vision as focusing on conceptual themes that she produced across media. The *New York Times'* critic Martha Schwendener hailed the exhibition as "excellent" and argued that the new paintings "exemplif[ied] a de-skilled, D.I.Y. aesthetic."[20]

Established artists, whose audiences have crystallized perceptions of their creative visions, make *associations with the iconic* when they present new work. Some continue to produce widely recognized formal elements. Others stop producing these elements and must work to convince viewers that new elements are formally and conceptually linked to their iconic formal elements. The latter tend to seek exhibition opportunities at more critically oriented galleries, museums, and alternative exhibition settings for their works, and this institutional support can give clout and visibility to their expansive visions. Retrospectives allow artists to exhibit their works in larger exhibition spaces where audiences can see work from multiple series. In these settings,

established artists can show works representing both more and less iconic elements alongside each other and explain the connections between the two in accompanying style scripts.

CONSTRAINING VISIONS

For Daniel Dove, boredom was not just a temporary emotional state. It was a career liability. Even as he received affirmations from his peers for not "selling out" by maintaining narrow formal elements, he also expressed frustration with how he perceived his creative choices to have impeded his career. As an emerging artist, Daniel had already presented several series in solo exhibitions, but he asserted that he had varied formal elements too often for any of these elements to become widely known as iconic of his creative vision. Had Daniel been a more established artist, he would have likely confronted a different problem—how to make new works that audiences associated with elements that they already accepted as iconic. Artists must attain recognition, and then overcome it.

Artists' decisions regarding their creative visions become fraught in different ways over their careers. Uninitiated artists exhibit works that they believe display the most distinctive elements of their creative visions and will accurately represent their desired future direction. They often perceive narrow formal elements, such as metal "skewers," as most amenable to recognition. Emerging artists want to build upon their recognition, but also show that their creative visions are not stagnant and allow room for future changes in their bodies of work. They signal directionality and breadth by maintaining consistency in what they view as core formal and conceptual elements of their creative visions while also varying certain elements, such as medium. Established artists contend with viewers' solidified perceptions of their creative visions. Some continue to present iterations of their recognized iconic works. Others deviate from formal consistencies, citing creative exhaustion, and draw formal and conceptual connections between iconic works and new works.

Artists change how they present their creative visions over their careers as their public recognition grows. They shift from trying to make an initial mark on the art world, to showing how their trajectory has evolved, to displaying how new work connects with iconic elements. As artists become increasingly well known, they gain access to more resources for exhibiting their work. An artist exhibiting work in a group exhibition will be able to show only a few works with little explanation included, whereas a solo exhibition allows an artist to present many works from a series accompanied by a press release, and

a retrospective exhibition affords the possibility to show works from multiple series and to describe the linkages between them. Artists' location in the art world also affects how they present their creative visions. Those working with critically oriented galleries and museums are more likely to find more institutional support for producing formally broad creative visions.

Artists and those who exhibit their works display certain works and use style scripts to influence how viewers perceive similarity and difference among elements in their bodies of work. When high-status viewers, like critics and curators, reinforce these style scripts, the meanings that artists assert gain more public credibility.[21] However, no artist has complete freedom to determine how their work will be interpreted by viewers. Artists cannot always convince viewers that textile collages have the "characteristic verve" of drippy paintings of soda cans and cigarettes or that gingham fabrics have the same "acidic" feminist tone as *Head.* Viewers must see these connections to some degree in the formal qualities of the work itself. They perceive certain formal elements with greater consensus and clarity. For example, viewers have a common interpretation of painting as a liquid pigmented medium. While Katherine Bernhardt called her collages "rug paintings" to connect them to her previous painting series, many seemingly still judged them as collages. As viewers saw Katherine's sloppy painting style as iconic, they did not consider the collages as highly representative of her creative vision. When viewers perceive two formal elements as obviously dissimilar, they are likely to view style scripts that link these elements as unconvincing at best and "bullshit" at worst.

Viewers more often perceive formal elements, rather than conceptual elements, as iconic, because visual artworks are mentally indexed and recalled as images. While viewers associate both formal and conceptual elements with an artist's body of work, it is the formal elements that imprint themselves on retinas and burrow into memories. Their visceral, material quality lives on in viewers' minds. When many viewers think of Cheryl Donegan's work, they visualize a woman chugging milk from a neon green jug against a cotton candy pink background. Artists may feel that viewers have falsely reduced their creative visions to the most iconic formal qualities, because artists have more expansive views about what is representative of their creative visions. Each artist is privy to all of his or her work in its various stages of development, including sketches, unfinished works, stored works, and even nascent ideas that have yet to be realized. The artist has the most comprehensive view of the "distributed object"[22] that is their body of work. In contrast, each other viewer encounters only a smaller slice of this object.[23]

Artists, dealers, curators, critics, collectors, art advisers, and others in the

art world communicate to each other multiple ideals related to creative visions. They assert that artists with "true" creative visions should be aesthetically obsessed with certain elements, while also being driven by a need for continued exploration. These ideals influence viewers' expectations of how artists' bodies of work should look over the course of their careers. Artists often experience these ideals as creative constraints. At different career stages, they feel pressured to mark their territory, to maintain a delicate balance between consistency and variation in elements, or to overcome their own success in establishing iconic elements. The creative process is constricted by the idea of creativity itself.

Conclusion:
Aesthetic Judgment
in the Creative Process

When we left Lucky DeBellevue at the beginning of this book, he was hovering near the edge of Mark Beckman's fair booth. With his fists in his jean pockets and his eyes wandering uncomfortably to other booths, he looked like he wanted to be anywhere else. He was watching collectors and curators passing over his new works of cut, printed, and pistachio shell studded canvases with cursory gazes. Would they, literally and figuratively, buy his creative vision?

Having examined the creative life of artists in their studios and then stepped back to view the creative process through the wider vantage point of the art world, we can now make sense of Lucky's work and career. Lucky and the other artists, dealers, curators, collectors, and art advisers discussed in this book provide a window for us to explore artists' interactions with materials in their studios and other people in the art world. Analyzed together, their stories reveal how artists come to understand their distinctive creative visions through the process of experimentation, and how they negotiate others' interpretations of their creative visions as their work circulates through the art world.

As Lucky produced his pipe cleaner sculptures, he felt an excitement that buoyed further experimentation. Ideas for variations of these works popped into mind: he could entwine feathers into the pipe cleaners, weave the pipe cleaners into various shapes, or interlace different colored pipe cleaners. Gradually, the squat globules evolved into sprawling multicolored webs. He also drew conceptual associations to the pipe cleaners, viewing the craft materials as associated with the DIY movement, "anti-macho" femininity, and the impermanence of life in a time of AIDS. By experimenting with these varia-

tions, he developed "creative competencies" in both technical know-how and conceptual understandings. Observing the formal and conceptual consistencies within this series, he felt that the series represented core commitments in his creative vision and his identity more broadly. But after years of pipe cleaner variations, his excitement wilted, and mind-numbing boredom set in. This was not how an artist was supposed to feel. He started experimenting with non–pipe cleaner materials, cutting out rubber shapes and printing them onto canvases, and then making new rubber shapes by tracing the white spaces. The rush of excitement returned. He conceptually linked the works to his more iconic works by describing his body of work as having an overarching DIY aesthetic. Over time, Lucky's creative vision shifted and expanded.

While Lucky saw the pipe cleaner sculptures and pistachio shells as sharing common themes, he had to persuade others that the pipe cleaner sculptures and the pistachio shell canvases were part of the same cohesive creative vision and that the new works were iconic enough within this creative vision. When Mark decided to invest in Lucky's creative vision by representing him and exhibiting his work, Lucky's problem became Mark's problem. At the NADA New York art fair, Mark flipped through an exhibition catalog and a portfolio binder that pictured both the old and new work, explaining to collectors that Lucky's pistachio shells on canvases were conceptually linked to his pipe cleaner sculptures because both referred to the DIY movement, used humor, and employed nontraditional media. Selling Lucky's work required selling his style script. Central to this style script was an explanation of what formal and conceptual elements were core features of Lucky's creative vision and how new works were linked to these elements.

And yet, upon entering Mark's booth, collector Peter Hort asked, "This is Lucky? I have his pipe cleaners." Even if Peter saw the pipe cleaner sculptures and pistachio shell canvases as conceptually related, he ostensibly did not see the pistachio shell canvases as iconic enough. While Peter would likely have had a less crystallized perception of a more emerging artist's creative vision, at Lucky's current career stage, the image of the pipe cleaners was firmly lodged in Peter's mind. Peter perceived the pipe cleaner sculptures as resonating with his own vision as a collector and as epitomizing what he valued about Lucky's mature creative vision. If he were to purchase more work by Lucky, he would still want to be able to look at it and say, "That's a Lucky DeBellevue." After lingering politely for a minute or so, Peter walked on to the next booth. He would not be investing in Lucky's creative vision today.

UNDERSTANDING CREATIVE VISIONS

Art critics can argue over whether Lucky DeBellevue's creative vision is distinctive, but his story is not unique. Lucky's work and career prompt broader questions about aesthetic judgment: What makes something aesthetically valuable? When is a work of art innovative, interesting, or good? These are big questions, which social scientists and humanists have pondered for centuries.

Aesthetic value is uncertain and indeterminate. Works of art are, by definition, one of a kind, and there is no standardized or objective way to evaluate them.[1] The value of contemporary art is especially unpredictable, as these works have not yet stood the test of time, and because traditional markers of value—like beauty—are less relevant criteria for aesthetic judgment.[2] Cultural and economic sociologists have argued that, in the absence of standardized criteria for value, audiences rely on status signals, such as reviews, rankings, prizes, and prices, to judge works of art. But aesthetic judgment cannot be fully accounted for by status signals. Status signals do not explain how artists make aesthetic decisions during the creative process, or why those who circulate their work choose certain artists over others with similar statuses, or how they interpret the meanings of work. Examining perceptions of creative visions gives us a key puzzle piece in addressing these questions.

First, analyzing perceptions of creative visions helps us understand how artists experiment during the creative process. Artists' perceptions of their creative visions emerge from experimentation, rather than merely being executed through experimentation. Artists test source materials through low-stakes experiments, the results of which are always somewhat unexpected. When they feel excitement, as Lucky initially did with his pipe cleaner sculptures, they produce iterations of these elements in other works, and they intellectually search for formal and conceptual connections to their previous works. As artists look back upon their bodies of work and consider the linkages among their works, they increasingly associate repeated elements as key components of their creative visions that reflect their aesthetic interests and commitments. They want to remain "true" to their own creative visions, while also continuing to develop these visions. When deciding which ideas to pursue and evaluating the material results, they ask themselves, "Is this my vocabulary?" "Is this my fingerprint?" "Is this me?" They also consider how others will aesthetically judge their works. What will their studio mates, their MFA program peers, and the fellow artists in their galleries' programs think? Will their dealer like or even be willing to exhibit the new works? How will both loyal and unac-

quainted collectors react? Their evolving perceptions of their creative visions feed back into the cyclical creative process, informing which source materials they use for future low-stakes experimentation and how they evaluate the results of experimentation. Artists judge their works not as aesthetically good or bad in an objective sense, but as more or less interesting and relevant to their distinctive creative visions.

Second, examining perceptions of creative visions provides an explanation of how cultural intermediaries (i.e., dealers, curators, and critics) and audiences or consumers (i.e., collectors and art advisers) choose some artists and artworks over others. In their daily interactions within the art world, artists, dealers, curators, critics, collectors, and art advisers communicate why and how they value creative visions. They convey that the true artist is one who elevates aesthetic concerns over economic interests and who has steadfast aesthetic commitments. Through written and verbal communication, they also express to one another their interpretations of specific creative visions and their expectations about how creative visions should evolve in general. Dealers respond to collectors' demands by obliquely telling artists what kind of work is marketable, while also interacting with collectors in ways that help train collectors' eyes. Together, those in the art world uphold the idea that a good creative vision is one that is distinctive and has enduring consistencies, while evolving through continued experimentation. Those who exhibit and collect artists' works tend to prefer iconic works—or works that they view as most representative of artists' creative visions—because they value artists' works precisely for their visions.

Third, exploring perceptions of creative visions improves understandings of how people form social networks, or durable relationships with others, in the art world. Dealers and collectors have their own creative visions, lasting aesthetic commitments that they view as represented by their gallery programs and collections. They not only select artists by referencing status signals, like exhibition histories and prices, but also use their social networks to find artists whom they view as aesthetically aligned with their own creative visions. As with artists, the creative visions of dealers and collectors cannot be boiled down to simple categorizations into genres or artistic movements. As creative visions are clusters of formal and conceptual elements, a dealer or collector can identify aesthetic fit with different elements. A collector might purchase Lucky's work because of the feminist theme or the nontraditional media and purchase another artist's work because of the palette or a special memory that the work elicits. When dealers and collectors select works according to per-

ceived aesthetic fit, they form working relationships with these artists, some of which are no more than singular transactions and others that ultimately span decades. Perceptions of aesthetic fit among creative visions shape the social networks in which artists are embedded.

Finally, exploring perceptions of creative visions allows us to more fully understand how those other than artists, particularly intermediaries and consumers, influence the creative process. Artists may view their creative visions to be self-evident. But to exhibit and sell their works, they must communicate to others that they have original creative visions and that particular works are representative of these visions. This process of translation is not always smooth. The collectively upheld idea of creative visions is one in which artists must show their commitment and originality by displaying enduring and distinctive elements in their works. They must also express that they care more about artistic experimentation than money by continuing to change elements of their work. When artists are less well known, displaying distinctive formal elements helps make them recognizable. Once these elements become widely understood as characteristic of their creative visions, audiences often devalue works that they view as deviating from these elements. Artists manage these competing pressures in different ways over their careers as their exhibition resources and recognition change.

Perceptions of creative visions anchor aesthetic judgments. They allow people to interpret and judge the content of work in a world where any media, technique, or subject matter can potentially make for "good" art. Artists, dealers, curators, critics, collectors, art advisers, and even casual viewers rely on their perceptions of creative visions to interpret the meaning of individual works within a body of work and in comparison to other artists' bodies of work. They evaluate whether the body of work is distinctive enough, if it has evolved enough, and whether each work is representative enough of the body of work. To understand how contemporary art and other cultural works are produced, distributed, and consumed, one cannot focus only on artists' careers, or the creation and circulation of individual works, or affiliations with genres or artistic movements. One must also examine how various actors within a cultural field develop, maintain, and negotiate perceptions of creative visions through their interactions with artworks and each other. Questions like, "How does an artist choose the medium of pistachio shells over that of pipe cleaners?" can lead us to the more general question, "How does a contemporary artist recognize and communicate his or her creative vision?," which can prompt the even broader question, "How do artists experiment in the creative process?"

Addressing these questions can engender understandings of how people

aesthetically judge works in other creative industries. Perceptions of creative visions are particularly important in fields where originality is highly prized. Originality is more salient in creative industries and sectors of creative industries in which creative producers especially rely on critical recognition for status and in which they position themselves as avant-garde. This includes Michelin star chefs, independent filmmakers and actors, experimental musicians, and critically acclaimed novelists. For example, a critic of a high-status restaurant will likely care about how the chef's vision is executed through the menu and ambience and will reflect on the chef's previous ventures, whereas a casual diner will be more concerned about whether his or her dish is tasty. Originality is particularly important in the contemporary art world, where artists are supposed to elevate aesthetic interests over economic concerns and where art movements have become less salient. Within the contemporary art world, originality is most emphasized for contemporary artists who show in critically reviewed galleries and sell work to elite collectors.

Creative visions are also most salient where there is high competition and potential payoffs in terms of money and prestige. Creative industries are "winner take all" markets, where the lion's share of the spoils goes to a few, and competition is particularly intense in certain places, such as the Hollywood film industry or the Korean pop industry. Creative visions are most socially significant in situations where people expend considerable resources on creative works. The person who finances a film will be more invested in the creative vision of a director than a moviegoer for whom much less time and money is on the line. The New York contemporary art world epitomizes a high-stakes market. Artists flood into the epicenter of the art world with outsized aspirations, and only a fraction of them will ever make their livings as artists. They strive to make their names by producing distinctive creative visions. Dealers and elite collectors invest their careers, reputation, and money in artists' bodies of work, and their decisions hinge on how they assess artists' creative visions.

Studying perceptions of creative visions in the contemporary art world reveals how, across cultural fields, creative producers make decisions about when to vary certain formal and conceptual elements, how they decide which elements to vary, and how they present these decisions to others. We see this most dramatically when they make decisions that they and their audiences view as sudden and significant shifts in their creative visions. Novelists like J. K. Rowling, Stephen King, and Nora Roberts publish books that they do not perceive as fitting their creative visions under different pennames, as if these books were written by entirely different authors. Chefs contend with the ire of loyal customers when they remove signature dishes from the menu

in an effort to change their restaurants' images.[3] Academics feel the freedom to depart from their collectively recognized creative visions once they achieve lifetime job security, embarking on their "post-tenure projects." As we zoom out from the contemporary art world to capture cultural fields at large, we can explore how differences in media and techniques—from the novelist's computer screen to the chef's chopping block—and various social structures surrounding creative processes—from the ivory tower to Silicon Valley—make certain kinds of creative works possible and others unlikely.

UNDERSTANDING AESTHETIC JUDGMENTS

Examining perceptions of creative visions sheds light on how people make aesthetic judgments more broadly. This focus reveals that aesthetic judgments are relational, temporally linked, and affective. First, aesthetic judgment is relational in that a person's aesthetic judgments are shaped by their interactions with objects and the aesthetic judgments of others in different social roles. Artists form understandings of the creative process by doing it. They learn that they should test out new elements in low-stakes settings, that they will grow bored after a certain number of variations, and that ambivalence about new elements will turn into enthusiasm when they can conceive of these elements as part of their distinctive visions. It is through experimentation itself that artists come to understand the creative process as nonlinear, unpredictable, and highly individualized. Artists then communicate the nature of the creative process to their dealers and others in the art world, and dealers work to sell certain style scripts to collectors and other viewers. In turn, collectors narrate their own aesthetic judgments to other collectors and dealers, and dealers communicate collectors' preferences to artists. Through these interactions, different actors in the art world convey to each other how the creative process unfolds, what a true creative vision looks like, and which elements characterize specific creative visions.

Second, aesthetic judgments are temporally linked. Artists make multiple aesthetic judgments of their artworks before, during, and after the creative process. In each moment of judgment,[4] they compare what they imagine the work will become with how the work actually materializes. These moments of judgment are connected with their judgments of other artworks. They evaluate their works based on the perceived relationship between the present work, their past works, and their imagined future works. They also situate the work in a landscape of works by other artists. As works circulate, other people—dealers, curators, critics, collectors, art advisers, and casual viewers—also

make aesthetic judgments. These aesthetic judgments are shaped by their aesthetic judgments of the same work, the artist's previous works, and the works of other artists. For example, a collector who displays a work in his or her home makes many aesthetic judgments of the work after the initial purchase. His or her aesthetic judgments can change over time as the collector rotates different works in the collection and continues to develop his or her "eye" through exposure to other works.

Third, aesthetic judgments are affective in nature, in that artists' emotional responses to the results of experimentation influence their creative decisions. Material objects often evoke emotional reactions. The contemporary art world and other cultural fields are especially good places for observing these emotional responses, because people expect to experience art emotionally and believe that expressing these emotions is valid. During the creative process, artists react to the results of experimentation emotionally and search for interpretations of the work that will align with their emotional responses. Certain emotions—like excitement, ambivalence, and boredom—tend to push artists toward particular creative decisions, such as repeating elements, pausing a work, or abandoning elements. Those who exhibit and collect artists' works also respond to work emotionally, and their emotions affect their decisions of which works to select.

By examining aesthetic judgment as relationally influenced, temporally linked, and emotionally felt, we can analyze the creative process itself as *a sequence of judgments directed toward objects that is oriented by social values.*

A sequence of judgments: Creative decisions are not only made in advance of production and then executed as planned. Instead, artists have many moments of judgment throughout the creative process, from the moment that they recognize an idea as such to the moment that they decide a work is complete. The potential pathways are infinite; however, artists continually identify a subset of choices and decide which choices to pursue. These moments of judgment are linked in temporal sequences, as each moment of judgment is influenced by previous judgments and guides future judgments. The links are fastened to each other by the physical materials that artists use during the creative process and artists' evolving imagination of the work. Each sequence represents the judgments regarding the work from start to finish. Sequences of judgment intersect with other sequences of judgment, as judgments of works are influenced not only by previous judgments of the same works, but also of other works by the artist and by other artists. It is not possible to catch the whole temporal flow of aesthetic judgment, as moments of judgment are fleeting and one moment merges with the next. However, by identifying multiple moments

of judgment, such as different stages of the creative process, one can better understand how past judgments affect future ones.

Directed toward objects: Judgments within a sequence are related through their directedness toward objects. In other words, artists make judgments through their engagement with media. Each time artists alter the physical work, they leave a gap between expectation and materialization, transforming their imagined work and allowing recognition of new possible variations. Artists' past decisions in making their works influence decisions about future works, as they assess material outcomes and then consider possible creative decisions in light of these results. Judgments are attached to and linked by artists' evolving works. One must focus both on how artists judge their works in the studio at different stages of the creative process as well as on how others' judgments of these works shape artists' future decisions. Examining the matrices of judgment among people in different roles reveals how the creative process and artists' interactions within the art world influence one another.

Oriented by social values: Artists evaluate ideas based on multiple forms of judgment.[5] For example, artists might weigh beliefs that collectors will want to buy certain works—an economic judgment—against perceptions that these works are not innovative—an aesthetic judgment. To choose one course of action over another, artists must be able to recognize and appraise potential decisions across multiple forms of judgment. These forms of judgments intertwine and flatten into decisions when artists choose courses of action. Artists learn what makes a work interesting or relevant to them and others through their engagement with materials and their social interactions. This orientation shapes their emotional responses, which in turn provide the impetus to construct style scripts that justify why particular elements are interesting and relevant. When one examines the creative process in action, one should distinguish specific emotions that arise and analyze how artists make sense of these emotions.[6] In doing so, one can account for aesthetic judgment in a way that retains and explains its intuitive quality, while also identifying broader social patterns. This theoretical and methodological approach for studying aesthetic judgments captures how material objects, relationships between those in different social roles, past and future judgments, and multiple forms of judgment shape the creative process.

Understanding how different people perceive creative visions reveals how artists and others make aesthetic judgments by assessing similarities and differences within and among bodies of work. This focus can help explain why artists change or maintain particular elements of their work, how they weigh

these decisions at various career stages, why some works are more popular than others by the same artist, and why some artists become more economically or critically successful than other artists. It demystifies the inner workings of the art world without stripping artworks of their special quality as objects of human expression.

ACKNOWLEDGMENTS

As a cultural sociologist, I appreciate that every creative work is collectively produced. This book is no exception. My interactions with mentors, colleagues, friends, family, and study participants over the past decade have deeply shaped this project, and without them, it would have never come to fruition. My graduate advisers, Gary Alan Fine, Wendy Griswold, Bruce Carruthers, Claudio Benzecry, and Charles Camic, each filled a distinct and essential role. Wendy Griswold taught me to think inductively from my empirical findings, encouraged me to pursue my quirky interests, and helped me develop my intellectual identity as a cultural sociologist. I learned the art of academic writing from Charles Camic, who also provided me with the foundation to link my research to the sociology of knowledge. Bruce Carruthers convinced me that I was, in fact, an economic sociologist. Claudio Benzecry and I had valuable discussions on art, materiality, and life over long coffee chats in New York.

I extend a special thanks to my chair, Gary Alan Fine, to whom I owe a debt that I can never repay. In his graduate course on ethnography, I learned to listen to the data. Gary patiently honed my analytic and writing abilities by insisting that I "write it down," reading and rereading my most terrible drafts, providing unfailingly astute and prompt feedback, and enduring my stubborn arguments over partially formed ideas. He guided me, while allowing me to find my own footing and never saying, "I told you so" (even though, in the end, he was almost always right). I try to follow his example of how to research and live by pursuing my intellectual interests and tracking down delicious food off the beaten path.

In 2017, I was hired as a postdoctoral research fellow in the sociology de-

partment at Columbia University. Shamus Khan provided excellent mentoring, and I greatly benefited from my relationships with others in the department, including David Stark, Josh Whitford, Diane Vaughan, Jennifer Lena, and Denise Milstein. After my postdoctoral fellowship, I was fortunate enough to receive a tenure-track position in the sociology department at the University of California, Santa Barbara. My colleagues have been welcoming, supportive, and intellectually stimulating. In particular, Maria Charles and Linda Adler-Kassner have been wonderful faculty mentors.

I have been extraordinarily lucky that my colleagues have been so much more than that. My cohort, especially Anna Hanson, Alka Menon, Marcel Knudsen, Kangsan Lee, Carlo Felizardo, and Iga Kowalski, taught me that the sum is always greater than its parts. I cannot imagine charting this career path without them. During my fieldwork in New York City, my writing group, Gemma Mangione, David Reinecke, Hillary Angelo, and Stacy Williams, proved to be great colleagues and even better therapists. In the larger communities of cultural sociology, economic sociology, ethnography, and sociological theory, scholars have been unexpectedly generous with their time and advice throughout my career. While I do not have room to name them all here, I extend a special thanks to Fabien Accominotti, Gianpaolo Baiocchi, Patricia Banks, Shyon Baumann, Max Besbris, Clayton Childress, Paul DiMaggio, Gregory Elliott, Dennis Hogan, Frédéric Godart, Fiona Greenland, Neil Gross, Terence McDonnell, Michael Mauskapf, Ashley Mears, Ben Merriman, Ann Mullen, Craig Rawlings, Isaac Reid, Iddo Tavory, and Michelle Weinberger.

Many scholars provided feedback on this research in workshops, including the Culture and Society Workshop at Northwestern University, the Ethnography Workshop at Northwestern University, the NYLON Workshop at New York University, the Initiative for the Study and Practice of Organized Creativity and Culture at Columbia University, the Collaborative Organization and Digital Ecologies Seminar at Columbia University, and the Sociological Workshop on Aesthetics, Meaning, and Power at University of Virginia. In December 2018, I held a book conference at Columbia University, where Alison Gerber, Frederick Wherry, and David Grazian provided invaluable advice on this manuscript. At the University of Chicago Press, Doug Mitchell took a leap of faith on an early career scholar by acquiring this manuscript. I will miss our correspondences about philosophy and art. Elizabeth Branch Dyson expertly guided the manuscript through the editorial process, Mollie McFee provided vital assistance as an editorial associate, and Audre Wolfe gave insightful feedback as a developmental editor. Marisa Meno and Amanda Rodriguez were

excellent research assistants. I am especially grateful to the artists, curators, dealers, art advisers, and collectors for letting me into their studios, galleries, and homes, opening their communities, and sharing their perspectives.

I appreciate my friends for putting up with me through the highs and lows of the research process. I thank my mother, Alba Passerini, who always finds the silver lining, and my father, Charles Wohl, who punctuates our conversations on any topic by insisting, "It's all sociology!" I am grateful to my partner's family for nurturing my interest in art. Most of all, I thank my partner, Jesse Gelburd-Meyers, for sparking my intellectual curiosity, talking through every idea, and supporting me in finding my own creative vision.

I have loved visual art for as long as I can remember. As a child, I would beg my parents to take me to museums, where I would walk from room to room until my legs were sore, staring with intensity at certain works. While I never considered myself skilled enough to pursue a career as a visual artist, I also enjoyed making art. Throughout high school, I could often be found after school drawing in the art room, and, once in college, I eagerly enrolled in a variety of art history and studio art courses. I found myself particularly captivated by contemporary art. I was taken by the idea that a concept or emotion could be rendered not in words, but in visual media. I wondered how this alchemy was possible. How did artists materialize a mental thought or image into a physical form? What made these forms represent the ideas that artists imagined? When were other viewers moved or unmoved?

As my passion for visual art developed, so did my sociological perspective. My undergraduate sociology courses taught me that social scientists could mentally deconstruct the social world as if it were made of Legos and examine how it was constructed. I was fascinated by how one could analyze these building blocks through a microscope or a bird's-eye view, observing everything from mundane interpersonal interactions to large-scale social changes. In graduate school, I connected my interests in art and sociology. As I read the academic literature on aesthetic judgment, I also became convinced that social scientists had not fully interrogated this topic. I wanted to better understand how artists produced their work in fields where standards of aesthetic judgment were highly uncertain.

This was how I ended up, on a balmy summer day, in contemporary artist

Ray Smith's Brooklyn studio. When I entered the high-ceilinged warehouse, I found Ray, a man in his sixties wearing shorts and a Hawaiian t-shirt, varnishing wood in the middle of the room. I had been put in touch with Ray through a family member who had known him in the 1980s. I called Ray, and he said I could come by to chat for a few minutes. When I explained what I wanted to study, he called my project "ambitious" in a tone that conveyed more skepticism than praise. Ray told me that I could ask him some questions, but not record. I sunk into a shabby, deep couch, and we started to talk, our conversation ranging from Picasso to the Miss Venezuela beauty pageant.

At one point, I asked, "How do you know when you've made something innovative or new?"

"It's a gut feeling, drawing on something never been done before, it's a sensation, riding on something magic between the lines, if you do something enough, there is the anomaly of doing that takes you to a new place. . . . There is the act of creation, but within that there is also an act of destruction," Ray replied.

Later in our conversation, we discussed the problem of value in contemporary art. Ray gestured to the concrete floor, which was spattered in dried paint, "Artists are trying to solve a problem of reality, to create something you don't see. Like these spots on the floor. Why isn't this just as good as anything else out there? It probably is. There are certain things that are invisible, you can't see it unless it dawns on you."

I asked Ray, "How do you separate the splattering on the floor from the work that gets made?"

Ray responded, "You are on a roll, you tapped into something, you are able to run with it, there is a flow of images, once you are in a place like that, somehow you can sense it, the thing knows itself."

At the end of our conversation, Ray pronounced my project to be "interesting," saying that he had been asking the same questions for years but had never seen them studied. He invited me to come back to his studio the next day and to turn on my recorder this time. I left Ray's studio with my mind reeling. I felt, in equal parts, elated and overwhelmed. I was excited and grateful that Ray and I had had a substantive theoretical discussion about art. But interviewing artists, I realized, would come with a host of methodological challenges. I wanted to understand artists' concrete artistic practices, to know what they did inside their studios. However, artists wanted to talk about their hearts and minds more than their hands. Artists were tasked with explaining to the rest of the world why people should pay thousands of dollars for objects that often required little technical skill or were made with low-cost materials.

They needed to convey how these sometimes simple objects contained complex ideas. In subsequent interviews, artists met my questions about artistic practice with talk of high theory, using words like "liminality" and "biopolitics" to describe their work. Furthermore, artists argued that much about the creative process was indescribable. They could not fully explain their aesthetic judgments because they formed these judgments at least partially in the realm of unconscious intuition.

As I interviewed more artists, I revised my original questions and interview approach to capture artists' aesthetic judgments with more detail and precision. I did not directly observe artists making their work, as most artists would find a hovering ethnographer to be disruptive to the creative process. Moreover, artists work on projects iteratively, picking up and putting down projects unpredictably. They tend to work without speaking and, therefore, their moment-to-moment reasoning about artistic decisions is not available to the researcher in an unmediated way. Instead, I began using specific artworks as "probes" that allowed me to discuss particular sequences of creative decisions. I examined works available in the studio at different stages of development.[1] I leafed through sketchbooks, toured storage closets, and examined unfinished works. I asked artists how they made certain artistic decisions regarding these works. What had been the first move in creating the work? How had they chosen to incorporate a particular formal element? Why did they think that the work was finished or unfinished? When possible, I returned several times over the course of my research, making subsequent visits anywhere from six months to two years apart.[2] I often attended the exhibition openings of the artists I interviewed, which allowed me to see how they installed the work and described the work in conversations and writings.

Eventually, my interviews and fieldwork with artists led me to others in the art world. As I discussed the creative process with artists, other individuals often crept into their stories: the curator for whom they had a quickly approaching exhibition deadline, the dealer who informed them that a certain series was not selling, the critic who reviewed their exhibition in a major periodical, the collector who wanted only their iconic work. Understanding artists' decisions, I realized, required widening my lens to capture a whole matrix of aesthetic judgments made by these different actors. I began interviewing dealers and curators and, after a high-status dealer agreed to put me in contact with several private collectors, extended my reach to collectors and art advisers. In doing so, I followed sociologist Matthew Desmond's relational approach to doing ethnography.[3] A relational ethnography examines people in different social roles, such as producers, intermediaries, and consumers. Rather than

analyzing how these various actors collaborate together, a relational approach focuses on how information and resources are exchanged among those in different roles.[4] I was interested in how those in different roles interpret and value artworks, and how evaluations by these various people influence one another. As with artists, I found that dealers, curators, collectors, and art advisers all described their aesthetic judgments as intuitive. I similarly used artworks as probes to tease out more specific evaluations. For example, I asked collectors to give me a tour of their collection and discuss specific works, and I accompanied collectors to art fairs where I watched them respond to particular works.

My interviewing and ethnographic observations were symbiotic in that I was able to solicit interviews from people whom I met during fieldwork, and interviewees often provided additional fieldwork opportunities. I also was able to compare what artists said they did in interviews to my own observations of what they did in the field. But fieldwork brought its own challenges. I struggled with the scope of the field I was trying to capture. Which of the dozens of exhibition openings should I attend each night? Should I stay at the flagship fair or go to one of the satellite fairs? Would it be better to observe from a gallery booth or accompany a collector? Sometimes, in retrospect, I felt like I had made the wrong choice, and I always had a nagging sense of having missed out on what I had not seen. It was the same feeling that the artists I interviewed described regarding their own participation in the art world.

To get deeper access to the art world, I forced myself to make socially inappropriate requests, such as asking collectors if they would invite me to their next VIP open house or private party, or if I could accompany them and their partner to the next exhibition opening or fair that they planned to attend. My research often felt as if it was balanced precariously on strung together favors. Understandably, there were also certain moments that people did not want me to observe. The art world sometimes felt like a matryoshka—within every back room seemed nested another. I could buy a ticket to an art fair, and even receive gifted tickets to the VIP hours of the fair, and even get invited to the VIP open house before the fair or the fair afterparty, only to later find out about a private dinner between a collector and dealer that had gone on simultaneously. Certain interactions, like studio visits with collectors or dealers present, were especially difficult to observe, either because participants felt that these moments were too intimate or because they worried about compromising their economic interests. No matter how long an ethnographer stays in the field or how deep his or her access, the view is always partial. Ethnographers must do their best to see, do, and experience as much as they can, until they feel that they are seeing similar interactions play out over and over.

To verify my data from interviews and ethnographic observations, I confirmed verbal statements with archival sources, including curricula vitae, websites of museums, galleries, and artists, articles and reviews in periodicals, and other documents. I also used these sources as additional data. I especially drew upon press releases from exhibitions and artist statements published on galleries' and artists' websites to discuss the style scripts that artists and dealers used. I also collected a data set of gallery and museum exhibitions reviews from the *New York Times*, *Artforum*, *Art in America*, and *ARTnews*, which I used to analyze critics' style scripts. I focused on reviews of solo exhibitions, as solo exhibitions are most important for artists' careers and because critics discuss the meanings of individual artists' bodies of work in more depth within these reviews. I analyzed 377 reviews in total, 134 from the *New York Times*, 133 from *Artforum*, 72 from *Art in America*, and 38 from *ARTnews*.[5] Together, these reviews comprised all reviews of solo exhibitions in New York City published in these periodicals in 2017, which was the last full calendar year at the time of data collection.

Depending on the situation, I wrote fieldnotes on my cellphone or in a small notebook. I audio recorded all interviews, with an exception of a few subjects who preferred me to take notes. Quotes from recorded interviews are verbatim from transcriptions, while quotes from fieldwork are based on fieldnotes. I coded all data, including fieldnotes, interview transcripts, and archival texts, in ATLAS.ti (a qualitative data analysis program) using an open coding method.

POSITIONALITY IN THE CONTEMPORARY ART WORLD

In every ethnographic fieldsite, people react to researchers in ways that reflect their understandings of what researchers are doing and who researchers are. The people I met in the art world were used to seeing art historians scampering around the Lower East Side and Chelsea. A sociologist, however, caused some confusion. Artists, dealers, curators, collectors, and art advisers alike were highly educated, and some had read the works of foundational sociologists of culture, like Pierre Bourdieu or Howard Becker. But most were less acquainted with sociology as a discipline. Some were surprised that sociologists studied art at all. Others were befuddled by my inductive and qualitative research design, thinking that sociological methods were exclusively quantitative. Still others believed that one could use only an art historical approach to study contemporary art because each artist's work was too unique to conform to social patterns. It seemed that my research was either not hard enough science or not soft enough humanities. When introducing myself or requesting

interviews, I often spent a fair amount of time situating my project within the broader discipline.

People also reacted to me based on their understandings of my identity vis-à-vis their own identities. I am a white, heterosexual, Jewish woman, who—at the time of this research—was in my mid-to-late twenties. Younger artists—with whom I was in the same age bracket and perceived income level—tended to treat me akin to a peer. In contrast, older collectors adopted a more paternal stance, as I was often the same age as their children or even grandchildren, and they often doled out well-intentioned career and relationship advice. As I moved between these different groups of people, I shifted the way I presented myself accordingly, for example, by wearing more formal clothing when visiting collectors' homes.

People's perception of my identity in relation to their own also shaped opportunities for access. With dealers, to whom my access was sometimes limited due to their status and busy work lives, I found that women were more likely to agree to be interviewed and provide fieldwork opportunities. In our conversations, some told me that they had made time for me because they wanted to support other professional women. Perhaps for this reason, I interviewed twice as many female dealers as male dealers. Many collectors I interviewed and accompanied to events were Jewish. While Jewish collectors may have felt a special affinity toward me due to our shared cultural background, it is difficult to say whether Jewish collectors are overrepresented in my sample, as many collectors in New York are Jewish.

Another aspect of identity that shaped my access was my status vis-à-vis the statuses of those I studied. During data collection, I subsisted on a $30,000 stipend provided by my graduate institution. I hopped between shared apartments in Brooklyn and Queens, once spending several months living in a pantry. While I was not in the economic elite, I was a member of the cultural elite, having been educated at prestigious universities. This cultural-but-not-economic elite status often aided my rapport with artists, many of whom were recent MFA graduates in economically precarious positions. In contrast, money was a barrier to researching collectors, who were both culturally and economically elite. The costs of participation in this field exponentially increased with the depth of access. Price tags for many events that collectors attended were inflated, as collectors often attended these events in the role of philanthropists. For example, contemporary art museums in New York had various patron groups through which collectors would meet for parties, collectors' open houses, studio visits, and other events. The most expensive patron groups afforded members positions on museum acquisition committees. I was

invited to join a patron group for collectors in their twenties and thirties, but had to decline, as membership cost $500 annually with an additional $500 per event. Beyond these formal costs, there were various informal ones, including expensive meals, designer clothes, and cab rides. After several awkward moments, I tried to avoid exposing economic disparities between me and the collectors with whom I socialized.[6]

ANONYMITY AND CONSENT

Artworks are special kinds of objects in their uniqueness and their expression of ideas. These qualities also make artworks special kinds of social scientific data. As I was interested in how people made aesthetic judgments of specific works and artists' creative trajectories, I could not have done justice to this project without describing, and in some cases showing, the works themselves. A reader would not recognize all of the works discussed in this book, but those who know a particular artist or are familiar with this artist's work would likely be able to identify the artist by the images and descriptions of works. Anonymity was often not possible when discussing artists' works and exhibition contexts in detail.[7]

When approaching subjects during fieldwork or explaining the project before interviews, I described myself as a sociologist, and I said that I was interested in understanding how artists produced their work and how their participation in the art world shaped their work. I gave each subject the option to be identified by their real name, to make certain information nonidentifiable, or to make all information nonidentifiable. I also allowed subjects to specify whether I could take and use photographs of their work and the interview site. Most subjects agreed to use their real names or make only certain information nonidentifiable. Typically, subjects asked for information to be nonidentifiable when they made negative evaluations of specific artists or discussed disputes with their dealers. Upon completion of the manuscript, I sent subjects the sections involving them in order to ensure full consent and correct possible inaccuracies or misunderstandings. I anonymized anyone who asked not to be identified at this stage. Finally, I used pseudonyms in cases when I thought that my data could feasibly contain professional risk for subjects, even when they had agreed to be named. When citing anonymized information, I use general terms (i.e., "an emerging artist," "a Lower East Side dealer," or "a major collector") or pseudonyms. I am grateful to all who participated in this project for their valuable time and insights.

NOTES

CHAPTER ONE

1. Shamim Momin, "Lucky DeBellevue: Khlysty, the Owls, and the Others," *Whitney Museum of American Art* 2002.

2. This is a pseudonym.

3. Ken Johnson, "Art in Review; Lucky DeBellevue," *New York Times*, June 2, 2000.

4. Wohl (2015) and Merriman (2017) use ethnographic studies of small groups to show how people negotiate aesthetic judgments in face-to-face interactions. Childress and Friedkin's (2011) study of book clubs shows how face-to-face interactions with others in group settings influence readers' interpretations of books.

5. Contemporary art has a broad and often fuzzy definition, as the discipline has an exceptionally wide scope. It can be defined by both its content and social context. For our purposes, contemporary art is work produced after circa 1968 that artists and audiences perceive as embodying, often open-ended and ambiguous, conceptual meanings. It is also that which is produced, exhibited, viewed, reviewed, and purchased by contemporary art world actors. When I speak of the "contemporary art world," I refer to the amalgamation of people and institutions involved in producing, exhibiting, and collecting contemporary art. These include a network of artists, dealers, curators, collectors, art advisers, critics, and support personnel (Becker 1974), such as gallery assistants, artist assistants, and art handlers, who work within a system of MFA programs, galleries, museums, and other institutions. Much visual art falls outside these boundaries. Art produced by outsider or folk artists, community-based artists, craftspeople, illustrators, and "Sunday painters" (hobbyists) is not included in this definition. For example, within the United States alone, sociologists have documented a diverse array of visual art communities, including communities of figure drawers (Wohl 2015), outsider or folk artists (Fine 2004; Zolberg and Cherbo 1997), Latinx artists working to build a "barrio" arts scene (Wherry 2011), and community-oriented artists who exhibit works in local cafes and other venues (Gerber 2017). These art worlds are important and interesting in their own right;

however, their work is produced, distributed, and consumed in art worlds largely separate from the contemporary art world as defined here.

6. "Chris Ofili. The Holy Virgin Mary. 1996," MoMA, accessed June 24, 2019, https://www .moma.org/collection/works/283373.

7. Thompson (2008).

8. Lucien Karpik (2010) argues that markets for creative works are markets of "singularities" as these goods are unique and incommensurable. The contemporary art market is characterized by "radical" uncertainty in aesthetic value because even experts in the field, like curators and critics, cannot come to a clear consensus regarding aesthetic value.

9. Management scholar Frédéric Godart (2018) traces the concept of "style" in sociology, anthropology, cultural studies, and management. Bringing together these diffuse strands of literature, he defines style as "a durable and recognizable pattern of aesthetic choices" (p. 114). As Godart argues, styles also vary in different ways, including implementation and levels of institutionalization, coherence, hybridity, and closeness. He argues that styles operate on any level. Individuals, groups, institutions, and even nations have distinctive styles. Speaking of collective artistic styles, sociologist of art Diana Crane (1987) argues that style represents a "collaborative endeavor" of a group of people who follow each other's work and exchange ideas with various levels of intensity (p. 19). This is akin to what sociologist Michael Farrell (2001) called a "collaborative circle." In contrast, I explore the individual level of styles—what I call creative visions—in which each style is composed of elements from a single individual's or institution's body of work.

10. A consistency requires that the element must appear in more than one work within an artist's body of work. Formal and conceptual consistencies manifest themselves in artworks differently. Formal consistencies—such as a signature color palette or preferred medium—tend to be more visually recognizable, with a wider consensus as to which formal elements are consistent. For example, if the majority of an artist's works are less than a square foot in size, most would agree that the artist works at a modest scale. Conceptual consistencies are often more visually ambiguous. Artists often work across media and assert that these formally diverse works are united by common conceptual concerns. For example, an artist may explore the concept of memory through photographs, drawings, and assemblages of found objects. Viewers perceive both formal and conceptual elements through both the work itself as well as verbal and written statements about the work, such as critical reviews, artist statements, and press releases. I refer to perceptions of creative visions, rather than objective creative visions, because consistencies are gleaned only through sensuous perception and interpretation and because individuals may disagree as to the content and relative significance of these consistencies.

11. Formal elements and conceptual elements are analytically distinct; however, the two interact during moments of perception. Conceptual elements are rooted in formal elements in that, within the work itself, they can be perceived only through these formal elements. An artist must employ certain media and techniques to convey conceptual elements. For philosopher John Dewey (1934), formal and conceptual qualities form a unified experience of art. A person has an aesthetic experience by conceptually appreciating the material qualities of works. The mental movement between formal and conceptual qualities creates an aesthetic experience through which viewers interpret meaning.

12. Holt (2004) defines different types of brands. For example, an identity brand is a brand

whose value to consumers comes from its contribution to self-expression, while an iconic brand is a brand whose value to consumers derives from the value of a person who acts as a symbol of a culture or movement (p. 11). Within the art world, brands are understood as bodies of work that repeat narrow formal elements across many works. These brands are defined as having a static, recognizable, and commercially viable quality.

13. Aesthetic judgment is a "slippery" term with many possible meanings (Fine 1992). This definition is drawn from my earlier research on figure drawing sessions (Wohl 2015).

14. While individuals make aesthetic judgments of both works of art and everyday objects, philosophical studies of aesthetic judgment have often focused on the former. As artworks, at least theoretically, have no practical utility, Kant ([1790] 2000) believed that individuals make purely aesthetic judgments when they interpret artworks. Additionally, individuals make explicit aesthetic judgments of artworks, as they expect these objects to have symbolic meanings and believe that they are supposed to contemplate them (Dewey 1934).

15. As sociologist Fernando Domínguez Rubio (2020) notes, things are "material processes that unfold over time," while objects are socially assigned to "different regimes of practice and value" (p. 4). Things are made into objects through social processes.

16. Kant ([1790] 2000).

17. Arendt ([1977] 1992).

18. Wohl (2015).

19. Florida's (2002) *The Rise of the Creative Class* charts the growth of creative industries.

20. Bourdieu (1984; 1993).

21. Becker (1982).

22. See Peterson and Berger (1975) and Peterson and Anand (2004) for a synthesis of this approach.

23. Griswold (1987b).

24. In particular, sociologist Janet Wolff (1999) has critiqued American sociology and the sociology of culture for its largely self-imposed insularity from other disciplines. As Wolff argues, sociologists of culture have not sufficiently incorporated aesthetic philosophy into sociological theories of aesthetic judgment. Wolff (1983) claims that social scientists should attend to the nature of art and aesthetic experience. For example, social scientists should explain why certain works are aesthetically challenging and why we find fulfillment in these provocations. Wolff (1984) asserts that social scientists should be critical of the timelessness and value-freedom of much aesthetic philosophy, while also further investigating the specific nature of art. Similarly, Kaufman (2004) calls for an endogenous approach to the sociology of culture, which analyzes how individuals interpret the meaning of cultural objects, in contrast to exogenous approaches, which examine factors external to meaning-making. Mohr et al.'s (2020) *Measuring Culture* examines how interpretation is patterned and how sociologists can use different methods, particularly formalist methods, to uncover these meaning-making structures at multiple levels of analysis.

25. Griswold (1987b). Similarly, Fine's (1992) ethnography of restaurant work focuses on the "culture of production" rather than the "production of culture" by analyzing how elite chefs come to an understanding of what constitutes a "good" restaurant dish.

26. Social scientists term these physical or sensory properties the "materiality" of an object. Scholars of science and technology studies (STS) have examined how these properties

change the way in which people use objects. Social scientific studies of materiality began with ethnographies of scientific laboratories, in which scholars examined how the materiality of the space, scientific instruments, and objects of study influenced scientific findings (Knorr Cetina 1999; Latour and Woolgar 1979). Social scientists later applied this approach to art worlds. Using the case of music, Tia DeNora (2000) coined the concept of affordances to describe how the materiality of objects enables certain uses and constrains others. Domínguez Rubio (2012) shows how the media of Robert Smithson's earthwork sculpture, *Spiral Jetty*, influenced the final work. Greenland (2016) analyzes audiences' reception of colored Greek and Roman marble sculptures in the *Gods in Color* exhibition. Greenland reveals how experiences of color are shaped by both the materiality of objects as well as cultural meanings, including beliefs regarding accuracy and authenticity.

27. For example, McDonnell (2010) reveals how Ghanaians often misinterpreted or could not decipher AIDS prevention media campaigns, due to the decay and displacement of media, such as billboards and stickers. McDonnell (2016) calls this process of transformation and re-interpretation of objects "cultural entropy." Similarly, Domínguez Rubio (2020) examines the "backstage" work at MoMA to show how art conservators and other museum personnel change and repair artworks, which physically decay over time, in ways that seek to preserve artists' intentionality and render the works legible as artworks to viewers.

28. Lena and Pachucki (2013).

29. Zuckerman (1999) shows that securities analysts are less likely to review firms whose products they cannot clearly categorize into a niche, creating a "categorical imperative" for firms to conform to established niches. Similarly, Askin and Mauskapf (2017) show that songs with optimal differentiation from other songs are most successful, in terms of both peak popularity and longevity.

30. Rao, Monin, and Durand (2005).

31. Previous research examines how audiences perceive creative producers with "specialist identities," or narrow bodies of work, differently from producers with "generalist identities," or broad bodies of work. See Ahlkvist and Fisher (2000), Becker (1960), Cattani et al. (2017), Freeman and Hannan (1983), and Giorgi and Weber (2015) on the benefits of specialist identities. See Hsu (2006), Merluzzi and Phillips (2016), and Pontikes (2012) on the benefits of generalist identities. For example, Zuckerman et al.'s (2003) study of typecasting in the film industry shows that low-status actors benefit from narrow affiliations to film categories, as this increases their chances of recognition and procuring similar future roles. On the other hand, high-status actors, who have already achieved recognition, profit more from affiliation with multiple genres, as this increases the number of roles for which they are considered.

32. Gell (1998) elaborates on this concept in his seminal monograph, *Art and Agency*.

33. Similarly, Vanina Leschziner (2015) discusses how elite chefs draw influences from lineages resembling a family tree, including past chefs that they did not know personally and their colleagues.

34. Sociologist Jennifer Lena (2012) views genres as composed of both sociocultural and aesthetic features, defining genres as "systems of orientations, expectations, and conventions that bind together industry, performers, critics, and fans in making what they identify as a distinctive sort of music" (p. 7).

35. In Molotch, Freudenburg, and Paulsen's (2000) comparison of two cities, the authors

argue that places attain a distinctive character due to the particular "lash-up" of connections between both physical and symbolic elements. Similarly, I claim that bodies of work take on distinctiveness due to the connections among a cluster of formal and conceptual elements.

36. Mears (2014).

37. See Baxandall (1972) for a description of the relationship between artists and patrons in fifteenth-century Italy.

38. Ibid., pp. 16–17.

39. Domínguez Rubio (2020) explains that authorial intent was not seen as significant in the Middle Ages. While notions of modern authorship originated during the Renaissance, people still did not always see it as necessary to preserve authorial intent. For example, people commonly repaired works in ways not intended to replicate the original. It was not until the latter half of the eighteenth century, following broader transformations in which art was conceived as self-expressive, that authorial intent became sacralized.

40. White and White (1965).

41. See Seigel (1986) and Shattuck (1955) for historical descriptions of the French avant-garde art scene during the Belle Époque.

42. White and White (1965) chart the social factors that caused the dealer-critic system to overtake the academy system in the Parisian art world.

43. Ibid., p. 98.

44. Ibid., p. 88.

45. Ibid.

46. Zukin (1982) reveals how artists popularized "loft living" among the wider public. Artists gentrified various New York neighborhoods, followed by non-artists who wanted to take part in this bohemian culture.

47. Sophie Howarth, "Marcel Duchamp, 'Fountain,' 1917, replica 1964," *Tate* 2000, accessed January 2, 2020, https://www.tate.org.uk/art/artworks/duchamp-fountain-t07573.

48. Replicas of *Fountain* have been widely exhibited.

49. Jerry Saltz, "Idol Thoughts," *Village Voice*, February 21, 2006.

50. Aesthetic philosophers took up this question as well. Some gave the rather sociological and Duchampian response that art was anything that was socially positioned as such (Dickie 1984). For aesthetic philosopher George Dickie (1974), Dadaism exposed the institutional underpinnings defining art, begging the question of how mundane objects could be considered art. Dickie (1974) claimed that art could, in fact, become a "closed concept," defined by criteria, if one brought in social contexts external to the work itself. Dickie defined an artwork as an artifact that has the status of a candidate for appreciation by someone acting on behalf of a certain social institution (p. 131). In Dickie's institutional approach, for an object to be art, someone in a formal or informal organization had to simply position the object as a work of art. The artist, in this view, creates a more or less prepared public by presenting work to them (Dickie 1984). Others answered through a more art historical approach, claiming that a work's innovativeness, and therefore its "art-ness," lay in the breach of artistic convention itself (Weitz 1956). For still others, contemporary art offered a new paradigm of art. Rather than representing objects, such as still lifes or portraits, or even evoking emotions, contemporary art expressed an idea in reference to some antecedent idea in art history (Carroll 1993; Danto 1964; 1981). These ideas were not reducible to written or spoken language, or else the works would be superfluous. Art could

represent an object or elicit an emotion, but only in service of the idea that the artist sought to communicate, even if this idea was often not one that could be easily put into words. Art was an idea embodied in form.

51. Sociologist Nathalie Heinich (2014) argues that art history evolves much like scientific revolutions. A new way of thinking contests previous modes of thought, with the incumbent movement either persevering or giving way.

52. Crane (1987).

53. Discussing the black square paintings, Reinhardt (1963) stated, "A square (neutral, shapeless) canvas, five feet wide, five feet high, as high as a man, as wide as a man's outstretched arms (not large, not small, sizeless), trisected (no composition), one horizontal form negating one vertical form (formless, no top, no bottom, directionless), three (more or less) dark (lightless) no-contrasting (colorless) colors, brushwork brushed out to remove brushwork, a matte, flat, free-hand, painted surface (glossless, textureless, non–linear, no hard-edge, no soft edge) which does not reflect its surroundings—a pure, abstract, non–objective, timeless, spaceless, changeless, relationless, disinterested painting—an object that is self-conscious (no unconsciousness) ideal, transcendent, aware of no thing [*sic*] but art (absolutely no anti–art)" (pp. 82–83).

54. Farrell (2001) termed these close-knit groups of artists "collaborative circles" and argued that members of collaborative circles heavily influenced each other's work and careers.

55. Aesthetic philosopher Arthur Danto (1997) draws this "end of art" thesis from Hegel (1975). For Danto (1964), art history progressed by the additions of columns to a metaphorical matrix, where each new column represented a quality that became newly included as a possible aspect of art. Danto (1997) asserts that "the end of art" came when the "age of manifestos," in which one style rapidly overtook another, lost its linearity. When artists recognized the true philosophical nature of art—that all art existed in the realm of ideas—there could be no one style or manifesto that was more truly art than any other style or manifesto. Art history, in effect, was flattened. Halle and Tiso (2014) argue that, as the market for contemporary art became more heated, dealers spent more time and money trying to promote new styles. The authors note that this claim is related to, but distinct from, Danto's (1997) claim that styles became obsolete in an age when the philosophy of art held that art could be any kind of object. Unlike Danto, the authors stress economic, rather than art historical, circumstances to account for this transformation.

56. Art historian Howard Singerman (1999) traces the rise of the MFA in universities in the United States.

57. *US News and World Report*, "Best Art Schools," 2020, accessed June 15, 2020, https://www.usnews.com/best-graduate-schools/top-fine-arts-schools/fine-arts-rankings.

58. Fine (2018).

59. This model of art education is specific to the United States and other Western countries. Anthropologist Lily Chumley (2016) explains how aspiring Chinese art students took a standardized test for admissions to fine arts schools, in which they were required to render photorealistic drawings and paintings. In Chinese art schools, students focused on learning technical skills. Students were exposed to a "creativity class," in which they were expected to find their unique voice, only during their final year. After the completion of Chumley's study, the standardized art test was changed in response to criticisms that the test discouraged stu-

dents' creativity (Fang 2020). Fang's (2020) study of Chinese art test prep schools shows how schools adapted their programs to promote both technical skill and a more flexible application of this skill so that students learned artistic competence while developing distinctive styles. However, feeling that the Chinese art world was still too constraining of creativity, most aspiring art students sought career tracks in design, where they believed they could express themselves more freely.

60. Velthuis (2005).

61. Social scientific research on contemporary art has increasingly focused on the globalization of the art market. Velthuis and Curioni (2015) examine the rise of the contemporary art market in Brazil, Russia, India, and China. Khaire and Wadhwani (2010) also explore the emergence of the contemporary art market in India. Buccholz (2016) and Velthuis (2013) explain the asymmetrical power dynamics in the globalization of contemporary art, where some regions remain core and others peripheral.

62. Kharchenkova and Velthuis (2018) explain why auction houses, rather than galleries, are viewed as legitimate judgment devices in China, while the reverse is true in Western markets. China is also home to many artists who sell their work in the international art market. Artist communities have developed in China since the 1990s, including the Yuanmingyuan Artist Village of Beijing and the East Village, which is named after New York's East Village (Pollack 2018).

63. See Horowitz (2011) on the financialization of contemporary art. Horowitz charts the rise of art investment funds and growing speculation on art in Asia and the Middle East.

64. Clare McAndrews, "The Art Market 2018," Art Basel and UBS report, 2018. See also Crane (2016).

65. With the rise of the internet, art world institutions can no longer be reduced to brick and mortar organizations, like galleries and museums. Increasingly, as art theorist Lane Relyea (2013) notes, the art world has become "itinerant and flexible" (p. 31), dispersed into online platforms and temporary projects. Halle and Tiso (2014) chart several technological developments in the art world. Galleries and technology startups have tried to move sales of art online through virtual galleries and online salesrooms of brick and mortar galleries, including Paddle8, Artspace, Amazon Art, and Saatchi's Saleroom Online. Most significantly, the technology startup Artsy uses genome technology to predict users' taste and connect them to artworks and the dealers selling these works. Sociologist Sarah Sachs (2017) examines the process of constructing the Artsy genome. The emergence of social media has also influenced the art world. For example, many artists and dealers use Instagram and other social media platforms to promote themselves. While it is unclear how technology will change the art world in the future, it seems unlikely that technological developments will completely supplant brick and mortar art spaces, like galleries and museums. Thus far, sales on online platforms have lagged. Collectors usually like to see work in person before they purchase it, and they enjoy participating in art events for friendship and leisure.

66. Fine (2018); Halle and Tiso (2014).

67. Over half of all represented artists in New York have MFA degrees, and younger artists are increasingly likely to have MFA degrees. Ben Davis, "Is Getting an MFA Worth the Price?" *Artnet News*, August 30, 2016.

68. Artsy, accessed June 24, 2019, https://www.artsy.net/. Note that galleries must pay to be listed on Artsy, so the actual number of galleries is likely higher.

69. "Member Galleries," ADAA, accessed June 24, 2019, https://artdealers.org/member -galleries.

70. "Top 200 Collectors," *ARTnews* 2019, accessed June 16, 2020, https://www.artnews .com/art-collectors/top-200-profiles/?filter_top200year=2019. Many collectors on this list have homes in multiple cities.

71. I manually counted the reviews in all *Artforum* issues in 2019.

72. Economist Sherwin Rosen (1981) defines the phenomenon of superstars as when "relatively small numbers of people earn enormous amounts of money and dominate the activities in which they engage" (p. 845).

73. Velthuis (2005).

74. As discussed in chapter 6, solo exhibitions are more prestigious and provide more visibility than group exhibitions.

75. Sharon Butler, "Lost in Space: Art Post-Studio," *Brooklyn Rail,* June 7, 2008.

76. Velthuis and Coslor (2012).

77. While galleries deal in the "primary market," auctions are part of the "secondary market" in the art world, as they primarily resell works that have already been sold by galleries to collectors. However, the line between the primary and secondary markets has become increasingly blurred. Auction houses now mount exhibitions (Thompson 2014), and galleries often operate a secondary market from the back rooms of their galleries by reselling work on commission.

78. See the methodological appendix for more information about the process of data collection and analysis, including consent and anonymity.

CHAPTER TWO

1. Within each art world, there are different conventions of authenticity. For example, Gary Fine's (2004) study of outsider artists reveals that curators, dealers, and collectors used perceptions of authenticity as a central way to evaluate work. In this field, authenticity was defined as living in a rural area, having low educational attainment, and having physical or mental disabilities. Accordingly, outsider artists and their dealers often emphasized these features of their biographies. In contrast, David Grazian's (2003) ethnography of blues clubs in Chicago reveals that race is highly salient to whether or not tourists view musicians as authentic. While Grazian emphasizes that authenticity is often constructed to commoditize creative works, Frederick Wherry (2011) shows that people also genuinely work to produce and circulate creative works that they view as authentic to promote the dignity and self-respect of their artistic communities.

2. See Goffman's (1959) theory of impression management. As Goffman argues, we interact with others repeatedly in the same social roles, such as parent, spouse, teacher, or doctor. We form certain habits of dress, speech, bodily comportment, and tastes as we work to inhabit these roles in ways that express how we want to be seen by others. This is our performance of self, a performance that shifts as we assume and shed different roles in the course of a day and a lifetime. Mead (1934) coined the concept of the "generalized other" to theorize how individuals take others' expectations into account even when others are not present.

3. Past research has mostly explored the role of the artist by focusing on large-scale histori-

cal changes and the organization of the field as a whole. In contrast, I examine how the idea of creative visions influences and is constructed within face-to-face interactions.

4. Both names are pseudonyms.

5. As in many industries, the #MeToo Movement forced a reckoning in the art world, which largely occurred after my fieldwork. Several high-status men in the contemporary art world, including those whom I had met during the course of my fieldwork, were fired for sexual harassment. The movement also catalyzed discussions about sexual harassment and gender discrimination in the art world more broadly.

6. Helguera (2012, p. 46).

7. Shattuck (1955, p. 25).

8. Zukin (1982).

9. Chapter 2 in Gerber's (2017) *The Work of Art* charts what she describes as the "occupational" turn in the art world over the past few decades, in which artists shifted from viewing their work as a calling to seeing it as a career.

10. While the MFA remains the most popular and widely accepted degree in studio art, the professionalization of the art world has also entailed an increase in PhD programs in studio art, which vary widely in standards (Elkins 2014).

11. Relyea (2013) explains that artist networks often begin in MFA programs and entrée into these networks is often used to justify these programs' steep price tags.

12. Fine (2018).

13. Fine (2018, p. 175).

14. Similarly, Fine (2018, p. 177) notes that the "swaggering" culture of the creative and eccentric genius in MFA programs may disadvantage female artists who may lead more conventional lives, have childcare responsibilities, or feel otherwise less inclined to engage in hard partying. This association between men and genius is socialized in early years. For example, Musto (2019) shows how middle school children learn to think of boys as geniuses, while viewing girls as merely smart, through classroom interactions.

15. Ben Schmidt, accessed July 19, 2018, http://benschmidt.org/profGender/#. Historian Ben Schmidt used 14 million reviews from ratemyprofessor.com to calculate the frequency of a term for every million words. The study does not account for disparities by race and ethnicity, due to the issues in collecting these statistics from names or profile photos. For every million words, the word "eccentric" was used 29 times when reviewing male fine arts professors and 25.4 times when reviewing female fine arts professors. The word "genius" was used 47.7 times when reviewing male fine arts professors and 15.2 times when reviewing female fine arts professors.

16. Van Tilburg and Igou (2014). However, this research does not examine how perceived eccentricity shapes social interactions within creative industries.

17. Representation by Tanya Bonakdar is an improbable outcome for an emerging artist, as Tanya Bonakdar Gallery is a major fixture in the Chelsea gallery scene.

18. Zukin (1982) explains that the studio visit became popularized in the 1950s and 1960s, serving as a site for collectors to appreciate artists' creative visions: "The studio becomes the place—perhaps the only place in society—where the self is created. For a public that is no less concerned than artists with questions of self-doubt and self-expression, the studio begins to

exert tremendous fascination" (p. 93). Moreover, as Zukin describes, the studio visit provided collectors with symbolic entrée into the upper class, as they could delight in "discovering" emerging artists, even if they could not afford to purchase the works of old masters. Today, the studio visit retains a sacred, intimate quality, as the artist exposes themself to and sometimes invites critiques of their creative visions.

19. While I was able to observe some studio visits between artists and other guests, I was often denied entrée to this arena. Artists and their guests treated these conversations as highly personal. In other cultural fields, access to these spaces may be even more restricted. For example, ethnographers have reported extreme difficulties in accessing creative writing critiques in MFA programs (Fine 2018).

20. While Leslie Lana used to be an accountant in her organization, she has since transitioned to a new role involving work that she described as more creative.

21. This move resulted in what Pierre Bourdieu (1993) called "the economic world reversed." Bourdieu's conception of cultural markets as economic worlds reversed reveals his broader framework of field theory, in which he views actors as inhabiting different social positions from which they struggle to control various resources. The inhabitants of the field interact with reference to a common set of rules, with each field operating by its own set of rules. In this view, cultural fields rely on a set of rules that are different than, and indeed opposing, the rules in markets for mundane objects.

22. In the art world, like markets for other kinds of "priceless," or sacred, goods, excessive economic interest is seen as morally contaminating. Sacred goods include goods seen to have transcendental or intimate qualities as well as goods that relate to human life. For example, see Almeling (2011) on sperm and egg donations, Anteby (2010) on cadaver sales, Healy (2000) on blood donations, and Zelizer (2005) on sex work. Moral understandings about sacred goods influence how these goods are exchanged and the price of these goods. Zelizer (1979) reveals how people build intimate social ties through which they circulate sacred goods in markets. Therefore, sacred goods are not cut off from market exchanges, but rather the character of these market exchanges is transformed by the symbolic meaning of these goods.

23. Similarly, Gerber (2017) finds that artists claim to place aesthetic judgments above economic concerns, but also emphasize their earnings on art to legitimize the time and resources that they pour into their art making.

24. Life events, like pregnancy, can exacerbate artists' precarious economic situations. Artists typically receive no parental leave, as they do not have regular salaries. When dealers' breadwinning artists become pregnant, dealers face some precarity as well. Dealers cannot simply call a temp agency to fill in for a nonworking artist because collectors invest in creative visions by specific artists. However, because dealers exhibit the work of multiple artists, they can better supplement these gaps in production. In contrast, when artists stop selling art, they stop making money, unless the gallery provides a stipend.

25. Sociologist Laura Adler (unpublished manuscript) has shown that creative producers, from dancers to musicians, continue to work in low-paid and creatively unsatisfying day jobs. She discovers that they do so to remain secure in the notion that they are committed to making it as an artist and that they will not be dulled into complacency by steady cash or tangentially artistic work. Given the importance of social networking in the contemporary art world, many of the artists whom I interviewed worked in part-time jobs within the art world, as I have de-

scribed, although some did labor unrelated to the art world. I reveal that artists demonstrate their commitment to their artistic practice not only through these occupational choices, but also by performing qualities that they associate with being a true artist.

26. In some notable cases, artists embraced money more wholeheartedly by folding economic interests into aesthetic commitments. Andy Warhol (1975) once declared, "Being good in business is the most fascinating kind of art" (p. 92). Much of Warhol's work, from Coca-Cola to dollar sign screen-prints, reflects an interest in consumer culture. Today, superstar artists like Damien Hirst, Jeff Koons, and Takashi Murakami adopt similar stances, with factory-like production and corporate sponsorships. While some deride these artists as sellouts, others offer a more sympathetic interpretation, perceiving the creative process, persona of the artist, and work itself as a meditation on the relationship between art and capitalism.

27. Sarah Douglas and Andrew Russeth, "Jute Sack Artworks Are at the Center of Simchowitz Lawsuit against Venice Biennale Artist," *ARTnews*, August 25, 2015.

28. Christopher Glasek, "The Art World's Patron Satan," *New York Times*, December 30, 2014.

29. Similarly, Khan (2011) discusses how wealthy students at an elite boarding school downplayed their wealth in order to make their social advantages appear merit-based and, therefore, deserved.

30. Different cultural fields vary in the acceptability of those other than artists intervening in the creative process, with these interventions generally having higher legitimacy in more commercially oriented fields. Rachel Skaggs (2019) shows that country music songwriters usually write songs with other songwriters or, given recent changes in the industry, write songs in collaboration with singers. Like art dealers, songwriters are careful to intervene appropriately in the creative process by writing songs that adhere to singers' personal brands or by leading singers to attribute songwriters' ideas to their own.

31. Winkleman (2015).

32. See also Velthuis (2005).

33. Karin Peterson (1997) argues that dealers also emphasize their devotion to art over money by representing emerging artists and working to reinvigorate the careers of forgotten artists. Velthuis (2005) reveals how dealers, especially those at more critically acclaimed galleries, work to show that they are not too mercantile by physically separating art and money in the gallery space. The front room of the gallery is typically a minimalist "white cube," with a spare layout absent of furniture and cash registers. In all but low-status galleries, there is no label next to the work to provide information, such as the artist's name and the medium, size, and price of the work. When collectors express interest in purchasing works, dealers invite them into the back rooms of their galleries to talk money.

34. As sociologist Ashley Mears (2011) reveals, this balancing of commercial and critical success is even more pronounced in the fashion modeling industry. Agencies have separate "boards" of models whom they represent, with one board for low-paid editorial models who maintain the status of the agency and another board for more economically successful commercial models.

35. Acord (2010) argues that curators construct the meaning of the work during the embodied process of installing the work for exhibition. As I demonstrate, curators often form not only meaning but also the work itself through their interactions with artists during the installation

process. Similarly, Yaneva (2003) draws upon an ethnography of a contemporary art exhibition installation to reveal how work is produced through the process of exhibiting the work. She shows that this process of production is collective as artists negotiate with curators over certain aesthetic decisions.

36. The names of this gallery and its dealers are pseudonyms.

37. Sociologist Karin Peterson (1997) notes that, as artists become more established, they have more options to move and therefore more control over dealers.

38. Randy Kennedy, "Vito Acconci, an Artist as Influential as He Is Eccentric," *New York Times*, June 2, 2016.

39. See Menger (1999) on the temporary, unstable nature of artistic careers.

40. Bourdieu (1993) theorizes cultural fields as ranging from "heteronomous"—in which creative works are evaluated by their degree of success with audiences and artists respond to audiences' demands—to "autonomous"—in which artists create "art for art's sake" and produce for a faction of other artists. Heteronomous fields are more commonly referred to as those that are commercially oriented, while autonomous fields are often referred to as those that are critically oriented. Bourdieu considers the visual art world to be an autonomous field. Bourdieu recognizes autonomy as a norm, under which direct introduction of external powers, such as commercial or political interests, begets disapproval (p. 289, fn. 5). I discuss autonomy not as disinterestedness in external audiences, but, more literally, as engaging in the process of producing work without direct intervention from others; however, this latter usage is related to the former, as the ability to produce work without intervention from others is afforded in fields in which others expect economic disinterestedness from artists.

41. Artists were often relieved to be uninvolved with pricing, feeling that they lacked business acumen. In two cases, artists explained to me that they had had conflicts with their dealers after accidentally misquoting the prices of their works when approached by collectors, as they had trouble remembering prices.

42. Mears (2015; 2020) examines the VIP global party circuit to understand why the women who attend these parties provide free labor for party promoters. She reveals that when women view their relationships with promoters as characterized by friendship and fun, they enjoy attending parties, while when women see their participation in terms of work, they often stop attending parties. Mears terms the latter as a "relational mismatch" between promoters and women. Similarly, collectors and artists often experience relational mismatches, as collectors perceive their relationships in terms of friendship and leisure, while artists view their relationships sometimes as friendship, but always as work. Collectors express more enjoyment from these relationships than do artists.

43. Only one collector couple whom I interviewed acknowledged or expressed discomfort at feeling an asymmetrical power dynamic between themselves and the artists whose work they purchased. This couple had the least prestigious collection of the collectors whom I interviewed.

44. This is a pseudonym.

45. Baxandall (1972, p. 17).

46. This is not unlike the fashion modeling market. Mears' (2011) ethnography of fashion models reveals that commercial models enjoy steady pay but forgo the status of the runway and potential jackpot of major advertisement campaigns, which only the most successful editorial

models receive. In contrast, editorial models walk runways and pose for haute couture fashion magazines, but these jobs are low-paid and sporadic.

47. Kate Brown and Javier Pes, "Biennials Are Proliferating Worldwide. There's Just One Problem: Nobody Wants to Pay for Them," *Artnet News*, March 21, 2019.

48. For example, artist Cheryl Donegan, whose work engages with gender and consumer culture, collaborated with the luxury brand M Missoni to make an installation in their flagship store.

<div align="center">CHAPTER THREE</div>

1. See the methodological appendix for a description of my method for interviewing artists in their studios.

2. Research on materiality reveals how materials afford certain uses and constrain others (see chapter 1). For example, Pickering's (1995) laboratory ethnography demonstrates that scientists were not always able to realize their preconceived goals, due to unpredictable results. Menger (2014) uses the case of Rodin's sketches to show that unpredictability is an inherent part of artists' creative processes and that artists balance unpredictability and inevitability in the creative process. Artists have some initial plan, without which they could not act, but they cannot completely foresee the result of this plan. Therefore, the artist repeatedly evaluates different possibilities of which he or she is aware, based on how he perceives the likely results, and then iteratively reinterprets these possibilities based on the actualized outcomes. Similarly, Aristotle employs the concepts "potentiality" and "actuality" to describe the possibilities that a form contains and the change by which a form realizes a possibility (Hicks 2015). However, examining creative experimentation reveals that actualization is not an end point, but a process that continually relies on the multiple potentialities of objects. At each moment, the actualized object elicits new potential forms, which lead to further actualization.

3. Creative producers across industries work to conserve resources when they make creative works. For example, Fine (1992) discusses how high-end chefs balance the need to save time and costs with their aesthetic ideals of "good" food.

4. As Fabien Accominotti (2009) notes, artists often have multiple "peaks" to their creativity, with their creative trajectories characterized by periods of both more settled styles and new experimentation.

5. Social and cognitive scientists often focus on the "eureka" moment of creative production—the first spark of the idea—and view especially creative thinkers as those who generate many of these sparks. However, more recently, scholars have shown that this eureka moment is overrated and that multiple moments of idea selection are critical (Sawyer 2012), arguing that creativity is driven by both divergent and convergent thinking (Bink and Marsh 2000; Csikszentmihalyi 1997; Csikszentmihalyi and Sawyer 1995; Lonergan et al. 2004). Similarly, as Amabile (1988) and Stark (2011) explain, creativity is not just about generating possible solutions, but also about evaluating resulting creative works.

6. While sociologists have not documented which emotions typically occur during creative experimentation, management scholar Lauren Rivera (2015) has found excitement to be a key emotion influencing hiring decisions in elite firms. Rivera reveals interviewers feel excitement toward candidates with whom they view themselves as "culturally matched," in that they per-

ceive shared interests and tastes, such as engaging in similar collegiate extracurricular activities. People also experience cultural matches with creative works. Sociologists Clayton Childress and Jean-Francois Nault (2019) show how literary editors feel excitement toward novels that have settings similar to their own cultural backgrounds. Fine (2018) notes that MFA students make their initial selection of which projects to pursue based on emotions of excitement, and professors and peers evaluate work positively when they experience excitement toward it.

7. Similarly, scientists conduct controlled experiments by providing each treatment to an experimental group and leaving a control group untreated.

8. As psychologist Mihaly Csikszentmihalyi (1990) explains, individuals engaged in producing creative work often enter a "flow" state of complete absorption in the activity. Although this state may entail repetitive and automatic motions, individuals are not bored, but engaged, when they are in flow.

9. Anthropologist Alfred Gell (1998) explains that the artist both has agency over the work and is influenced by the work. For example, an artist will visualize a drawing before executing the drawing, but the execution of the drawing occurs before the artist can cognitively process what has occurred.

10. Gell (1998) coined the concept of the "distributed object" to refer to the works within each artist's oeuvre. See chapter 1 for a discussion of this concept.

11. For art historian George Kubler (1962), artists make works of art in attempts to solve problems. Each attempt is linked to other attempts, both by the same artist and by other artists. Works constitute positions in the field, with each work limiting the number of future positions that can be taken in relation to a given problem. Some linked solutions are ongoing, constituting an open sequence, while others are finished, representing a closed series, and still others can be reopened intermittently. I focus on the construction of series within each artist's body of work, rather than collective attempts to solve problems in artistic movements. I also treat the possible set of solutions as perceived, rather than actual. While the number of actual possible variations are limitless, artists perceive a finite number of possibilities before experiencing boredom.

12. Fine (2018) explains that, although female artists and artists of color in MFA programs do not always address gender or race as central themes in their work, professors and peers expect these categories to be salient and encourage them to introduce these themes in their work.

13. Other creative producers have similarly liberal political leanings. Sociologist Neil Gross (2013) shows that professors are overwhelmingly liberal. He finds that the reputation of academia as a liberal enclave encourages liberals to pursue this career path, while discouraging conservatives, in a self-reproducing cycle.

14. Gross (2008) terms academics' perceptions of their own identities as academics their "intellectual self-concepts." Self-concepts are "identities, attitudes, beliefs, values, motives, and experiences, along with their evaluative and affective components (e.g., self-efficacy, self-esteem), in terms of which individuals define themselves" (Gecas and Burke 1995, p. 42). As part of their self-concepts, individuals identify with and against particular social roles and categories, such as profession, religion, marital status, race, gender, and class (Brubaker and Cooper 2000). While self-concepts are individual, as they are one's own beliefs about one's identity, they are also social, as these beliefs are shaped by one's perceptions about how others view oneself. Cooley (1902) defines the "looking-glass self" as an individual's perception of how others view him or her.

15. Leschziner (2015).

16. Sociologist Randall Collins (2004) coined the term "emotional energy" to describe the swell of confidence and enthusiasm that individuals feel when they interact with others. Collins argued that we gravitate toward those who elicit this buzz and retreat from those who deplete it.

17. Faulkner and Becker (2009); Fine (1992).

18. Parker and Hackett (2012).

19. Social scientists claim that individuals make decisions based on both "slow thinking"—conscious, rational thought—and "fast thinking"—unconscious, emotional responses (Kahneman 2011; Vaisey 2009). Using the case of elite chefs, Leschziner (2015) shows that, like artists, chefs rely on both culinary knowledge as well as intuition when creating new dishes. Leschziner describes, in contrast to Vaisey's "dual-process model of culture," three paths of action: action motivated by deliberative thinking, action instigated by automatic response, and action motivated by intuition: "One path relies on deliberative thinking to accomplish purposeful action; another is automatic, involving little to no deliberative thinking or conscious experience of the action, and the third is phenomenologically experienced as motivated action (therefore not automatic), though not driven by deliberation but by intuitions experienced as a sense of what feels right. There is an important distinction in this tripartite model that is absent from the sociological literature on culture and cognition, which has been built on the dichotomous understanding of action, as either automatic or deliberative—of dual-process models. . . . Even when chefs do not experience any conscious thought in creating a dish, they often experience their actions as motivated by intuitions, the embodied sense of what feels right. What is more, this type of action is phenomenologically experienced as motivated and creative" (p. 119). Leschziner argues that creative producers rely on action motivated by intuition during experimentation, although they may experience all three modes of action at different points of experimentation. Speaking of how contemporary artists encounter their own work after it has been completed and how they want audiences to interpret their work, Mullen (2020) argues that artists do not only prioritize cognitive decoding of meanings, but also perceive aesthetic, visceral, emotional, and embodied responses as critical to successful engagement with their work.

20. Creative producers often have intense emotional reactions in relationship to their nonliving creative works. For example, science and technology scholar Janet Vertesi (2014) reveals how NASA scientists develop affective relationships with the robots they design and use, even holding funerals for robots that stop operating.

21. However, Rivera (2015) argues that interviewing is an appropriate method for determining which emotions people experience and how they react to them. Drawing from Collins (2004), Rivera states that people feel emotions bodily, such as through sweating, and also subjectively, as when they interpret their experience as corresponding to an emotion. While social scientists have often perceived the study of emotion to be inaccessible without biological markers, Rivera notes that the subjective labeling of emotion is critical to how people act upon their emotions. Interviews capture the labeling of emotions well.

22. Sociologists Terence McDonnell, Christopher Bail, and Iddo Tavory (2017) have argued that people feel that an object resonates with them when they can use the object to solve a problem of interpretation in their lives, addressing the question: How can I better make sense of the world in which I live? The authors claim that people experience resonance when they view an object as both novel and consonant. To use Griswold's example (1986: 201–202; see

also McDonnell, Bail, and Tavory 2017: 6), Shakespeare's line "Juliet is the sun" resonated broadly with audiences because it had enough social distance to be surprising, but enough recognizability to be sensical (the line "Juliet is a girl" would have been obvious enough to be uninteresting, while the line "Juliet is [a] frying pan" would have been discordant to the point of incomprehension). When people experience heightened emotional charge toward an object, like excitement or enthusiasm, they are more likely to feel resonance with the object. Contemporary artists experience a kind of resonance that is different from that of a broad audience connecting with their work. The interpretive problem, for artists, is how to make a work that both feels new and surprising to them, but also aligns with their distinctive identities as artists. The former requires variation; the latter necessitates consistency. During the creative process, artists feel resonance when they experience an emotional charge and accompanying intellectual identification with particular formal and conceptual elements. The solution to the problem occurs when artists connect the thread from recognized elements of their creative visions to the new work, absorbing the new work into the creative vision and changing the boundaries of the creative vision as a result. Artists experience resonance based on their existing perceptions of their creative visions, which does not arise from a blank slate but from broader commitments and identifications. In turn, the repeated and somewhat unexpected experience of resonance during the creative process gives shape to perceptions of their creative visions. Resonance is central to forming an identity as an artist.

CHAPTER FOUR

1. Maguire and Matthews (2012) argue that social scientists have used the term "cultural intermediaries" as an overly general catchall to describe cultural workers. They argue that cultural intermediaries are those who claim expertise in order to convince others—especially consumers and other intermediaries—that certain cultural goods are legitimate and valuable.

2. Bielby and Bielby (1994); Childress (2017).

3. Critics are audience members in that they primarily view work after artists and dealers have chosen works for exhibition, but are also intermediaries in that they select which exhibitions to review and because they supply expert opinions that shape other audience members' interpretations.

4. In the case of the Israeli art market, Yogev (2010) argues that sending portfolios to dealers and curators without an invitation to do so can destroy social connections, as those "in the know" view this as an inappropriate method of contact. Artists whom I interviewed stated that they believed that dealers would view this as "desperate" and too self-promotional.

5. Curators solicit recommendations from artists as well. For example, Michelle Grabner, artist and curator of the Whitney Biennial in 2014, described how she asked her peers who lived in various American cities to recommend artists for the Biennial. After doing studio visits all over the country, she selected a group of artists—not artworks—for the Biennial and asked each artist to contribute work. Similarly, Fine (2018) described how, at major curatorial shows, such as Documenta and the Whitney Biennial, curators often select artists instead of artworks, and ask artists to produce work for the show. This emphasizes how those who exhibit work often deal in creative visions over discrete works.

6. Becker (1974).

7. Similarly, sociologist Jooyoung Lee (2016) discusses how aspiring hip hop artists often get their big breaks by serving as support personnel for more successful artists.

8. Giuffre's (1999) study of artistic networks among artists and galleries reveals that the statuses of dealers and those of artists affect one another. Examining network ties among artists who share gallery representation, the study shows that artists who are connected to other artists in a wide network receive more critical attention than artists who are densely connected to other artists, as the latter fail to extend their reputations beyond the small groups of which they are a part.

9. Aspers (2009) differentiates between "standard markets," such as the market for crude oil, where the quality of goods is based on a quantitative standard, and "status markets," where the quality of goods is based on the status of the producers, intermediaries, and consumers associated with these goods. Creative industries are status markets. In status markets, individuals assess the quality of goods by using "status signals," also called "judgment devices." See Beckert and Aspers (2011) and Karpik (2010) for more research on status markets.

10. While each artist's creative vision is distinct and galleries have different aesthetic sensibilities, certain formal and conceptual themes emerge across galleries within a given time period. For example, Halle and Tiso (2014) sampled the content of art exhibitions in Chelsea's "star" and lower-status galleries. They found that central themes included classic landscapes, environmental landscapes, abstraction, pop art, and depictions of troubled families, nudes, and sexual activity. The prevalence of these themes varied by gallery status. For example, classic landscapes were more common in upper-floor "buyers" galleries, while portrayals of sexual activity were more common in "star" galleries. Similarly, I find that higher-status dealers sometimes display "difficult" work, such as video art or overtly political art, as higher-status collectors are more willing to purchase this work, while lower-status galleries focus on selling more aesthetically pleasing work in traditional media.

11. Similarly, Childress and Nault (2019) describe how book editors are likely to have culturally and economically privileged backgrounds. No official credentials or skills are expected for this career path. Instead, aspiring editors must be able to weather the economic precarity of unpaid internships (which often requires financial support from parents), have access to social networks within the industry, and have elite literary tastes. Brook, O'Brien, and Taylor (2020) describe unpaid work as endemic to occupations in creative industries.

12. Curators look for aesthetic fit as well. Yogev (2010) shows that, in the Israeli art market, artists present their work to curators in a particular aesthetic area of interest. In the case of a perceived mismatch, a curator might show the work to another curator in that area. Artists might tailor their work to fit curators, while curators might select only works that reinforce certain themes. Yogev defines these "areas of interest" as broad artistic styles and movements, rather than specific creative visions.

13. Collectors loan their works to museums for exhibitions, which they and others perceive as philanthropic, while also increasing the economic worth of the work through visibility and prestige. Similarly, dealers sell work to museums at steeply discounted prices and privilege museums in the waiting list of collectors, as museum acquisitions increase artists' prestige and the price point of their bodies of work. While museums usually come before collectors in the peck-

ing order, there is also a hierarchy among museums. For example, one curator at the Whitney explained that MoMA has more prestige and a larger budget for collecting than the Whitney, so that the Whitney often ends up with MoMA's unwanted works.

14. Represented artists can participate in group or solo exhibitions at other galleries, increasing their visibility and prestige, but only with permission from the gallery that represents them, and this gallery usually receives a commission.

15. As Velthuis (2005) shows, dealers work to increase artists' critical success by encouraging critics to write about their shows, curators to include works in museum exhibitions, and high-status collectors to recommend the work to others.

16. Economic sociologist Jens Beckert's (2016) *Imagined Futures* shows how individuals base decisions about how to produce, distribute, and consume creative works on the perceived future economic worth of these works. Because these futures can never be known definitively, they always entail some level of economic risk. Karin Peterson (1997) reveals that dealers, like artists, face economic uncertainty, as the economic value of works and artists' future careers are unpredictable. Peterson examines how dealers manage this risk at different levels. Young galleries represent emerging artists, but they do not invest much money in these artists. In contrast, galleries for established artists invest substantial monetary and social resources in these artists but enjoy more certainty in their artists' careers. Galleries representing established artists work to connect these artists with important collectors and curators who might nurture their careers. Many galleries diversify their risk by including artists at a range of career stages.

17. In 2018, the Oscars announced the inclusion of a new category for "popular" films to widely negative press. Among the chief complaints, critics and reporters worried that the inclusion of a popular film category would provide even fewer opportunities for critically prestigious, but not popular, films to receive acclaim. Moreover, they questioned the ability to clearly separate the popular from the critically acclaimed. Todd VanDerWolff, "The Oscars' New 'Popular Film' Category Is a Bad Idea from a Panicked Organization," *Vox*, August 9, 2018, accessed August 30, 2018, https://www.vox.com/culture/2018/8/8/17664682/oscars-popular -film-category-2019.

18. In other creative industries, commercial and critical success also sometimes dovetail, such as in the case of literary bestsellers (Pouly 2016). However, in many cases, blockbuster hits do not become critical darlings, as the tastes of mass audiences differ from those of critics (Bourdieu 1985). Furthermore, critics and connoisseurs express ambivalence and suspicion regarding the aesthetic value of commercially successful creative works.

19. Tim Schneider, "The Gray Market: Why Blockbuster Museum Shows Aren't Actually Solving the Attendance Problem (and Other Insights)," *Artnet News*, April 30, 2018, accessed August 31, 2018, https://news.artnet.com/opinion/michael-jackson-blockbusters-1275152.

20. See chapter 5 in Moulin (1987) for an overview of different types of collectors.

21. Pénet and Lee (2014).

22. For example, critics accused Saatchi of using his influence as a trustee to have his own collection exhibited at the Tate Gallery (Pénet and Lee 2014).

23. Nate Freeman, "What It Costs Galleries to Go to Art Basel," Artsy, June 15, 2018, accessed August 21, 2019, https://www.artsy.net/article/artsy-editorial-costs-galleries-art-basel.

24. Nate Freeman, "Mom & Popped: In a Market Contraction, the Middle-Class Gallery Is Getting Squeezed," *ARTnews*, November 29, 2016, accessed August 21, 2019, http://www

.artnews.com/2016/11/29/mom-popped-in-a-market-contraction-the-middle-class-gallery-is -getting-squeezed/.

25. The European Fine Art Fair (TEFAF), TEFAF Art Market Report, 2015, accessed March 1, 2016, http://www.tefaf.com/artmarketreport.

26. The term "iconic" has different uses. Marketing scholar Douglas Holt (2004) refers to the iconic when discussing broader cultural icons of a society, such as Marilyn Monroe or Coca Cola. Cultural sociologist Jeffrey Alexander (2010) studies these broader cultural icons, defining the iconic as aesthetic experiences through which meaning is made visible. In sociologist Diane Crane's (1987) exploration of collective styles, Crane finds that core members of a style make works exhibiting most elements associated with the style, while peripheral members exhibit fewer elements of the style. In contrast, I analyze what is perceived as iconic in relation to individual artists' bodies of work. Therefore, I examine the iconic as formal and conceptual qualities representing particular creative visions. However, like Crane's distinction of a "core" member in relation to other members, I define an iconic work in relation to other works. An iconic work is one that contains many or all of the qualities representing the creative vision of an artist's body of work. I do not view the iconic as objective, but as perceptions that individuals have about which elements are core and enduring within artists' bodies of work. As I reveal, individuals do not always concur in their perceptions of iconicity.

27. Similarly, Pablo Helguera (2012) draws on symbolic interactionism to term the narratives that artists and others use to make meaning from their work "social scripts" or "art historical scripts" (p. 18). I use the term "style scripts" to focus more specifically on how artists discuss consistencies and variations within their bodies of work.

28. "Ginny Casey: Skeleton Key," *NY Art Beat*, 2018, accessed August 30, 2018, http://www .nyartbeat.com/event/2018/BDFC.

29. Fine (2018) explains that discourse shapes interpretations of art and therefore must be carefully managed. During critiques, MFA students struggled with how much or little meaning to reveal. Those who asked faculty to respond without guidance were seen as having not enough intentionality in their work, while those who described the meaning in detail were seen as having overly facile work that could not take on multiple meanings.

30. Jillian Steinhauer, "Worst. Press. Release. Ever: Luxury," *Hyperallergic*, September 19, 2014, accessed August 30, 2018, https://hyperallergic.com/149952/worst-press-release-ever -luxury/.

31. As described in chapter 1, critics legitimated artists, rather than discrete artworks, as they described the creative visions of artists and the place of works within these creative visions (White and White 1965). Certain critics, like Clement Greenberg and Leo Steinberg, wielded enough power to make or break an artist's career (Wolfe 1975).

32. Velthuis (2005).

33. See the methodological appendix for details on how I collected and analyzed these reviews.

34. *Artforum* and *Art in America* cover contemporary art, while *ARTnews* reviews visual art more broadly. *Artforum* has a reputation for being more experimental, *Art in America* is thought of as more aesthetically conservative, and *ARTnews* is considered more commercial.

35. Across the four periodicals, there was near gender parity in the allocation of reviews. Critics reviewed 191 exhibitions by male artists and 186 exhibitions by female artists.

36. Will Heinrich, "Bonnie Lucas," *New York Times*, February 9, 2017.

37. Barry Schwabsky, "Ena Swansea," *Artforum*, February 2017.

38. Works are exhibited "salon style" when they are hung close together in several rows on a wall.

39. Barry Schwabsky, "Peter Doig," *Artforum*, October 2017.

40. Richardo Venturi, "Jean-Luc Moulène," *Artforum*, February 2017.

41. Jeffrey Kastner, "Bernadette Mayer," *Artforum*, October 2017.

42. Lilly Lei, "Trickster Strategies: Leandro Erlich's Thought-Provoking Survey Kept Viewers on Edge," *ARTnews*, August 24, 2017, accessed December 14, 2019, https://www.art news.com/art-news/reviews/trickster-strategies-leandro-ehrlichs-thought-provoking-survey -kept-viewers-on-edge-082417–8837/.

43. Roberta Smith, "Susan Cianciolo," *New York Times*, November 17, 2017.

44. Holland Cotter, "Tiffany Chung," *New York Times*, September 28, 2017.

45. Michael Wilson, "Matt Johnson," *Artforum*, March 2017.

46. As Baumann (2001) and Becker (1980) claim, critics help consecrate particular works and fields as a whole by classifying certain works as "art" or "good art."

47. Phillipa Chong (2020) explains how, like art critics, those who review books usually do so as part-time, contingent labor. Most book critics who publish reviews in leading US periodicals are also published authors. Book critics often avoid writing negative reviews to maintain social relationships with other authors and to avoid seeming as if they are willing to take cheap shots at authors, especially emerging authors.

48. Similarly, Johnston and Baumann (2007) analyze food critics' reviews to see how experts in the culinary industry legitimate what counts as good taste.

49. Holland Cotter, "Anthony Hernandez," *New York Times*, October 18, 2017.

50. Rachel Wetzler, "Dara Friedman," *Art in America*, May 26, 2017, accessed December 14, 2019, https://www.artnews.com/art-in-america/aia-reviews/dara-friedman-62355/.

51. Roberta Smith, "Flora Crockett," *New York Times*, May 25, 2017.

52. Martha Schwendener, "Darren Bader," *New York Times*, June 22, 2017.

53. Roberta Smith, "Louis Fratino," *New York Times*, September 28, 2017.

54. Cat Kron, "Austė," *Artforum*, January 2017.

55. Martha Schwendener, "Joan Wallace," *New York Times*, March 30, 2017.

56. Barry Schwabsky, "Ernest Mancoba," *Artforum*, May 2017.

57. Alex Kitnick, "Heji Shin," *Artforum*, March 2017.

58. McDonnell (2010) defines legibility as "the capacity for audiences to read the intended meaning of an object" (p. 1807).

59. Barry Schwabsky, "Marisa Merz," *Artforum*, April 2017.

60. Roberta Smith, "Leonhard Hurzlmeier," *New York Times*, March 16, 2017.

61. Holland Cotter, "May Stevens," *New York Times*, March 23, 2017.

62. Martha Schwendener, "Henrique Oliveira," *New York Times*, July 14, 2017.

63. In the case of novels, Griswold (1987a) argues that readers evaluate novels positively when the work is optimally ambiguous. When novels are too straightforward in meaning, readers have little to discuss. When multiple audiences can each draw a distinctive meaning that resonates with their social context, the novel is circulated to a wider readership and readers debate the meaning. However, audiences evaluate novels negatively when they view them as

so ambiguous as to be incoherent, or open to any possible meaning. Similarly, Santana-Acuña (2020) reveals how ambiguity in meaning was one factor in *One Hundred Years of Solitude*'s widespread and sustained readership. See also McDonnell, Bail, and Tavory (2017).

64. David Frankel, "James Coleman," *Artforum*, April 2017.

65. Michael Wilson, "Vik Muniz," *Artforum*, May 2017.

66. Roberta Smith, "Rochelle Goldberg," *New York Times*, May 10, 2017.

67. Barry Schwabsky, "Marisa Merz," *Artforum*, April 2017.

68. Barry Schwabsky, "Edward Clark," *Artforum*, April 2017.

69. Rachel Wetzler, "Petra Cortright," *Art in America*, October 24, 2017, accessed December 14, 2019, https://www.artinamericamagazine.com/reviews/petra-cortright/.

70. "Ginny Casey," *New Yorker*, accessed August 31, 2018, https://www.newyorker.com/goings-on-about-town/art/ginny-casey-2.

71. Martha Schwendener, "Half Gallery," *New York Times*, April 26, 2018.

72. This is a less explored role of intermediaries, as sociologists usually portray intermediaries as responding to audiences' preferences and even at the mercy of audiences' whims.

73. Research on soap opera fans (Harrington and Bielby 1995) and syndicated television shows (Bielby and Harrington 2008) reveals that audiences are active meaning makers who interpret and respond to creative works in sometimes unexpected ways.

CHAPTER FIVE

1. The Armory Show was founded in 1994 by four New York City dealers. Its name harkens back to the 1913 Armory Show exhibition. The fair covers over 250,000 square feet of exhibition space and is housed on the piers overlooking the Hudson River on Manhattan's West Side. An estimated 65,000 visitors attend the Armory Show annually. The Armory Show, "Information: General Facts & Figures," accessed July 5, 2018, https://www.thearmoryshow.com/content/5-press/2-facts-and-figures/tas_information_general.pdf.

2. While the collectors I interviewed varied in wealth, they were all well within the "one percent" and tended to be highly educated. A predilection for avant-garde art over other kinds of visual art is characteristic of wealthy, highly educated, and urban people. In the 1990s, sociologist David Halle (1993) interviewed New Yorkers from various neighborhoods and income levels to examine the relationship between socioeconomic status and taste in visual art. Halle finds markedly different kinds of art on display, including landscape paintings, family photographs, abstract art, "primitive" sculpture, and religious iconography. He shows that lower socioeconomic status people were more likely to hang religious iconography and that middle socioeconomic status people had a preference for indigenous art. Halle discovers that abstract art is present in the homes of middle and upper-middle socioeconomic status families, but nearly absent in the homes of low socioeconomic status families. Halle also reveals that Manhattan families are more likely to hang abstract art than those living in the surrounding suburbs. Those who exhibited abstract art stated that they enjoyed its formal qualities, such as color and shapes, and that it encouraged their imagination. Halle claims that the attraction to abstract art is associated with the declining popularity of wallpaper. In other words, the design features of the work replaced those that used to be on the walls themselves. In contrast, those I interviewed were staunchly opposed to the idea of artwork functioning as wallpaper and

more interested in understanding the meaning of the work. This difference is likely because my sample was composed of comparatively "serious" and very wealthy collectors, and perhaps because of the roughly 25 years that elapsed between Halle's study and my own. In accordance with my findings, Gary Fine (2004, p.166) notes that collectors of outsider art argue that those who do not have works stacked in every nook and cranny of their homes are "decorators," not "real collectors."

3. Similarly, sociologist Max Besbris' (2016) study of the New York City housing market shows that real estate agents match clients to homes that they believe will specifically suit them, based on clients' stated preferences and criteria.

4. Elites increasingly engage in global travel and form international social networks. Mears' (2020) ethnography of the VIP global party circuit shows how wealthy men travel annually to different leisure destinations, such as Cannes and St. Tropez.

5. In sociological terminology, they would be termed "elites," in that they control a disproportionate amount of cultural, economic, and social resources (Khan 2012).

6. "American Community Survey," United States Census Bureau, 2018, accessed Sept. 11, 2020. https://data.census.gov/cedsci/table?g=0400000US36_1600000US3651000&d=ACS %205-Year%20Estimates%20Data%20Profiles&tid=ACSDP5Y2018.DP03.

7. Advisers also develop relationships with dealers, which they use to broker access to works that collectors may otherwise be unable to buy.

8. When I accompanied the art adviser and her client at the fair, I had expected the adviser to lead the client and recommend specific works. However, their relationship appeared casual and somewhat reciprocal. The client was knowledgeable about various artists, sometimes telling the adviser about an artist that the adviser did not know, and the client often led the adviser from booth to booth. This was likely because many clients use art advisers not merely to recommend work, but also to gain access to work. Art advisers help collectors move up dealers' waiting lists for the work of popular artists, as dealers hope that advisers will refer other clients to their galleries (Thompson 2008).

9. It is debatable whether art collections are wise investments, economically speaking. First, artworks are highly illiquid, and it is difficult to find secondary markets for works by emerging artists (Velthuis and Cosler 2012). Second, they may not necessarily outperform other forms of investments, such as stocks. Economists have used auction data to determine this question, with some finding that certain kinds of art investments could rival stocks, and others finding that art underperformed in comparison to stocks (Goetzmann 1993; Mei and Moses 2002). However, these studies have their limitations. They account only for auction prices, while contemporary art collectors tend to buy most of their works from galleries, and they do not specifically examine the prices of contemporary art. These data would be nearly impossible to collect, as sales by galleries are not made public. The collectors whom I interviewed often laughingly described art as a "bad investment," but this script served to downplay their economic incentives. It is unclear whether contemporary art is actually a bad investment for these collectors. In particular, the higher-status collectors whom I interviewed received discounts for the work that they purchased. More importantly, other collectors followed the purchases of major collectors, so it was more likely that the artists whose work these major collectors purchased would be successful, just by virtue of them purchasing it. Therefore, art may be a bad investment for some and a good investment for others.

10. Zelizer (1989) describes how heterosexual couples negotiated household finances from 1870 to 1930. She finds that, while men often retained control of the "serious" financial accounting, especially in high socioeconomic households, women maintained control over daily household expenditures, often through their husbands' allotment of an allowance. In the New York art world, collectors are generally politically liberal, and many claim to have egalitarian partnerships. However, in both egalitarian and more traditional partnerships, both male and female partners can legitimate their authority over art collecting. Women have historically managed cultural consumption, while men have long controlled financial investments. Contemporary art, as simultaneously a financial asset (although most collectors do not use this term) and a cultural work, cuts across both the financial and cultural sphere.

11. Douglas Maxwell also served as an adjunct assistant professor who taught courses on contemporary art in the School of Professional Studies at New York University.

12. Bourdieu (1984).

13. Museums often declined donations because they frequently assessed that the works were not worth their finite storage space and the cost of preservation over time. Domínguez Rubio (2020) describes the complex aesthetic labor, from conservation to storage, conducted by museum personnel in order to physically sustain and render legible as art these temporary and fragile works. Recently, museums have begun deaccessioning, or selling, certain works in their collections to generate the funds and space to purchase new works. Deaccessioning can be highly contentious, as some museumgoers believe that museums have an obligation to keep and display the works that they own through purchase or donation. For example, a regional art museum in Western Massachusetts, the Berkshire Museum, planned to offset its financial woes by deaccessioning 40 works, including two celebrated Norman Rockwell paintings. The public backlash was so intense that it attracted national media attention, and the Massachusetts attorney general eventually asked the state's supreme court to settle the case (the works were indeed deaccessioned). Andrew Russeth, "Berkshire Museum, Massachusetts Attorney General Will Ask State Supreme Court to Resolve Deaccession Disagreement," *ARTnews*, February 5, 2018.

14. Fine (2004, p. 194) also shows that dealers of outsider artists encourage loyalty to their galleries by giving discounts to repeat collectors and letting these collectors know that they are "special" clients. Monetary arrangements between dealers and collectors are usually private.

15. Similarly, Claudio Benzecry's (2011) ethnography of an opera house in Buenos Aires shows how opera fanatics claim moral superiority to other listeners by asserting that they have an irrepressible obsession with the music.

16. Boltanski and Esquerre (2020) claim that contemporary art and other luxury purchases are part of an "enrichment economy." They use the term enrichment in a double sense. First, commodities in these markets are intended for consumption by the wealthy. Second, these markets involve commodities that already exist, but that are enriched through the unique way in which they are brought together (i.e., in a collection) and through the production of narratives, or stories about these commodities' value.

17. As literary scholar Wolfgang Iser (1978) reveals in the case of reading literature, the reader engages in a cognitive back and forth movement between the information provided in the text and his or her own imagination. Similarly, viewers of art are guided by the work itself and style scripts, but do not take the meaning of the work as determinate. Instead, they imprint

their own experiences onto the meaning of the work, so that the work takes on various meanings for different people.

18. Braden (2015). All of the collectors I interviewed were white, with the exception of a Latino man. Collectors who are ethnic minorities in the United States tend to be most active in art institutions that focus on artists of that ethnicity (Banks 2017; 2019b). These institutions have, unfortunately, not yet become part of the mainstream art world. As described in the methodological appendix, I interviewed collectors through snowball sampling and had limited access to non-white collectors.

19. Given that collections are not public and the majority of works are not on display at any given time, it is impossible to know what percentage of works that collectors own are by female artists and artists of color.

20. James Case-Leal, "Art Statistics 2016–2017," 2017, accessed October 8, 2018, http://www.havenforthedispossessed.org/.

21. In recent years, major auction houses have begun regular evening and daytime auctions devoted specifically to contemporary African art, increasing the representation of African artists, but also separating these artists from the mainstream contemporary art market. Patricia Banks, "Fluid Categories," *Contemporary And*, May 25, 2017, accessed October 8, 2018, http://www.contemporaryand.com/magazines/fluid-categories/.

22. In chapter 3, I discuss in more detail how artists draw upon aspects of their identities, including race and gender, in their works.

23. Braden (2015).

24. Halle and Tiso (2014) interviewed samples of the general Chelsea gallerygoer audience and collectors at the Armory Show in 2010. They find that both casual gallerygoers and collectors stated that they liked works that resonated explicitly or implicitly with their lives.

25. See Childress and Nault (2019) and Rivera (2015).

26. Banks (2010; 2019a). See also Grams (2010).

27. Thompson (2008) notes that waiting lists serve to get art to the "right" people, ensuring that works are placed with the collectors of not only the highest status but also the most trustworthiness. Dealers want to sell to collectors who will act as good stewards of the work and not "flip" the work quickly at auction.

28. Gell (1998).

29. In an experimental study, researchers Stoyan Sgourev and Niek Althuizen (2014) showed business school students a set of four artworks and asked them to rate the works' aesthetic value and each artist's creativity. The researchers gave the students two different sets of artworks, one in which the works showed a large variation in formal qualities, and the other in which the works were more highly consistent in formal qualities. While both sets of works actually belonged to Pablo Picasso, the researchers told different students that the works were produced by a low-status, medium-status, or high-status artist. Students rated the aesthetic quality of the works and the creativity of the artist more highly when they believed that the artist was high-status, while viewing lower-status artists who varied formal qualities broadly as less competent.

30. Bourdieu (1987).

31. I attended several parties at this penthouse. The dealer who organized these events claimed that the hotel paid him to hold art world parties there as part of its branding efforts.

32. While collectors place works from different price points next to each other, they tend to

concentrate serious buys in more public rooms, such as the living and dining room. In contrast, they place fliers in private rooms, less formal rooms, and rooms where work is less physically protected, such as kitchens and bathrooms.

33. In her study of the French art market, sociologist and art historian Raymonde Moulin (1987) asserts that collectors claim that they buy art for love, rather than money. Halle and Tiso's (2014) interviews with contemporary collectors reveal that, while a small portion argued that they were predominantly motivated to purchase for investment, most asserted that they bought works that they liked. Some stated that they exclusively based their choices on aesthetic preference. Others said that they primarily based their choices on aesthetic preference while also wanting to know that they had bought works at a reasonable price and that the works were likely to maintain or increase in value. Drawing from published interviews of major collectors, Velthuis (2005) argues that most collectors do not intend on actually selling their work. However, collectors want to know that their collection is economically valuable so that they do not feel foolish about their hefty purchases. While I found that collectors sometimes did sell their work, the collectors I interviewed stated that they sold a small proportion of their collections.

34. Gerber (2017) argues that artists, like collectors, view making money and loving art as potentially complementary.

35. Art advisers, whose job it was to advise clients on "undervalued" artists, and collectors who are more concerned about economic returns vet earlier buys as well as serious buys. For example, on the day that Marcia Eitelberg and I toured different galleries, she would ask each dealer or gallery assistant to tell her about the exhibit. If she was interested in what she heard and saw, she would ask for the artist's age (correct answer: under 30), whether this was his or her first solo show (correct answer: no), from where he or she received an MFA degree (correct answer: a top-ranked program), and whether he or she was based in New York City (correct answer: yes). Then, she would ask if the gallery would have a booth at the upcoming New Art Dealers Alliance or Frieze New York art fairs and which artists' works they planned to exhibit. The aloof dealers and gallery assistants endured these credentialing questions with measured patience and curt responses, nearly audibly thinking to themselves that they hated this part of the job.

36. Curators recalled the works of collections they had toured with a nearly photographic memory and would later contact collectors when orchestrating exhibitions. Museum loans and donations also increased the visibility of collectors, whose names were printed on a plaque next to the work. Some collectors, like the Mallins, opted to anonymously donate the work, meaning that they would not have their name printed. Sherry Mallin joked that her friends knew that it was their donation when they saw the word "anonymous" next to a work.

37. Wohl (2020).

38. Baxandall (1972) claims that people in different historical epochs have "period eyes" in which they perceive art in distinctive ways due to their historical location. Similarly, sociologist Pierre Bourdieu (1984) argues that the eye is a product of history. However, Bourdieu emphasizes socioeconomic status as a central influence on viewers' eyes. Bourdieu claims that people are socialized into their tastes through education and other life experiences. To appreciate a work of art as meaningful and interesting, someone must possess the right "cultural code." Otherwise, Bourdieu argues, the person "feels lost in the chaos of sounds and rhythms, colours and lines, without rhyme or reason" (p. 3). Similar to my findings, Fine (2004) discusses the

rhetoric of the "eye" among collectors of outsider art. These collectors express relief when their choices are validated by critics, as they lack objective metrics for verifying the qualities of their eyes. However, collectors of outsider art differ from collectors of contemporary art in that the former prize certain perceived qualities more highly, such as artists' authenticity as outsiders. Velthuis (2005) also notes that collectors emphasize their reliance on their eyes. Velthuis argues that collectors find their eyes to be validated when their purchases subsequently increase in economic value. I find collectors to legitimize their eyes by drawing upon *both* increases and decreases in economic value. Collectors express economic wins as evidence that the market has followed their tastes, and they claim economic losses as evidence that they are far ahead of the market.

39. Moulin (1987) argues that there are different types of these "prestige" collectors: "scholars" who seek to rediscover artists, "discoverers" who like to find new artists, "snobs" who are attracted to provocative artists, and "speculators" who view increases in artists' price points as proof of their innovativeness. I show how these collectors all claim aesthetic confidence in order to assert their status and authenticity, and I reveal how claims of aesthetic confidence solidify the status hierarchy among collectors as these claims are confirmed or denied in interaction.

40. Art advisers and their clients also referred to each other as "friends," although collectors who did not use art advisers emphasized that these relationships were economically oriented. Similarly, Mears (2020) reveals that promoters for elite nightclubs, the conventionally attractive "girls" whom they bring to clubs, and the clients who purchase bottle service all emphasize their friendships with one another, downplaying the economic nature of these relationships in their interactions. However, clubs and promoters derive substantial financial benefits from these relationships, while "girls" are paid in more modest and informal gifts, like dinners and drinks.

41. While this would be the equivalent of insider trading in the stock market, the art market is unregulated and receiving such information is legal.

42. Collectors also criticized several categories of collectors: "flippers," who they believed rapidly resold work for profit; "buyers," who they claimed were interested in art only for decoration; and those who used art advisers, who they thought lacked their own taste and were overly concerned with economic appreciation.

43. This practice is called making "symbolic boundaries." Until the 1960s, elites marked their distinctive tastes by consuming highbrow cultural goods, while non-elites consumed middlebrow and lowbrow goods. For example, Bourdieu (1984) draws on survey research to show how people's socioeconomic status shaped their musical tastes in France, with lower socioeconomic people preferring ballroom dance music, middle socioeconomic people listening to jazz, and affluent people liking opera music. Social scientists noticed that, in subsequent decades, elite tastes became increasingly omnivorous (Peterson and Kern 1996). Rather than being distinctive for consuming only highbrow culture, elites were now differentiated by the range of cultural goods they consumed, sampling from lowbrow, middlebrow, and highbrow genres, while middle and lower socioeconomic people continued to consume cultural goods from a narrower range of genres. A wealthy and highly educated person might now go to an experimental theater performance and then get dinner from a fusion food truck, listening to a playlist including hip hop, indie, and jazz on their way home. However, Bryson (1996) reveals that not all lowbrow tastes are equally acceptable to elites. Elites draw selectively among lowbrow genres, continuing

to reject certain genres, such as country music or heavy metal. Johnston and Baumann (2007) find that elites consume lowbrow genres that they view as authentic and exotic. Lena (2019) charts the historical changes within arts organizations that encouraged wealthy audiences to adopt omnivorous tastes that reaffirmed their elite and cosmopolitan tastes. I show that, in certain cultural fields, claims to independent taste are at least as consequential for drawing symbolic boundaries as displays of omnivorous taste.

44. Sherman (2017).

45. Similarly, Mears (2020) shows how wealthy men participate in conspicuous displays of consumption, such as paying for bottle service in elite nightclubs, while marking their purchases as more reasonable than those of other elites.

46. As Zelizer (1989) observes, money takes on various moral meanings when earmarked for different purposes.

47. These collectors are likely philanthropists of other causes as well. Sociologist Rachel Sherman's (2017) study of the New York City economic elite reveals that they often donate to arts organizations and other kinds of organizations, such as their children's schools, their alma maters, and politically liberal nonprofits.

CHAPTER SIX

1. Gell (1998).

2. Giuffre (1999) has argued that artists do not climb artistic careers like ladders, but like sandpiles, with each step changing the shape of the climb to the top. Similarly, artists develop their bodies of work as if ascending sandpiles, with each choice changing how their work is perceived in the future and their possible future decisions.

3. Other sociologists have similarly used career stages to describe artists and galleries (for example, see Peterson 1997). These categories are inherently imprecise. Artistic careers are neither clear-cut nor linear. There is no single moment where artists shift decisively from one career stage to another, and many artists stall at one career stage, lose recognition, or drop out of the art world altogether. Commercial success and critical success are continuums. The former is primarily defined by sales, while the latter is marked by multiple indicators, including exhibitions, gallery representation, critical reviews, and museum acquisitions. Critical and commercial success sometimes coincide (Pouly 2016). Critical success often precedes and influences commercial success. For example, the institutionalization of the Turner Prize for contemporary British artists hastened the commercial success of the winners (Pénet and Lee 2014). However, critical and commercial success also continue to operate somewhat independently and can diverge, such as when middlebrow creative works appeal to mass audiences but not critics (Bourdieu 1985).

4. I identify 16 artists as uninitiated, 15 artists as emerging, and 22 artists as established. In the art world, these terms are used inconsistently, sometimes describing the length of time an artist has exhibited his or her work and other times indicating an artist's degree of critical or commercial success. Moreover, multiple terms are used to describe each career stage. For example, more established artists are sometimes described as mid-career artists or early blue-chip artists. I categorize artists primarily depending on the number of solo exhibitions that they have had at reputable galleries, but also consider other factors, such as gallery representation,

reviews, and museum acquisitions. Not all artists had linear career paths, as some artists lost critical and/or commercial success after a period of higher recognition. I classified artists' career stage by the cumulative critical success throughout their careers, rather than their recent level of success. I have categorized artists based on their accolades at the time of my research. As careers can change quickly in the art world, some may have moved to different career stages by the time of publication. I note specific cases in which critical and commercial success diverge.

5. I distinguish uninitiated artists from emerging artists for more analytic granularity.

6. I did not interview "superstar" artists, like Jeff Koons or Christopher Wool. I also did not interview artists who had exited the art world.

7. MFA students take courses in theory and have critiques, but they enroll in few or no art history courses and courses that teach artistic technique. Students learn this information and skills as needed, and they refer to the work of other artists as "inspirations," rather than seeking to directly emulate this work (Fine 2018).

8. Group exhibitions also provide artists with the opportunity to implicitly associate their work with the work of other, sometimes better-known artists in the exhibition (Braden 2009).

9. Catherine Clark Gallery, "Kambui Olujimi," accessed October 22, 2019, https://cclarkgallery.com/artists/bios/kambui-olujimi.

10. Leschziner (2015) explores how elite chefs perform authenticity by balancing conformity to and distinction from other chefs. Changing styles too often would make chefs seem uncommitted, but lacking novelty would make chefs seem unoriginal (p. 74). I extend Leschziner's findings by focusing on how artists balance consistency and variation within their own bodies of work and showing how these strategies change over their careers.

11. Halsey McKay Gallery, "Dark Interiors & Bright Landscapes," accessed October 18, 2019, http://www.halseymckay.com/dark-interiors-bright-landscapes-press-release.

12. Kendra Patrick, "Heliotrope," accessed October 18, 2019, http://www.halseymckay.com/lauren-luloff-heliotrope-press-release.

13. Halsey McKay Gallery, "Sun Drawn," accessed October 18, 2019, http://www.halseymckay.com/lauren-luloff-sun-drawn-press-release.

14. Halsey McKay Gallery, "Small Landscapes," October 18, 2019, http://www.halseymckay.com/lauren-luloff-small-landscapes-press-release.

15. Roberta Smith, "Katherine Bernhardt and Youssef Jdia: 'Holiday Services,'" *New York Times*, November 21, 2013.

16. Roberta Smith, "Katherine Bernhardt: 'Stupid, Crazy, Ridiculous, Funny Patterns,'" *New York Times*, February 20, 2014.

17. Velthuis (2005).

18. Ibid.

19. New Museum, "Cheryl Donegan: Scenes and Commercials," 2017, accessed January 26, 2017, http://www.newmuseum.org/exhibitions/view/cheryl-donegan-scenes-commercials.

20. Martha Schwendener, "Cheryl Donegan, 'Scenes and Commercials,'" *New York Times*, March 10, 2016.

21. In McDonnell, Bail, and Tavory's (2017) article on resonance, the authors discuss Mears' (2011) case of fashion models. Bookers begin to see a model as having the right "look" once the model is already chosen by high-status clients. Individuals in a cultural field are stratified based on a "hierarchy of credibility," with higher-status individuals having more power to influence

what others see as resonant. In the same way, high-status actors in the art world have more credibility when they assert the meaning of artworks, and other viewers are more likely to see these interpretations as valid.

22. Gell (1998).

23. Management scholar Frédéric Godart (2018) notes that "insiders" and "outsiders" in fields perceive style differently. Insiders have more knowledge in their field than outsiders and therefore will be able to better differentiate between styles. In the art world, insiders and outsiders can be defined in multiple ways. In one sense, an insider could refer to anyone active in the art world, including artists, dealers, curators, critics, art advisers, collectors, and frequent gallerygoers and museumgoers. These insiders are more perceptive to formal and conceptual differences among and within artists' bodies of work than those less familiar with contemporary art. In another sense, an insider could be the artist, with anyone else constituting an outsider of that creative vision. Here too, artists have more fine-grained and in-depth understandings of their own bodies of work. They may be the only individuals who have seen certain sketches, unfinished works, or works that have not left the studio, and therefore may perceive consistencies and variations less visible to anyone else.

CHAPTER SEVEN

1. Karpik (2010).

2. Velthuis (2005).

3. For example, Rao et al. (2003) discuss a case in which a man who inherits his father-in-law's Creole restaurant struggles to keep both customers and positive reviews after defying his audience's expectations by changing the recipe of the restaurant's "quintessential" sauce (p. 809–810). Regular customers objected to the new menu because it omitted the signature sauce on which the restaurant built its name, not because they perceived the cuisine to be less Creole.

4. In Antal, Hutter, and Stark's (2015) edited volume, *Moments of Valuation: Exploring Sites of Dissonance*, the editors argue that "moments of valuation" are temporally and spatially marked situations in which individuals taste, test, and contest the worth of goods. The editors claim that dissonant moments—moments when actors weigh multiple forms of value—are especially profitable for understanding processes of valuation. I show how moments of judgment are distributed over time, place, and people in interlocking sequences.

5. Boltanski and Thévenot's (2006) seminal *On Justification* argues that individuals evaluate objects based on multiple forms of judgment, or orders of worth, which they apply simultaneously.

6. See also Rivera (2015).

METHODOLOGICAL APPENDIX

1. Becker (2006) says that, in the case of visual art, analyzing "intermediate products"—the "alternatives and scraps of the labor process," including sketches, unfinished works, failures, and editings—reveals how an artist produces the finished works by making a series of decisions. Following Becker's proposal, sociologist Pierre-Michel Menger (2014) uses archival research to analyze the process of creative production of a single artist, Rodin, through the examina-

tion of these intermediate products. Similarly, in the case of scientific experiments, historian of science Peter Galison (1987) claims that analyzing failed experiments, rather than successful ones, highlights different stages of experimentation, as experimenters must return to earlier stages to examine their assumptions and tests.

2. Jerolmack and Khan (2014) examine the methodological implications of interviewees' tendencies to portray themselves as they want to be seen. They show how sociologists often take subjects' self-portrayals as unproblematic reflections of how subjects behave, in effect conflating self-reports of behavior with actual behavior. They argue that only ethnography can capture behavior. Vaisey (2014), DiMaggio (2014), and others have critiqued this position, claiming that interviewing and other methods can, in fact, analyze attitude and behavior, when certain techniques are used.

3. Desmond (2014).

4. Bandelj (2020).

5. Reviews for the *New York Times* were written by only 5 staff critics with an additional guest critic writing one review. The other periodicals relied on freelance critics. Reviews for *Artforum* were written by 36 critics, reviews for *Art in America* were written by 27 critics, and reviews for *ARTnews* were written by 12 critics.

6. Cousin, Khan, and Mears (2018) explain directions for future research on elites and cite specific methodological issues to studying elites, including cost, access, and symbolic domination.

7. Similarly, Childress (2017) reveals the identities of the author and key people associated with the publication of *Jarrettsville*, given the specificity of this work. See Jerolmack and Murphy (2019) for a discussion of the benefits and consequences of rendering subjects identifiable.

REFERENCES

Accominotti, Fabien. 2009. "Creativity from Interaction: Artistic Movements and the Creativity Careers of Modern Painters." *Poetics* 37(3): 267–294.

Acord, Sophia Krzys. 2010. "Beyond the Head: The Practical Work of Curating Contemporary Art." *Qualitative Sociology* 33(4): 447–467.

Adler, Laura. "Choosing Precarious Work: Job Preferences and the Value of 'Bad Jobs.'" Unpublished manuscript.

Ahlkvist, Jarl, and Gene Fisher. 2000. "And the Hits Just Keep on Coming: Music Programming Standardization in Commercial Radio." *Poetics* 27(5–6): 301–325.

Alexander, Jeffrey. 2010. "Iconic Consciousness: The Material Feeling of Meaning." *Environment and Planning D: Society and Space* 26: 782–794.

Almeling, Rene. 2011. *Sex Cells: The Medical Market for Eggs and Sperm*. Berkeley: University of California Press.

Amabile, Theresa. 1988. "A Model of Creativity and Innovation in Organizations." *Research in Organizational Behavior* 10: 123–167.

Antal, Ariane, Michael Hutter, and David Stark, eds. 2015. *Moments of Valuation: Exploring Sites of Dissonance*. Oxford: Oxford University Press.

Anteby, Michel. 2010. "Markets, Morals, and Practices of Trade: Jurisdictional Disputes in the U.S. Commerce in Cadavers." *Administrative Science Quarterly* 55(4): 606–638.

Arendt, Hannah. [1977] 1992. *Lectures on Kant's Political Philosophy*. Edited by Ronald Beiner. Chicago: University of Chicago Press.

Askin, Noah, and Michael Mauskapf. 2017. "What Makes Popular Culture Popular? Product Features and Optimal Differentiation in Music." *American Sociological Review* 82(5): 910–944.

Aspers, Patrik. 2009. "Knowledge and Valuation in Markets." *Theory and Society* 38(2): 111–131.

Bandelj, Nina. 2020. "Relational Work in the Economy." *Annual Review of Sociology* 46: 251–272.

Banks, Patricia A. 2010. *Represent: Art and Identity among the Black Upper-Middle Class.* New York: Routledge.

Banks, Patricia A. 2017. "Ethnicity, Class, and Trusteeship at African American and Mainstream Museums." *Cultural Sociology* 11(1): 97–112.

Banks, Patricia A. 2019a. "Cultural Justice and Collecting: Challenging the Underrecognition of African American Artists." In *Race in the Marketplace: Crossing Critical Boundaries,* edited by Guillaume D. Johnson, Sonya A. Grier, Kevin Thomas, and Anthony Kwame Harrison, 213–226. Cham, Switzerland: Springer Nature.

Banks, Patricia A. 2019b. "High Culture, Black Culture: Strategic Assimilation and Cultural Steering in Museum Patronage." *Journal of Consumer Culture* 1–23.

Baumann, Shyon. 2001. "Intellectualization and Art World Development: Film in the United States." *American Sociological Review* 66: 404–426.

Baxandall, Michael. 1972. *Painting and Experience in Fifteenth-Century Italy: A Primer in the Social History of Pictorial Style.* Oxford: Clarendon Press.

Becker, Howard S. 1960. "Notes on the Concept of Commitment." *American Journal of Sociology* 66: 32–40.

Becker, Howard S. 1974. "Art as Collective Action." *American Sociological Review* 39(6): 767–776.

Becker, Howard S. 1980. "Aesthetics, Aestheticians, and Critics." *Studies in Visual Communication* 6(1): 58–68.

Becker, Howard S. 1982. *Art Worlds.* Berkeley: University of California Press.

Becker, Howard S. 2006. "The Work Itself." In *Art from Start to Finish: Jazz, Painting, and Other Improvisations,* edited by H. S. Becker, R. R. Faulkner, and B. Kirschenblatt-Gimblett, 21–30. Chicago: University of Chicago Press.

Beckert, Jens. 2016. *Imagined Futures: Fictional Expectations and Capitalist Dynamics.* Cambridge, MA: Harvard University Press.

Beckert, Jens, and Patrik Aspers, eds. 2011. *The Worth of Goods: Valuation and Pricing in the Economy.* Oxford: Oxford University Press.

Benzecry, Claudio. 2011. *The Opera Fanatic: Ethnography of an Obsession.* Chicago: University of Chicago Press.

Besbris, Max. 2016. "Romancing the Home: Emotions and the Interactional Creation of Demand in the Housing Market." *Socio-Economic Review* 14(3): 461–482.

Bielby, Denise D., and C. Lee Harrington. 2008. *Global TV: Exporting Television and Culture in the World Market.* New York: New York University Press.

Bielby, William T., and Denise D. Bielby. 1994. "'All Hits Are Flukes': Institutionalized Decision Making and the Rhetoric of Network Prime-Time Program Development." *American Journal of Sociology* 99(5): 1287–1313.

Bink, Martin L., and Richard L. Marsh. 2000. "Cognitive Regularities in Creative Activity." *Review of General Psychology* 4: 59–78.

Boltanski, Luc, and Arnaud Esquerre. 2020. *Enrichment: A Critique of Commodities.* Translated by Catherine Porter. Cambridge, MA: Polity Press.

Boltanski, Luc, and Laurent Thévenot. 2006. *On Justification: Orders of Worth.* Princeton: Princeton University Press.

Bourdieu, Pierre. 1984. *Distinction: A Social Critique of the Judgment of Taste*. Cambridge, MA: Harvard University Press.

Bourdieu, Pierre. 1985. "The Market of Symbolic Goods." *Poetics* 14(1–2): 13–44.

Bourdieu, Pierre. 1987. "The Historical Genesis of a Pure Aesthetic." *Journal of Aesthetics and Art Criticism* 46: 201–210.

Bourdieu, Pierre. 1993. *The Field of Cultural Production*. New York: Polity.

Braden, Laura. 2009. "From the Armory to Academia: Careers and Reputations of Early Modern Artists in the United States." *Poetics* 37(5–6): 439–455.

Braden, Laura. 2015. "Collectors and Collections: Critical Recognition of the World's Top Art Collectors." *Social Forces* 94(4): 1483–1507.

Brook, Orian, Dave O'Brien, and Mark Taylor. 2020. *Culture Is Bad for You: Inequality in the Cultural and Creative Industries*. Manchester: Manchester University Press.

Brubaker, Rogers, and Frederick Cooper. 2000. "Beyond 'Identity.'" *Theory and Society* 29(1): 1–47.

Bryson, Bethany. 1996. "'Anything but Heavy Metal': Symbolic Exclusion and Musical Dislikes." *American Sociological Review* 61(5): 884–899.

Buccholz, Larissa. 2016. "What Is a Global Field? Theorizing Fields beyond the Nation-State." *Sociological Review* 64(2): 31–60.

Carroll, Noël. 1993. "Historical Narratives and the Philosophy of Art." *Journal of Aesthetics and Art Criticism* 51(3): 313–326.

Cattani, Gino, Roger Dunbar, and Zur Shapira. 2017. "How Commitment to Craftsmanship Leads to Unique Value: Steinway and Sons' Differentiation Strategy." *Strategy Science* 2(1): 13–38.

Childress, Clayton. 2017. *Under the Cover: The Creation, Production, and Reception of a Novel*. Princeton: Princeton University Press.

Childress, Clayton, and Noah Friedkin. 2011. "Cultural Reception and Production: The Social Construction of Meaning in Book Clubs." *American Sociological Review* 77(1): 45–68.

Childress, Clayton, and Jean-Francois Nault. 2019. "Encultured Biases: The Role of Products in Pathways to Inequality." *American Sociological Review* 84(1): 115–141.

Chong, Phillipa. 2020. *Inside the Critics' Circle: Book Reviewing in Uncertain Times*. Princeton: Princeton University Press.

Chumley, Lily. 2016. *Creativity Class: Art School and Culture Work in Postsocialist China*. Princeton: Princeton University Press.

Collins, Randall. 2004. *Interaction Ritual Chains*. Princeton: Princeton University Press.

Cooley, Charles H. 1902. *Human Nature and the Social Order*. New York: Scribner's.

Cousin, Bruno, Shamus Khan, and Ashley Mears. 2018. "Theoretical and Methodological Pathways for Research on Elites." *Socio-Economic Review* 16(2): 225–249.

Crane, Diana. 1987. *The Transformation of the Avant-Garde: The New York Art World, 1940–1985*. Chicago: University of Chicago Press.

Crane, Diana. 2016. "The Changing Geography of the Global Art Market: National Leadership, Regionalization and Cultural Flows." Paper presented at the Art Market in a Global Perspective Conference, panel on "The Changing Geography of Art," Amsterdam, Netherlands, August.

Csikszentmihalyi, Mihaly. 1990. *Flow: The Psychology of Optimal Experience.* New York: Harper and Row.

Csikszentmihalyi, Mihaly. 1997. *Creativity: Flow and the Psychology of Discovery and Innovation.* New York: HarperCollins.

Csikszentmihalyi, Mihaly, and R. Keith Sawyer. 1995. "Creative Insight: The Social Dimension of a Solitary Moment." In *The Nature of Insight,* edited by R. J. Sternberg and J. E. Davidson, 329–363. Cambridge, MA: MIT Press.

Danto, Arthur C. 1964. "The Artworld." *Journal of Philosophy* 61(19): 571–584.

Danto, Arthur C. 1981. *The Transfiguration of the Commonplace.* Cambridge, MA: Harvard University Press.

Danto, Arthur C. 1997. *After the End of Art: Contemporary Art and the Pale of History.* Princeton: Princeton University Press.

DeNora, Tia. 2000. *Music in Everyday Life.* Cambridge: Cambridge University Press.

Desmond, Matthew. 2014. "Relational Ethnography." *Theory and Society* 43: 547–579.

Dewey, John. 1934. *Art as Experience.* Carbondale: Southern Illinois University Press.

Dickie, George. 1974. *Art and the Aesthetic: An Institutional Analysis.* Ithaca, NY: Cornell University Press.

Dickie, George. 1984. *The Art Circle: A Theory of Art.* New York: Haven Publications.

DiMaggio, Paul. 2014. "Comment on Jerolmack and Khan, 'Talk Is Cheap': Ethnography and the Attitudinal Fallacy." *Sociological Methods & Research* 43(2): 232–235.

Domínguez Rubio, Fernando. 2012. "The Material Production of the Spiral Jetty: A Study of Culture in the Making." *Cultural Sociology* 6(2): 143–161.

Domínguez Rubio, Fernando. 2020. *Still Life: Ecologies of the Modern Imagination at the Art Museum.* Chicago: University of Chicago Press.

Elkins, James. 2014. *Artists with PhDs: On the New Doctoral Degree in Studio Art.* Washington, DC: New Academia Publishing.

Fang, Jun. 2020. "Tensions in Aesthetic Socialization: Negotiating Competence and Differentiation in Chinese Art Test Prep Schools." *Poetics* 79: https://doi.org/10.1016/j.poetic.2020.101443.

Farrell, Michael P. 2001. *Collaborative Circles: Friendship Dynamics and Creative Work.* Chicago: University of Chicago Press.

Faulkner, Robert R., and Howard S. Becker. 2009. *"Do You Know . . . ?" The Jazz Repertoire in Action.* Chicago: University of Chicago Press.

Fine, Gary Alan. 1992. "The Culture of Production: Aesthetic Choices and Constraints in Culinary Work." *American Journal of Sociology* 97(5): 1268–1294.

Fine, Gary Alan. 2004. *Everyday Genius: Self-Taught Art and the Culture of Authenticity.* Chicago: University of Chicago Press.

Fine, Gary Alan. 2018. *Talking Art: The Culture of Practice and the Practice of Culture in MFA Education.* Chicago: University of Chicago Press.

Florida, Richard. 2002. *The Rise of the Creative Class.* New York: Basic Books.

Freeman, John, and Michael Hannan. 1983. "Niche Width and the Dynamics of Organizational Populations." *American Journal of Sociology* 88(6): 1116–1145.

Galison, Peter. 1987. *How Experiments End.* Chicago: University of Chicago Press.

Gecas, Viktor, and Peter J. Burke. 1995. "Self and Identity." In *Sociological Perspectives on*

Social Psychology, edited by K. Cook, G. A. Fine, and J. S. House, 41–67. Boston: Allyn and Bacon.

Gell, Alfred. 1998. *Art and Agency*. Oxford: Clarendon Press.

Gerber, Alison. 2017. *The Work of Art: Value in Artistic Careers*. Stanford: Stanford University Press.

Giorgi, Simona, and Weber, Klaus. 2015. "Marks of Distinction: Framing and Audience Appreciation in the Context of Investment Advice." *Administrative Science Quarterly* 60(2): 333–367.

Giuffre, Katherine. 1999. "Sandpiles of Opportunity: Success in the Art World." *Social Forces* 77(3): 815–832.

Godart, Frédéric C. 2018. "Why Is Style Not in Fashion? Using the Concept of 'Style' to Understand the Creative Industries." In *Frontiers of Creative Industries: Exploring Structural and Categorical Dynamics*, vol. 55 of *Research in the Sociology of Organizations*, edited by C. Jones and M. Maoret, 103–128. Bingley, UK: Emerald Publishing Limited.

Goetzmann, William. 1993. "Accounting for Taste: Art and the Financial Markets over Three Centuries." *American Economic Review* 83(5): 1370–1376.

Goffman, Erving. 1959. *The Presentation of Self in Everyday Life*. New York: Random House.

Grams, Diane. 2010. *Producing Local Color: Art Networks in Ethnic Chicago*. Chicago: University of Chicago Press.

Grazian, David. 2003. *Blue Chicago: The Search for Authenticity in Urban Blues Clubs*. Chicago: University of Chicago Press.

Greenland, Fiona. 2016. "Color Perception in Sociology: Materiality and Authenticity at the *Gods in Color* Show." *Sociological Theory* 34(2): 81–105.

Griswold, Wendy. 1986. *Renaissance Revivals: City Comedy and Revenge Tragedy in the London Theatre, 1576–1980*. Chicago: University of Chicago Press.

Griswold, Wendy. 1987a. "The Fabrication of Meaning: Literary Interpretation in the United States, Great Britain, and the West Indies." *American Journal of Sociology* 92(5): 1077–1117.

Griswold, Wendy. 1987b. "A Methodological Framework for the Study of Culture." *Sociological Methodology* 17: 1–35.

Gross, Neil. 2008. *Richard Rorty: The Making of an American Philosopher*. Chicago: University of Chicago Press.

Gross, Neil. 2013. *Why Are Professors Liberal and Why Do Conservatives Care?* Cambridge, MA: Harvard University Press.

Halle, David. 1993. *Inside Culture: Art and Class in the American Home*. Chicago: University of Chicago Press.

Halle, David, and Elizabeth Tiso. 2014. *New York's New Edge: Contemporary Art, the High Line, and Urban Megaprojects on the Far West Side*. Chicago: University of Chicago Press.

Harrington, C. Lee, and Denise D. Bielby. 1995. *Soap Fans: Pursuing Pleasure and Making Meaning in Everyday Life*. Philadelphia: Temple University Press.

Healy, Kieran. 2000. "Embedded Altruism: Blood Collection Regimes and the European Union's Donor Population." *American Journal of Sociology* 105(6): 1633–1657.

Hegel, Georg Wilhelm Friedrich. 1975. *Hegel's Aesthetics: Lectures on Fine Arts*. Translated by T. M. Knox. Oxford: Clarendon Press.

Heinich, Nathalie. 2014. "Practices of Contemporary Art: A Pragmatic Approach to a New Artistic Paradigm." In *Artistic Practices: Social Interactions and Cultural Dynamics*, edited by T. Zembylas, 32–43. New York: Routledge.

Helguera, Pablo. 2012. *Art Scenes: The Social Scripts of the Art World.* New York: Jorge Pinto Books.

Hicks, Robert D., ed. 2015. *Aristotle's "De Anima."* Cambridge: Cambridge University Press.

Holt, Douglas. 2004. *How Brands Become Icons: The Principles of Cultural Branding.* Cambridge, MA: Harvard Business School Press.

Horowitz, Noah. 2011. *Art of the Deal: Contemporary Art in a Global Financial Market.* Princeton: Princeton University Press.

Hsu, Greta. 2006. "Jacks of All Trades and Masters of None: Audiences' Reactions to Spanning Genres in Feature Film Production." *Administrative Science Quarterly* 51(3): 420–450.

Iser, Wolfgang. 1978. *The Act of Reading: A Theory of Aesthetic Response.* Baltimore: Johns Hopkins University Press.

Jerolmack, Colin, and Shamus Khan. 2014. "Talk Is Cheap: Ethnography and the Attitudinal Fallacy." *Sociological Methods and Research* 43(2): 178–209.

Jerolmack, Colin, and Alexandra Murphy. 2019. "The Ethical Dilemmas and Social Scientific Trade-Offs of Masking in Ethnography." *Sociological Methods and Research* 48(4): 801–827.

Johnston, Josée, and Shyon Baumann. 2007. "Democracy versus Distinction: A Study of Omnivorousness in Gourmet Food Writing." *American Journal of Sociology* 113(1): 165–204.

Kahneman, Daniel. 2011. *Thinking, Fast and Slow.* New York: Farrar, Straus and Giroux.

Kant, Immanuel. [1790] 2000. *Critique of the Power of Judgement.* Edited by Paul Guyer and Allen Wood. Cambridge: Cambridge University Press.

Karpik, Lucien. 2010. *Valuing the Unique: The Economics of Singularities.* Princeton: Princeton University Press.

Kaufman, Jason. 2004. "Endogenous Explanations in the Study of Culture." *Annual Review of Sociology* 30: 335–357.

Khaire, Mukti, and R. Daniel Wadhwani. 2010. "Changing Landscapes: The Construction of Meaning and Value in a New Market—Modern Indian Art." *Academy of Management Journal* 53(6): 1281–1304.

Khan, Shamus. 2011. *Privilege: The Making of an Adolescent Elite at St. Paul's School.* Princeton: Princeton University Press.

Khan, Shamus. 2012. "The Sociology of Elites." *Annual Review of Sociology* 38: 361–377.

Kharchenkova, Svetlana, and Olav Velthuis. 2018. "How to Become a Judgment Device: Valuation Practices and the Role of Auctions in the Emerging Chinese Art Market." *Socio-Economic Review* 16(3): 459–477.

Knorr Cetina, Karin. 1999. *Epistemic Cultures: How the Sciences Make Knowledge.* Cambridge, MA: Harvard University Press.

Kubler, George. 1962. *The Shape of Time.* New Haven: Yale University Press.

Latour, Bruno, and Steve Woolgar. 1979. *Laboratory Life: The Construction of Scientific Facts.* Princeton: Princeton University Press.

Lee, Jooyoung. 2016. *Blowin' Up: Rap Dreams in South Central.* Chicago: University of Chicago Press.

Lena, Jennifer. 2012. *Banding Together: How Communities Create Genres in Popular Music.* Princeton: Princeton University Press.

Lena, Jennifer. 2019. *Entitled: Discriminating Tastes and the Expansion of the Arts.* Princeton: Princeton University Press.

Lena, Jennifer, and Mark Pachucki. 2013. "The Sincerest Form of Flattery: Innovation, Repetition, and Status in an Art Movement." *Poetics* 41(3): 236–264.

Leschziner, Vanina. 2015. *At the Chef's Table: Culinary Creativity in Elite Restaurants.* Stanford: Stanford University Press.

Lonergan, Devin C., Ginamarie M. Scott, and Michael D. Mumford. 2004. "Evaluative Aspects of Creative Thought: Effects of Appraisal and Revision Standards." *Creativity Research Journal* 16: 231–246.

Maguire, Jennifer S., and Julian Matthews. 2012. "Are We All Cultural Intermediaries Now? An Introduction to Cultural Intermediaries in Context." *European Journal of Cultural Studies* 15(5): 551–562.

McDonnell, Terence E. 2010. "Cultural Objects as Objects: Materiality, Urban Space, and the Interpretation of AIDS Campaigns in Accra, Ghana." *American Journal of Sociology* 115(6): 1800–1852.

McDonnell, Terence E. 2016. *Best Laid Plans: Cultural Entropy and the Unraveling of AIDS Media Campaigns.* Chicago: University of Chicago Press.

McDonnell, Terence E., Christopher A. Bail, and Iddo Tavory. 2017. "A Theory of Resonance." *Sociological Theory* 35(1): 1–14.

Mead, George Herbert. 1934. *Mind, Self, and Society.* Chicago: University of Chicago Press.

Mears, Ashley. 2011. *Pricing Beauty: The Making of a Fashion Model.* Berkeley: University of California Press.

Mears, Ashley. 2014. "Seeing Culture through the Eye of the Beholder: Four Methods in Pursuit of Taste." *Theory and Society* 43(3/4): 291–309.

Mears, Ashley. 2015. "Working for Free in the VIP: Relational Work and the Production of Consent." *American Sociological Review* 80(6): 1099–1122.

Mears, Ashley. 2020. *Very Important People: The Labor of Conspicuous Consumption.* Princeton: Princeton University Press.

Mei, Jianping, and Michael Moses. 2002. "Art as an Investment and the Underperformance of Masterpieces." *American Economic Review* 92(5): 1656–1668.

Menger, Pierre-Michel. 1999. "Artistic Labor Markets and Careers." *Annual Review of Sociology* 25: 541–574.

Menger, Pierre-Michel. 2014. *The Economics of Creativity: Art and Achievement under Uncertainty.* Cambridge, MA: Harvard University Press.

Merluzzi, Jennifer, and Damon Phillips. 2016. "The Specialist Discount: Negative Returns for MBAs with Focused Profiles in Investment Banking." *Administrative Science Quarterly* 61(1): 87–124.

Merriman, Ben. 2017. "The Editorial Meeting at a Little Magazine: An Ethnography of Group Judgment." *Journal of Contemporary Ethnography* 46(4): 440–463.

Mohr, John, Christopher A. Bail, Margaret Frye, Jennifer C. Lena, Omar Lizardo, Terence E. McDonnell, Ann Mische, Iddo Tavory, and Frederick F. Wherry. 2020. *Measuring Culture.* New York: Columbia University Press.

Molotch, Harvey, William Freudenburg, and Krista Paulsen. 2000. "History Repeats Itself, but How? City Character, Urban Tradition, and the Accomplishment of Place." *American Sociological Review* 65(6): 791–823.

Moulin, Raymonde. 1987. *The French Art Market: A Sociological View.* New Brunswick: Rutgers University Press.

Mullen, Ann. 2020. "Beyond Classification, Decoding, and Meaning-Making: Contemporary Artists' Perspectives on the Reception of Visual Art." Paper presented at the American Sociological Association Annual Meeting, panel on "Art, Aesthetics and the Social," virtual engagement, August.

Musto, Michela. 2019. "Brilliant or Bad: The Gendered Social Construction of Exceptionalism in Early Adolescence." *American Sociological Review* 84(3): 369–393.

Parker, John, and Edward Hackett. 2012. "Hot Spots and Hot Moments in Scientific Collaborations and Social Movements." *American Sociological Review* 77(1): 21–44.

Pénet, Pierre, and Kangsan Lee. 2014. "Prize and Price: The Turner Prize as a Valuation Device in the Contemporary Art Market." *Poetics* 43(1): 149–171.

Peterson, Karin. 1997. "The Distribution and Dynamics of Uncertainty in Art Galleries: A Case Study of New Dealerships in the Parisian Art Market, 1985–1990." *Poetics* 25(4): 241–263.

Peterson, Richard A., and Narasimhan Anand. 2004. "The Production of Culture Perspective." *Annual Review of Sociology* 30: 311–334.

Peterson, Richard A., and David G. Berger. 1975. "The Production of Culture Perspective." *American Sociological Review* 40(2): 158–173.

Peterson, Richard A., and Roger M. Kern. 1996. "Changing Highbrow Taste: From Snob to Omnivore." *American Sociological Review* 61(5): 900–907.

Pickering, Andrew. 1995. *The Mangle of Practice: Time, Agency, and Science.* Chicago: University of Chicago Press.

Pollack, Barbara. 2018. *Brand New Art from China: A Generation on the Rise.* London: I. B. Tauris.

Pontikes, Elizabeth. 2012. "Two Sides of the Same Coin: How Ambiguous Classification Affects Multiple Audiences' Evaluations." *Administrative Science Quarterly* 57(1): 81–118.

Pouly, Marie-Pierre. 2016. "Playing Both Sides of the Field: The Anatomy of a 'Quality' Bestseller." *Poetics* 59: 20–34.

Rao, Hayagreeva, Philippe Monin, and Rodolphe Durand. 2003. "Institutional Change in Toque Ville: Nouvelle Cuisine as an Identity Movement in French Gastronomy." *American Journal of Sociology* 108(4): 795–843.

Rao, Hayagreeva, Philippe Monin, and Rodolphe Durand. 2005. "Border Crossing: Bricolage and the Erosion of Categorical Boundaries in French Gastronomy." *American Sociological Review* 70(6): 968–991.

Reinhardt, Ad. 1963. "Autocritique de Reinhardt," *Iris-Time* (Newsletter of Galerie Iris Clert, Paris), June 10; reprinted 1975 in *Art as Art: The Selected Writings of Ad Reinhardt*, edited by B. Rose, 82–83. New York: Viking Press.

Relyea, Lane. 2013. *Your Everyday Art World.* Cambridge, MA: MIT Press.

Rivera, Lauren A. 2015. "Go with Your Gut: Emotion and Evaluation in Job Interviews." *American Journal of Sociology* 120(5): 1339–1389.

Rosen, Sherwin. 1981. "The Economics of Superstars." *American Economic Review* 71(5): 845–858.

Sachs, Sarah. 2017. "The Algorithm at Work: The Practice of Constructing Similarity at the Art Genome Project." Paper presented for Columbia University Science, Knowledge, and Technology Workshop, New York, New York.

Santana-Acuña, Álvaro. 2020. *Ascent to Glory: How "One Hundred Years of Solitude" Was Written and Became a Global Classic.* New York: Columbia University Press.

Sawyer, R. Keith. 2012. *Explaining Creativity: The Science of Human Innovation.* Oxford: Oxford University Press.

Seigel, Jerold. 1986. *Bohemian Paris: Culture, Politics, and the Boundaries of Bourgeois Life, 1830–1930.* Baltimore: Johns Hopkins University Press.

Sgourev, Stoyan, and Niek Althuizen. 2014. "'Notable' or 'Not Able': When Are Acts of Inconsistency Rewarded?" *American Sociological Review* 79(2): 282–302.

Shattuck, Roger. 1955. *The Banquet Years: The Origins of the Avant-Garde in France—1885 to World War I.* New York: Random House.

Sherman, Rachel. 2017. *Uneasy Street: The Anxieties of Affluence.* Princeton: Princeton University Press.

Singerman, Howard. 1999. *Art Subjects: Making Artists in the American University.* Berkeley: University of California Press.

Skaggs, Rachel. 2019. "Harmonizing Small-Group Cohesion and Status in Creative Collaborations: How Songwriters Facilitate and Manipulate the Cowriting Process." *Social Psychology Quarterly* 82(4): 367–385.

Stark, David. 2011. *The Sense of Dissonance: Accounts of Worth in Economic Life.* Princeton: Princeton University Press.

Thompson, Don. 2008. *The $12 Million Stuffed Shark: The Curious Economics of Contemporary Art.* New York: Palgrave Macmillan.

Thompson, Don. 2014. *The Supermodel and the Brillo Box: Back Stories and Peculiar Economics from the World of Contemporary Art.* New York: Palgrave Macmillan.

Vaisey, Stephan. 2009. "Motivation and Justification: A Dual-Process Model of Culture in Action." *American Journal of Sociology* 114(6): 1675–1715.

Vaisey, Stephen. 2014. "The 'Attitudinal Fallacy' Is a Fallacy: Why We Need Many Methods to Study Culture." *Sociological Methods and Research* 43(2): 227–231.

Van Tilburg, Wijnand A. P., and Eric R. Igou. 2014. "From Van Gogh to Lady Gaga: Artist Eccentricity Increases Perceived Artistic Skill and Art Appreciation." *European Journal of Social Psychology* 44(2): 93–103.

Velthuis, Olav. 2005. *Talking Prices: Symbolic Meaning of Prices on the Market for Contemporary Art.* Princeton: Princeton University Press.

Velthuis, Olav. 2013. "Globalization of Markets for Contemporary Art." *European Societies* 15(2): 290–308.

Velthuis, Olav, and Stephano Baia Curioni, eds. 2015. *Cosmopolitan Canvases: The Globalization of Markets for Contemporary Art.* Oxford: Oxford University Press.

Velthuis, Olav, and Erica Coslor. 2012. "The Financialization of Art." In *The Oxford Handbook of the Sociology of Finance*, edited by K. Knorr Cetina and A. Preda, 471–487. Oxford: Oxford University Press.

Vertesi, Janet. 2014. *Seeing like a Rover: Images in Interaction on the Mars Exploration Rover Mission*. Chicago: University of Chicago Press.

Warhol, Andy. 1975. *The Philosophy of Andy Warhol (From A to B & Back Again)*. New York: Harcourt Brace Jovanovich.

Weitz, Morris. 1956. "The Role of Theory in Aesthetics." *Journal of Aesthetics and Art Criticism* 15(1): 27–35.

Wherry, Frederick. 2011. *The Philadelphia Barrio: The Arts, Branding, and Neighborhood Transformation*. Chicago: University of Chicago Press.

White, Harrison C., and Cynthia A. White. 1965. *Canvases and Careers: Institutional Change in the French Painting World*. Chicago: University of Chicago Press.

Winkleman, Edward. 2015. *Selling Contemporary Art: How to Navigate the Evolving Art Market*. New York: Allworth Press.

Wohl, Hannah. 2015. "Community Sense: The Cohesive Power of Aesthetic Judgment." *Sociological Theory* 33(4): 299–326.

Wohl, Hannah. 2020. "Performing Aesthetic Confidence: How Contemporary Art Collectors Maintain Status." *Socio-Economic Review* 18(1): 215–233.

Wolfe, Tom. 1975. *The Painted Word*. New York: Bantam Books.

Wolff, Janet. 1983. *Aesthetics and the Sociology of Art*. Boston: Allen and Unwin.

Wolff, Janet. 1984. *The Social Production of Art*. New York: New York University Press.

Wolff, Janet. 1999. "Cultural Studies and the Sociology of Culture." *Contemporary Sociology* 28(5): 499–507.

Yaneva, Albena. 2003. "Chalk Steps on the Museum Floor: The 'Pulses' of Objects in an Art Installation." *Journal of Material Culture* 8(2): 169–188.

Yogev, Tamar. 2010. "The Social Construction of Quality: Status Dynamics in the Market for Contemporary Art." *Socio-Economic Review* 8(3): 511–536.

Zelizer, Viviana A. 1979. *Morals and Markets: The Development of Life Insurance in the United States*. New York: Columbia University Press.

Zelizer, Viviana A. 1989. "The Social Meaning of Money: 'Special Monies.'" *American Journal of Sociology* 95(2): 342–377.

Zelizer, Viviana A. 2005. *The Purchase of Intimacy*. Princeton: Princeton University Press.

Zolberg, Vera, and Joni Maya Cherbo, eds. 1997. *Outsider Art: Contesting Boundaries in Contemporary Culture*. Cambridge: Cambridge University Press.

Zuckerman, Ezra. 1999. "The Categorical Imperative: Securities Analysts and the Illegitimacy Discount." *American Journal of Sociology* 104(5): 1398–1438.

Zuckerman, Ezra, Tai-Young Kim, Kalinda Ukanwa, and James von Rittmann. 2003. "Robust Identities or Nonentities? Typecasting in the Feature-Film Labor Market." *American Journal of Sociology* 108(5): 1018–1074.

Zukin, Sharon. 1982. *Loft Living: Culture and Capital in Urban Change*. Baltimore: Johns Hopkins University Press.

INDEX